D1132705

THE LAW
(IN PLAIN ENGLISH)®
FOR GALLERIES

Second Edition

Leonard D. DuBoff

ATTORNEY-AT-LAW

ALLWORTH PRESS
NEW YORK

© 1999 Leonard D. DuBoff

All rights reserved. Copyright under Berne Copyright Convention, Universal
Copyright Convention, and Pan-American Copyright Convention. No part
of this book may be reproduced, stored in a retrieval system, or transmitted
in any form, or by any means, electronic, mechanical, photocopying,
recording, or otherwise, without prior permission of the publisher.

04 03 02 01 00 99 5 4 3 2 1

Published by Allworth Press
An imprint of Allworth Communications
10 East 23rd Street, New York, NY 10010

Cover design by Douglas Design Associates, New York, NY

Page composition/typography by SR Desktop Services, Ridge, NY

ISBN: 1-58115-026-1

Library of Congress Catalog Card Number: 98-074532

Printed in Canada

Dedication

To the memory of my sister-in-law,
Diane DuBoff, an artist and craftsperson
whose beautiful work continues to inspire.

CONTENTS

FOREWORD

Art appeals most to that side of our being most removed from the quotidian aspects of life. In art, we discover the delight of painting, the strength of sculpture, the intimate contact with the hands of artists in drawings and sketches. For many of us, art is a refuge from the pressures of our own lives.

So it is no wonder that most of us who are drawn to making our lives and careers in the world of art do not think very much about its mundane, practical underpinnings. This is as true of the makers of art as it is of those who work in the marketplace for art. As a result, many are victims of pitfalls that could have been avoided through an awareness of how the law today affects all relationships, even—and indeed especially—those in the arts.

Fortunately, there now is a simple, straightforward guide for perplexed art professionals. In *The Law (in Plain English)® for Galleries*, Leonard DuBoff addresses laymen in terms free of legal jargon. He sets up guideposts and, with great common sense and the benefit of long experience, outlines safe paths to follow. The book's store of advice is invaluable—and, in this litigious age, essential for all who make their lives and livings in art.

André Emmerich
senior vice president, Sotheby's
former owner and founder,
André Emmerich Gallery

PREFACE

Throughout my professional career as a law professor, and now as a practicing attorney, I have realized the importance of preproblem counseling. This is especially true in the field of art and craft law, where many of the issues are complex and not usually understood by the attorney engaged in a general practice.

Creative people and gallery owners are often depicted as opposing teams in a tug of war. Nothing could be further from the truth. The individuals who create and those who sell their works are allies, engaged in a mutually beneficial relationship that results in making art and crafts available to the public. However, while those who create and those who retail the creations share a common interest, the legal issues encountered by each group are unique.

My goal is to sensitize art and craft professionals to the law so that they can avoid risky courses of conduct and spot problems at an early enough stage so as to minimize their ultimate impact on the success of the business.

Although there are a number of books available for visual artists and craftspeople, there have been, until now, none for the art or craft gallery owner. This book fills that void and provides a readable source of information.

I have tried to present the most up-to-date analysis of the myriad legal issues that galleries and craft retailers encounter in their business activities. This book is not intended to serve as a substitute for an attorney; rather, it is designed to make you aware of the options available in a host of common business situations and to provide you with sufficient knowledge to communicate effectively with a business attorney.

I sincerely hope that *The Law (in Plain English)® for Galleries* continues the tradition established by the other books in this series of providing an accurate, up-to-date, and readable text for an important segment of the business community.

Leonard D. DuBoff

ACKNOWLEDGMENTS

The process of revising this text has taken many years and involved numerous colleagues. While it is impossible to identify all of the individuals who have contributed to this second edition of *The Law (in Plain English)® for Galleries,* I would like to give special thanks to the people who have played the most active roles.

I am indebted to Christy King, one of the principals of the law firm of DuBoff, Dorband, Cushing & King, for her understanding of the law and her editing skills, and to Michael Supancich, also an attorney with the firm, for his help with editing. I am grateful to Don Davies for his computer skills and assistance; to Nicole Rhoades (Willamette University School of Law, Class of 1999) for her research; and to Peggy Reckow for her secretarial input.

I am also indebted to my three children, Colleen, Robert, and Sabrina, for their understanding and cooperation, though many times I was forced to refrain from participating in activities with them in order to work on this volume. My grandson, Brian, also cooperated in providing me with work time to complete this revision. Finally, I would like to express my greatest appreciation to my partner in law and life, Mary Ann DuBoff, for her help in this and all our other projects.

Leonard D. DuBoff

INTRODUCTION

After nearly twenty years of on-the-job training in the gallery business, much of the material in Leonard DuBoff's latest book is familiar to me. How I wish this book had been available at the beginning of my career! *The Law (in Plain English)® for Galleries* is a survival manual for anyone entering or, for that matter, already in the commercial gallery world.

Mr. DuBoff's clear, straightforward approach makes a complicated subject easy to grasp. With explanations that are simple without being simplistic, he guides the reader through the essential stages of establishing a viable business. By demystifying many intimidating legal and business issues, Mr. DuBoff enables the prospective entrepreneur to focus more effectively on the creative and artistic aspects of this fascinating profession.

Often a gallery is founded by individuals with a strong vision that, regrettably, is frequently undermined by a fuzzy business plan. A commercial gallery faces many challenges beyond that of making an artistic or philosophical statement. Clearly, the business must be an intelligently planned, efficiently managed enterprise if it is to survive. This goal is not easily met. With Mr. DuBoff's good counsel, however, the odds for success are in your favor.

Douglas Heller
President and Director, Heller Gallery

1 ORGANIZING YOUR BUSINESS

E veryone in business knows that survival requires careful financial planning, yet few people fully realize the importance of selecting the best structure for the business. There are only a handful of basic forms to choose from: the sole proprietorship, the partnership, the corporation, the limited liability company, the limited liability partnership, and a few hybrids.

Art galleries and craft retailers have little need for the sophisticated organizational structures utilized in industry, but because all entrepreneurs must pay taxes, obtain loans, and expose themselves to potential liability with every sale, it makes sense to structure one's business so as to minimize these concerns. When I counsel people on organizing their businesses, I usually adopt a two-step approach. First, we discuss various aspects of taxes and liability to determine which basic form is best. Once we have decided which form is appropriate, we discuss the organizational details, such as partnership agreements or corporate papers. These documents define the day-to-day operations of a business and, therefore, must be tailored to individual situations.

What I offer here is an explanation of the features, as well as some advantages and disadvantages, of the various organizational forms. But, because I cannot address the intricate details of your specific business, you should consult an attorney before deciding to adopt any particular structure. My purpose here is to enable you to better understand the choices available and to communicate more easily with your lawyer.

THE SOLE PROPRIETORSHIP

The technical name "sole proprietorship" may be unfamiliar to you, but you actually may be operating under this form. A sole proprietorship is an unincorporated business owned by one person. Although not peculiar to the United States, it is the backbone of the American dream to the extent that personal freedom follows economic freedom. As a form of business, it is elegant in its simplicity. Legal requirements are few and simple. In most localities, you must obtain a business license from the city or county for a small fee. If you wish to operate the business under a name other than your own, the name must be registered with the state and, in some cases, with the county in which you are doing business. With these details taken care of, you are in business.

Disadvantages

There are many financial risks involved in operating your business and, as a sole proprietor, the property you personally own is at stake. In other words, if, for any reason, you owe more than the dollar value of your business, your creditors can force a sale of your personal property to satisfy the business debt.

You can buy insurance that will shift the burden of a potential loss from you to the insurance company, but for many business risks, insurance is simply not available—for instance, the potential risk that a promotional event, such as an opening, will be unsuccessful. The cost of liability insurance is also quite high and may be economically unavailable to some businesses. Once procured, every insurance policy has a limited, strictly defined scope of coverage. These liability risks, as well as many other uncertain economic factors, can drive the sole proprietor into bankruptcy. If you recognize any of these dangers as a real threat, you should probably consider an alternative form of organization.

Taxes

The sole proprietor is taxed on all profits of the business and may deduct losses. Of course, the rate of taxation will change with increases in income. Fortunately, there are ways to ease this tax burden. For instance, you can establish an approved IRA or pension plan, deducting a specified amount of your net income for placement into the pension plan. There are severe restrictions, however, on withdrawal of this money prior to retirement age.

For further information on tax-planning devices, you should contact your local Internal Revenue Service (IRS) office and ask for a list of free pamphlets. Alternatively, you might wish to consult an accountant experienced in business tax planning.

THE PARTNERSHIP

Most state laws define a partnership as an association of two or more persons formed to conduct, as co-owners, a business for profit. No formalities are required to create a partnership. In fact, in some cases, people have been considered partners even though they never had any intention of forming a partnership. For example, if a friend lends you money to start your gallery and you agree to pay your friend a certain percentage of the profits, in the eyes of the law, the two of you may be partners, even though your friend has no part in running your business.

If the partners do not have a formal agreement defining the terms of the partnership—such as control of the partnership or the distribution of profits—state law will determine the terms. State laws are based on the fundamental characteristics of the typical partnership as it has existed throughout the ages and are, therefore, thought to correspond to the reasonable expectations of the partners. The most important of these legally presumed characteristics are the following:

- No one can become a partner in a partnership without the unanimous consent of all partners.
- All partners have an equal vote in the management of the partnership, regardless of the size of their interest in it.
- All partners share equally in the profits and losses of the partnership no matter how much capital they have contributed.
- A simple majority vote is required for decisions in the ordinary course of business, and a unanimous vote is required to change the fundamental character of the business.
- A partnership is terminable at will by any partner; a partner can withdraw from the partnership at any time, and this withdrawal causes a dissolution of the partnership.

Most state laws contain a provision that allows the partners to make their own agreements regarding the management structure and division of profits that best suit the needs of the individual partners.

Advantages and Disadvantages

The economic advantages of doing business in a partnership form are the pooling of capital, collaboration of skills, easier access to credit enhanced by the collective credit rating, and a potentially more efficient allocation of labor and resources. A major disadvantage is that each partner is fully and personally liable for all the debts of the partnership, even if not personally involved in incurring those debts. Each partner is

also liable for the negligence of another partner and for the partnership's employees when a negligent act occurs in the usual course of business.

If you are getting involved in a partnership, you should be especially cautious. First, because the involvement of a partner increases your potential liability, you should choose a responsible partner. Second, the partnership should be adequately insured to protect both the assets of the partnership and the personal assets of each partner.

Taxes

A partnership has no tax advantages over a sole proprietorship. Each partner pays tax on his or her share of the profits, whether distributed or retained, and each is entitled to the same proportion of the partnership deductions and credits. The partnership must prepare an annual information return known as Schedule Kl, Form 1065, which details each partner's share of income, credits, and deductions, and against which the IRS can check the individual returns filed by the partners.

THE LIMITED PARTNERSHIP

The limited partnership is a hybrid form containing elements of both the partnership and the corporation. A limited partnership may be formed by parties who wish to invest in a gallery or shop and, in return, to share in its profits, but who also seek to limit their risk to the amount of their investment. The law provides for such limited risk, but only so long as the limited partner plays no active role in the day-to-day management and operation of the business. In effect, the limited partner is very much like an investor who buys a few shares of stock in a corporation but has no significant role in running the corporation. One or more general partners run the business and have full personal liability, and one or more limited partners play a passive role.

To form a limited partnership, you must file a document with the proper state office—usually the Secretary of State. If the document is not filed or is improperly filed, the limited partner could be treated as a general partner and, thus, lose the protection of limited liability. In addition, the limited partner must stay uninvolved in the day-to-day operation of the partnership. If found to be actively participating in the business, the limited partner might be considered a general partner with unlimited personal liability.

Limited partnership is a convenient form for securing needed financial backers who wish to share in the profits of an enterprise without undue exposure to personal liability when a corporation or limited liability company may not be appropriate—for example, when one does

not meet all the requirements of a small corporation or when one does not desire ownership in a limited liability company (LLC). A limited partnership may be necessary to obtain funding when credit is hard to get or is too expensive. In return for investing, the limited partner may receive a designated share of the profits. From the entrepreneur's point of view, this may be an attractive way to fund a business because the limited partner receives nothing if there are no profits. Had the entrepreneur borrowed money from a creditor, however, she would be at risk to repay the loan regardless of the success or failure of the business.

Another use of the limited partnership is to facilitate reorganization of a general partnership after the death or retirement of a general partner. A partnership, remember, is terminated when any partner requests it. Although the original partnership is technically dissolved when one partner retires, it is common for the remaining partners to buy out the retiring partner's share—that is, to return that person's capital contribution to the business and keep the business going. Raising enough cash to buy out a retiring partner, however, could jeopardize the business by forcing the remaining partners to liquidate certain partnership assets. A convenient way to avoid such a detrimental liquidation is for the retiree to step into a limited-partner status. Thus, he can continue to share in the profits (which, to some extent, flow from that partner's past labor) while removing personal assets from the risk of partnership liabilities. In the meantime, the remaining partners are afforded the opportunity to restructure the partnership funding under more favorable conditions.

UNINTENDED PARTNERS

Whether yours is a straightforward partnership or a limited partnership, you want to avoid the unintended partnership. If you work with another person without formally describing your relationship in writing, you could find that the other person is technically a partner and, thus, entitled to half of the income you receive, even though his contribution is minimal. If you and another person decide to operate a retail craft gallery, for example, you can avoid an unintended partnership by making that person an employee or independent contractor. Whatever arrangement you choose, put it in writing.

COOPERATIVE GALLERIES AND SHOPS

Historically, individual farmers who found themselves exploited by commercial buyers or rural residents who could not purchase electricity from distant utilities banded together to form cooperatives. Those groups were able to accomplish together what their individual members could not do

on their own. Forming cooperative galleries or shops is also an alternative for artists or artisans who have not yet found a gallery or shop willing to display and sell their works or who have chosen not to sell through traditional channels.

A cooperative pools the resources and talents of each member in order to benefit the whole group. Generally, each member works several hours to help run the gallery and provides some items for display and sale. The members also hold regular business meetings to make decisions about how the cooperative should be run. The primary purpose of a co-op is to sell art and craft works. Members should be prepared for at least one of their number to gain recognition. In such cases, the newly recognized artist or artisan may find it personally advantageous to leave the co-op and spend more time creating new work and pursuing more profitable commercial avenues for marketing his or her pieces. Remaining members will then be left to take up the departing artist's share of the work, dues, and other obligations.

A cooperative is essentially a kind of partnership, although it may be structured as any of the business forms discussed in this chapter for purposes of taxation, liability, and the like. Some have been set up as nonprofit corporations; however, if the business generates a profit from successful activity, and if the members receive compensation, the organization will not be entitled to claim nonprofit status. It has even been held that a business engaging primarily in commercial activities, such as art or craft sales, whether or not it earns a profit, is not permitted to claim that it is a nonprofit organization.

There are many important factors to consider when forming a cooperative. Among these are:

- Focus and goals
- How to resolve disputes
- How often the members will meet
- Fiscal responsibilities
- Procedures for admission of new members
- Size of the organization
- Staffing
- Type and frequency of exhibitions
- Promotional activities
- Commission structure
- Insurances
- Financial and other obligations of members, including contributions of money, time, and artwork

Once these and other important issues have been decided, they should be embodied in a formal agreement signed by all members, and each member should receive a copy.

Artists are rarely trained in marketing and other business aspects of a gallery. It is, therefore, a good idea for the cooperative to hire or consult with an experienced gallery professional. Accountants, attorneys, insurance brokers, and other professionals should also be consulted in order to ensure that the co-op complies with local, state, and federal laws regulating businesses.

For more information about co-ops, contact the National Cooperative Business Association, 1401 New York Avenue, NW, Suite 1100, Washington, DC 20005.

THE CORPORATION

The word "corporation" may bring to mind a large company with hundreds or thousands of employees. In fact, the majority of corporations in the United States are small- or moderate-size companies. There are usually two reasons to incorporate: limiting personal liability and minimizing income tax liability. If you find it advantageous to incorporate, it can be done with surprising ease and little expense. You will, however, need a lawyer's assistance to ensure compliance with state formalities, provide instruction on corporate mechanics, and give advice on corporate taxation.

The Differences between Corporations and Partnerships

Like limited partners, the owners of the corporation—commonly known as shareholders or stockholders—are not personally liable for the corporation's debts; they stand to lose only their investment.

For the small corporation, however, limited liability may be something of an illusion because, very often, creditors will require that the owners either personally cosign or guarantee any credit extended. In addition, individuals remain responsible for their own wrongful acts; thus, a shareholder who negligently causes an injury while engaged in corporate business subjects the corporation to liability and, as well, remains personally liable.

The corporate liability shield does protect a shareholder from liability based on the corporation's breach of contract if the other contracting party has agreed to look only to the corporation for responsibility. The corporate liability shield also offers protection when an agent hired by the corporation has committed a wrongful act while working for the corporation. If, for example, a gallery employee negligently injures a

pedestrian while driving somewhere on corporate business, the employ-ee will be liable for the wrongful act and the corporation may be liable, but the shareholder who owns the corporation probably will not be held personally liable.

Unlike partners, shareholders cannot decide to withdraw and demand a return of capital from the corporation; all they may do is sell their stock. A corporation, therefore, may have both legal and economic con-tinuity—in fact, it is common for perpetual existence to be established in the articles of incorporation—but the continuity can also be a tremendous disadvantage to shareholders or their heirs if they want to sell stock when there are no buyers for it. Agreements can be made that guarantee return of capital to the estate of a shareholder who dies or to a shareholder who decides to withdraw.

Whereas, unless otherwise agreed, no one can become a partner with-out the unanimous consent of the other partners, shareholders of a cor-poration can generally sell some or all their shares to whomever they wish and whenever they wish. If the owners of a small corporation do not want it to be open to outside ownership, they can restrict the trans-fer of stock.

Unlike a limited partner, a shareholder is allowed full participation in the control of the corporation through voting privileges. Shareholders are given a vote in proportion to their ownership in the corporation; the higher the percentage of outstanding shares owned, the more significant the control. A voting shareholder uses the vote to elect a board of direc-tors and to create rules under which the board will operate. However, shareholders without voting rights exist under some corporation systems.

The basic rules of the corporation are stated in the articles of in-corporation, which are filed with the state. These serve as a sort of constitution and can be amended by shareholder vote. More detailed operational rules, called bylaws, should also be prepared. Shareholders and, in many states, directors have the power to create or amend by-laws. This varies from state to state and may be determined by the share-holders themselves in some states. The board of directors then makes operational decisions for the corporation and might delegate day-to-day control to a president.

A shareholder, even one who owns all the stock, may not preempt a decision of the board of directors. If the board has exceeded the powers granted it by the articles or bylaws, any shareholder may sue for a court order remedying the situation, but if the board is acting within its pow-ers, the shareholders have no recourse except to formally remove the board or certain board members. In a few more progressive states, a small

corporation may entirely forego a board of directors. In such cases, the corporation is authorized to allow shareholders to vote on business decisions, just as in a partnership.

Partnerships are quite restricted in the means available for raising capital. They can borrow money or, if all the partners agree, take on additional partners. A corporation, on the other hand, may issue more stock, and this stock can be of many different varieties—for example, recallable at a set price or convertible into another kind of stock. The authorization of new stock merely requires, in most cases, approval by a majority of the existing shareholders.

A means frequently used to attract a new investor is the issuance of preferred stock. The corporation agrees to pay the preferred shareholder some predetermined amount, known as a "dividend preference," before it pays any dividends to other shareholders. It also means that, if the corporation should go bankrupt, the preferred shareholder will generally be paid out of the proceeds of liquidation before the other shareholders (known as "common shareholders") but only after the corporation's creditors are paid.

In addition, corporations can borrow money on a short-term basis by issuing notes or, for a longer period, by using long-term debt instruments known as "debentures" or bonds.

Taxes

The last distinction between a partnership and a corporation that will be discussed here is the manner in which a corporation is taxed. Under both state and federal laws, the profits of the corporation are taxed to the corporation before they are paid out as dividends. Because the dividends constitute income to the shareholders, however, the profits are taxed again as personal income. This double taxation constitutes the major disadvantage of incorporating.

There are several methods of avoiding double taxation. First, a corporation can plan its business so as not to show very much profit. This can be done by drawing off what would become profit in payments to shareholders for a variety of services. For example, a shareholder can be paid a salary, rent for property leased to the corporation, or interest on a loan made to the corporation. All of these are legal deductions from the corporate income, provided they are reasonable. The corporation can also get larger deductions for the various health and retirement benefits provided for its employees than can a sole proprietorship or a partnership. It can also reinvest its profits into reasonable business expansion; this undistributed money is not taxed as income to the shareholder,

though the corporation must pay corporate tax on it. By contrast, the retained earnings of a partnership are taxed to the individual partners even though the money is not distributed.

Corporate reinvestment has two advantages. First, the business can be built up with money that has been taxed only at the corporate level and on which no individual shareholder needs to pay any tax. Second, within reasonable limits, the corporation can delay the distribution of corporate earnings until the shareholder's personal income—and, thus, personal tax rates—is lower. If the amount withheld for expansion is unreasonably high, then the corporation may be exposed to a penalty. It is, therefore, wise to work with an experienced tax planner on a regular basis.

The S Corporation

Congress has created a hybrid organizational form that allows the owners of a small corporation to take advantage of many of the features offered by a corporate form, but to be taxed in a manner similar to a partnership, thereby avoiding the double-taxation problem. In this form of organization, which is known as an "S corporation," income and losses flow directly to shareholders, and the corporation pays no income tax.

This form can be particularly advantageous in a corporation's early years, because the owners can deduct almost all of the corporate losses from their personal incomes, which they cannot do in a standard, or "C," corporation. Also, they can have this favorable tax situation while simultaneously enjoying the shareholder's limited-liability status. If the corporation is likely to sustain major losses and shareholders have other sources of income against which they wish to write off those losses, the S corporation is probably the best form for the business.

"Small corporation," as defined in the tax law, does not refer to the amount of business generated but, rather, to the number of owners. An S corporation may not have more than seventy-five owners, all of which must be either individual U.S. citizens or certain kinds of trusts or nonprofit corporations. Also, it cannot have more than one class of stock.

S corporations are generally taxed in the same way as partnerships, although, unfortunately, the tax rules for S corporations are not as simple as they are for partnerships. Generally speaking, however, the shareholder/owner of an S corporation can be taxed on his or her pro rata share of the distributable profits and may deduct his or her share of distributable losses.

LIMITED LIABILITY COMPANIES

There is a relatively new business form known as the "limited liability company," or LLC. This business form, which is available in all fifty states, combines the limited liability features of a corporation with all of the tax advantages available to the sole proprietorship or partnership. Although the first LLC statute was enacted in Wyoming in 1977, the form did not become attractive until 1988, when the IRS issued a ruling classifying the LLC as a partnership for tax purposes.

An art gallery or craft retailer conducting business through an LLC can shield personal assets from the risks of the business for all situations except her wrongful acts. This liability shield is identical to the one offered by the corporate form. The owners of an LLC can also enjoy all of the tax features accorded to sole proprietors or partners in a partnership.

LLCs do not have the same restrictions imposed on S corporations regarding the number of owners, their citizenship, and whether or not they must be individuals or particular entities. In fact, corporations, partnerships, and other business forms can own interests in LLCs. LLCs also may have more than one class of ownership.

Keep in mind that the LLC form is new, so there is not yet any significant body of case law interpreting the meaning of the statutes creating them. This business form is, however, extremely flexible. In 1997 the Internal Revenue Code was amended to permit LLCs to be taxed like C corporations or like sole proprietorships and partnerships at the business's option. As well, most state LLC statutes now permit the organization to be run by a single manager.

Limited Liability Partnerships

For businesses conducted in the partnership form that desire a liability shield, the "limited liability partnership," or LLP, is now available. This business form parallels the LLC in most respects, though it is created by converting a partnership into an LLP. It is often available to professionals in states that prohibit conducting business through an LLC. Licensed professionals who desire some form of liability shield may also create professional corporations. These business entities do not generally have the same liability shields available to S corporations.

Precautions for Minority Owners

Dissolving a corporation is not only painful because of certain tax penalties, but it is almost always impossible without the consent of the majority of the owners. This may be true of LLCs and LLPs as well. If you are involved in the formation of a corporation and will be a minority

shareholder, you must realize that the majority shareholders will have ultimate and absolute control unless minority shareholders take certain precautions from the start.

Numerous horror stories relate what majority shareholders have done to minority shareholders. Avoiding these problems is no more difficult than drafting an agreement among the shareholders. Both LLCs and LLPs have operating agreements that can be structured for minority protection. You should always retain your own attorney to represent you during the business entity's formation rather than waiting until it is too late.

In the next chapter, I have prepared some questions that you may wish to answer before meeting with your attorney. This should help minimize the amount of attorney's time necessary to create your new business entity.

BUSINESS ORGANIZATION CHECKLIST

A s discussed in chapter 1, creating any type of business is a simple process. But, to do it right and to make the most of all the advantages, I recommend you consult an experienced business lawyer. A lawyer's time, of course, is money, but you can save some of that money if you are well informed and properly prepared. Here is a checklist of some of the points you will need to discuss with your lawyer.

Other than you, the most important person with whom your attorney will work is your accountant. A Certified Public Accountant (CPA) can provide valuable input on the business's financial structure, funding, capitalization, allocation of ownership, etc. (See chapter 22 for guidelines on selecting a lawyer and an accountant best suited to your needs.)

Every business, regardless of its form, will have a name. Contact your attorney ahead of time with the proposed name of the business. Your attorney's office can identify the availability of your proposed business name and reserve it until you are ready to use it. You will also have to consider whether the business will have a special mark or logo that needs federal trademark protection or state registration. (See chapter 12 for a discussion of trademarks.)

CHECKLIST FOR A PARTNERSHIP

If you have decided to conduct your business in the partnership form, a formal written agreement prepared by a skilled business attorney is essential to ensure the smooth organization, operation, and, when necessary, final dissolution of the partnership. The more time you and your

prospective partners spend discussing these details in advance of meeting with a lawyer, the less such a meeting is likely to cost you.

Some of the major considerations in preparing a partnership agreement include the name of the partnership, a description of the business, its requirements of capital and labor, the partners' contributions of capital and labor, the duration of the partnership, the distribution of profits, the management responsibilities, the duties of partners, the prohibited acts, some features of future growth, and provisions for the dissolution of the partnership.

1. Partnership Name

Most partnerships simply use the surnames of the major partners. The choice then is simply the ordering of the names. Various factors from prestige to euphony may be considered in their arrangement. If the partnership has a name other than the partners', that name will have to be filed with the state. Choose a name that is distinctive and not already in use. If the name is not distinctive, then others can copy it; if the name is already in use, you may be liable for trademark infringement.

2. Description of the Business

The partners should describe the basic scope of the business, its requirements of capital and labor and their contributions to those, as well as some features of its future growth.

3. Partnership Capital

After determining how much capital to contribute, the partners must decide when it must be contributed, how to value the property contributed, and whether there is to be a right to withdraw or to contribute additional property at a later date.

4. Duration of the Partnership

Sometimes partnerships are organized for a fixed duration or are automatically dissolved upon the occurrence of certain events.

5. Distribution of Profit

There are any number of arrangements for distribution of profits. Although ordinarily a partner does not receive a salary, it is possible to give an active partner a guaranteed salary in addition to a share of the profits. Because the partnership's profits can be determined only at the close of a business year, usually no distribution of profits is made until that time. It is possible to allow the partners a monthly draw of money against

their final share of profits. In some cases, it may also be necessary to allow limited expense accounts for some partners. Not all of the profits of the partnership need to be distributed at the year's end. The partnership agreement can provide that some profits be retained for expansion. If no agreement has been reached, the law presumes all partners are entitled to an equal share of profits.

6. Management

Power in a partnership can be divided in many ways. All partners can be given an equal voice, or a few partners may be allowed to manage the business entirely with the remaining partners given a vote only on pre-designated areas of concern.

Some consideration should be given to the unfortunate possibility of a dispute among the partners that leads to a deadlock vote and possible dissolution of the partnership. One way to avoid this is to distribute the voting power so as to make a deadlock impossible. In a two-man partnership, for example, one partner might be in absolute control (although this may not be acceptable to the other partner). If the power is divided evenly between two partners or among a larger even number of partners, the agreement should designate a neutral party or arbitrator to settle the dispute.

You should also specify who can sign checks, place orders, or sell partnership property. Under state partnership laws, any partner may do these things as long as they do so in the usual course of business. However, such a broad delegation of authority may lead to confusion, so it is best to delegate this authority more narrowly. It is also a good idea to determine a regular date for partnership meetings.

7. Prohibited Acts

Acts prohibited to a partner can be listed. This list can be an elaboration or expansion of the three fundamental duties that each partner owes the partnership by virtue of being its employee or agent. First is the duty of diligence: The partner must exercise reasonable care in his or her actions as a partner. Second is the duty of obedience: The partner must obey the rules that the partnership has promulgated, and, most importantly, he must not exceed the authority that the partnership has vested in him. Finally, there is a duty of loyalty: A partner may not, without approval of the other partners, compete with the partnership in another business or seize upon a business opportunity that would be of value to the partnership without first disclosing the opportunity and allowing the partnership to pursue it.

8. Dissolution and Liquidation

Unless stipulated otherwise, a partnership is automatically dissolved upon the death, withdrawal, or expulsion of a partner. This changes the legal relationship between the partners, but need not affect the ongoing business. The partnership agreement should provide for the continuation of the business after any partner dies or otherwise leaves the partnership, if this is an agreeable arrangement.

Regardless, a partner who withdraws or is expelled, or the estate of a deceased partner, will be entitled to a return of capital proportionate to what that particular partner had contributed. Exactly how this capital will be returned should be decided in advance because it may be difficult or impossible to negotiate at the time of dissolution. One method would be to provide for a return of capital in cash over a period of time. After a partner leaves, the partnership may need to be reorganized and recapitalized. Some provision should be made to define in what proportion the remaining partners may purchase the interest of the departed partner.

Finally, because the partners may choose to liquidate the partnership, it should be decided in advance who will liquidate the assets, which assets will be liquidated prior to distribution, and what property will be returned to its original contributor.

CHECKLIST FOR CORPORATIONS AND LIMITED LIABILITY COMPANIES

1. Officers and Structure

Decide who will be president, vice president, secretary, and treasurer. In the case of an LLC electing centralized management, who will the manager be? It may be that the corporate bylaws or the LLC's management agreement should have a separate description for specialized officers. State statutes generally require a corporation to have some chief operating officer, such as a president. In addition, state statutes may require other administrative officers, such as a secretary or a treasurer.

2. Shareholders and Owners

How many shares should your corporation be authorized to issue? In the case of LLCs, certificates of participation or ownership, which resemble shares of stock in a corporation, are used, with the same considerations for their issuance. How many units should be issued when the business commences operations, and how many should be held in reserve for future issuance? Should there be separate classes of corporate shareholders and LLC owners? For example, if you need to borrow money, you may

want to issue preferred interest to the lender rather than show the loan as a debt on the books.

If the corporation or LLC is family owned, ownership may be used to some extent as a means of estate planning. You might, therefore, wish to ask your attorney about updating your will at the same time that you incorporate or create an LLC.

If your corporation has several shareholders, or if the LLC has several owners, you will want to find a way to prevent a voting deadlock. You may also wish to discuss with your lawyer the possibility of creating owner agreements that govern the employment status of key individuals or commit owners to voting a certain way on specific issues.

3. The Buy-Sell Agreement

The first meeting with your lawyer is a good time to discuss buy-sell agreements. You will need to specify what happens when one of the owners wishes to leave the business. Under what circumstances should he or she be able to sell to outsiders? In small businesses, the corporation or other owners are generally granted the first option to buy the interest. Specify what circumstances—death, disability, retirement, termination, and so on—will trigger the corporation's or other shareholders' right to buy the stock. You might also want to tie the buy-sell agreement to key-person insurance, which would fund the purchase of ownership interest by the corporation or LLC in the event of a key owner's death. Also, determine the mechanism for valuing stock or LLC interests, whether it be annual appraisal, book value, multiple earnings, arbitration, or some other method.

4. Planning for Future Owners

Are there plans to take on new investors, shareholders, or certificate owners in the future? Do you have plans for converting the corporation into one that is publicly held, that is, owned by a large number of investors? If so, the initial structure of the articles of incorporation and stock may be used as an important planning tool for the future. While ownership interests in LLCs cannot be publicly traded, it is still possible to bring in some additional owners. If this is anticipated, you and your attorney should discuss the method by which this may be accomplished and the legal restrictions that are imposed on the sale and transfer of LLC interests.

5. Capitalization

You and your attorney will work closely with your CPA to determine how best to plan this aspect of your business. You will need to decide

what the initial capitalization or funding of the corporation or LLC will be. Will the owners make loans to the business and contribute the rest in exchange for ownership interest? Owners may contribute money, past services, equipment, assets of an ongoing business, licensing agreements, or other things in exchange for ownership interest. What value will be placed on assets that are contributed to the corporation or LLC?

6. The Board of Directors

Decide who will be on the board of directors or, if the entity is an LLC with centralized management, the board of managers and, as well, how many initial directors or managers there will be. It is a good idea to have an odd number of directors or managers in order to avoid a voting dead-lock. Also, determine whether owners will have the right to elect members of the board of directors or managers based on their percentage of ownership, or perhaps by one vote per person regardless of percentage of ownership.

7. Housekeeping

Your attorney will need to know several other details: the number of employees the business anticipates in the next twelve-month period (this must be stated on the application for a federal tax ID number); the date the business's tax year ends; whether the accounting method will be on a cash or accrual basis; whether the business will authorize salaries for its officers; the date of the annual meeting of the board of directors and owners; the name of the registered agent, if other than your attorney; and the bank that your business will use.

8. Employee Benefits

Be prepared to consider employee benefit plans, such as life and health insurance, profit sharing, pension or other retirement plans, employee ownership programs, as well as other fringe benefits. If not implemented when the corporation or LLC is created, it is a good idea to determine when or if such programs may be instituted.

9. S or C corporation, or LLC?

Will the corporation elect to be an S corporation, where income and most losses flow directly to shareholders, and the corporation pays no income tax? Will it be a standard C corporation, which does pay income tax, and where corporate income is not taxed to the shareholders? If the corporation is likely to sustain major losses and shareholders have other sources of income against which they wish to write off those losses,

chances are the S election would be appropriate. Like S corporations, LLCs are ordinarily not taxable entities, though an LLC can choose to be taxed as a corporation.

As you can see, there is much to discuss at the first meeting with your lawyer. A little time and thought prior to that meeting will prove to be a worthwhile investment.

THE BUSINESS PLAN

E very business needs capital at one time or another. This funding might come through bank loans or other conventional financing, through public sale of securities, or as venture-capital money. No matter what the source, the first step in obtaining capital is the creation of a business plan, which will enable the banker, venture capitalist, or prospective owner to evaluate your company. Creating a business plan also provides a useful opportunity to think about all the features of a successful business and to formally establish your goals.

THE ROLE OF LAWYERS AND ACCOUNTANTS

The development of a well-written business plan is a considerable undertaking. It forces you to focus your ideas, ferret out weak spots in your organization, and turn abstract concepts into concrete plans. Experienced professionals, such as lawyers and accountants, can provide invaluable assistance in putting together a sound and attractive business plan and lend credibility to your numbers and projections. Your lawyer can help you obtain the legal protection your business needs while steering you away from the potential pitfalls that confront all new or expanding businesses. Your CPA can assist with the myriad financial assessments you must make. In addition, experienced lawyers and accountants have invaluable contacts within the venture capital and banking communities. They can tell you who has the capital, where it is being invested, and how you can best get a share. By enlisting the help of experienced professionals and following the suggestions

presented here, you can develop a business plan that will help you attract the financing you need.

HOW TO STRUCTURE YOUR BUSINESS PLAN

The structure and content of your business plan will vary depending upon your company's stage of development, the nature of the business, and the markets it will serve. Many different formats have been used for business plans. Although the order of presentation is, by no means standard, the following topics should be addressed in every business plan.

Executive Summary

This section provides the reader with a short overview of the key elements of the business plan. Sophisticated businesspeople are turned away by exaggeration. Thus, the summary must provide an accurate appraisal of your business while distinguishing your product or service and your organization from others that may be competing for the same funding. Include your key financial projections and the funding required to meet those projections. The summary should also describe your management team, emphasizing its experience and skills and outlining its weaknesses and your strategy to overcome them. Above all, the summary must catch the reader's attention. The summary must inspire one to read on, or else it has not served its purpose.

History

Businesspeople want to know about a business's past performance before they assess its future potential. Toward this end, the business plan should provide a brief history of the business, including when it was founded; its subsequent development and growth; how it has been organized (as a partnership or corporation, for example); and how well past performance reflects future potential. If you have good reason to believe that the business's past performance is not indicative of future potential, be sure to state why.

Products and Services

This section describes in detail the products and services of your art gallery or craft shop. Explain any unique features, and include a summary of present performance and status. Mention any special events and services, such as one-person shows and the publishing of prints, posters, newsletters, and catalogs. Keep in mind that investors are not likely to be art or craft experts but businesspeople, so avoid jargon and be clear and specific.

The Market

This section describes the market your gallery or shop serves. If the work you are selling is particularly innovative, such as high-tech crafts, you may need to include independent market research to define both the initial and future markets. If the work you are selling is by recognized artists, the market has likely already been defined. In that case, you may rely on available data provided by the artists, similar businesses, industry professional associations, the National Endowment for the Arts (NEA), state arts commissions, etc.

For the purposes of obtaining investment capital, the market section may be the most important part of your business plan. To the banker, venture capitalist, or prospective owner, a business without a strong understanding of the targeted market is a bad risk, even if the work sold is first-rate. Consequently, the market description should be more detailed than the product description, indicating to potential investors that you understand the priority of marketplace savvy.

The Competition

Identify your competitors, discuss their relative strengths and weaknesses, and indicate the market share likely held by each. Include a forecast of the market share you expect to capture in the first three to five years and the sources from which you expect to draw customers. Be sure to spell out your rationale for each projection—for example, more innovative art or more creative crafts, marketing strategies, procurement of favorable reviews, competitive pricing, better service, or other factors. As with all projections in the business plan, be as accurate as possible. Do not understate the strengths of your competition while overstating your own. Sophisticated businesspeople will not back a company that does not have a realistic view of its competition.

Source of Work

Obtaining sought-after art or craft work at an economical price and selling it expeditiously are the keys to profit making. In this section, describe the trade or other shows you attend; the artists or craftspeople who constitute your list of clients, and those with whom you have exclusivity agreements; the steps you have taken to expand your portfolio of work, and the markets for it; and whether you acquire the work wholesale or on consignment. Also, indicate whether you deal with resales or handle only newly created works. You should also present information about the reputation of the artists, including, for example, favorable reviews and relevant data from publications such as *Who's Who in America*, and the like.

Management

As a general rule, bankers, venture capitalists, and prospective owners prefer to invest in a start-up business with first-rate management rather than an established business with mediocre management. Therefore, emphasize the experience of each key management executive. Include job descriptions and salaries, and provide resumes detailing your executives' past business experiences, educations, publications, and any other information that will indicate to potential financiers that you have a qualified management team. If your management team has weak spots, define them and explain in detail how you intend to correct them.

Financial Data

Superior artwork and top-flight management count for nothing if your financial projections do not show a substantial return on investment. This section is the bottom line of your business plan. Begin by summarizing previous financial performance. If your business is new, be sure that all projections are realistic and justifiable. Most prospective investors and lenders will check out other galleries or craft retail shops before making a financial commitment to your business. If your projections deviate widely from the industry norm, you will lose both the credibility and the financing you seek. Do not, however, inundate your reader with yards of computer-generated spreadsheets. Your financial data should be concise and easy to understand.

Finally, your financial section should discuss the financing itself. Indicate how much money the business needs, the form of financing sought, and how the money is to be used. Most importantly, discuss the projected return within the next five years of operation. Again, be realistic and support your projections with solid data and a sound rationale.

4 BORROWING FROM BANKS

Commercial loans can be a valuable source of capital for qualified business borrowers. Lending policies vary dramatically from institution to institution, and although lenders by nature are conservative, some may be more flexible than others. You should talk to several banks to determine which ones would be more likely to lend to your business under the most favorable terms. To save time and increase the chances of loan approval, approach those banks first. (Your search should not be limited to your community. You might have to conduct a statewide, regional, or even national search before you find the right combination of willing lender and beneficial terms.) Using your credit card as a source of financing is not a good idea except in the most extreme cases. Interest rates are high and the terms are generally not good for business planning.

Once you have shopped the marketplace and selected a bank or banks, you are ready for the next step: preparing the loan proposal. It is very important to be properly prepared before taking this critical step. Loan officers are not likely to be impressed by a hastily prepared application containing vague, incomplete information and unsubstantiated claims. Many loan requests are doomed at this early stage because ill-prepared applicants do not present themselves and their businesses adequately to the lender, even though the proposed ventures are, in fact, sound.

THE LOAN PROPOSAL

To avoid an unexpected rejection, it is essential to know the bank's lending policy and to follow its procedures for a loan application. At a minimum, you should be prepared to satisfactorily address each of the following questions when applying for a loan. The lender's decision will be based on your answers. The ability to obtain money when you need it may be as important to the operation of your business as having a good location and a rich portfolio of art or crafts. Before an institution will agree to lend you money, the loan officer must be satisfied that you and your business constitute a good risk—that is, that you are creditworthy. There are several criteria:

- Do you have a good reputation?
- For what purpose is the money needed? Do you need a short-term or long-term loan?
- When and how will the loan be repaid?
- How much money do you really need?
- What kind of collateral do you and your business have to secure the loan?

Do You Have a Good Reputation?

The lender will want to know what sort of person you are. Do you have a good reputation in the community and in your field? Are you known in the community? What is your past credit history, and what is the likelihood that you will repay the loan if your business falters or fails?

Despite its subjective nature, consideration of the borrower's character figures prominently in the lender's decision making. Often a loan officer will deny a loan request, regardless of how qualified or how well collateralized the applicant appears on paper, if not convinced of the borrower's good character. Even "signature loans"—which require only the applicant's signature and are available only to businesses and entrepreneurs with the highest credit standing, integrity, and management skills—have been denied on the basis of character.

For What Purpose Is the Money Needed?
Will the Loan Be Short- or Long-Term?

Will you use the money to purchase inventory? To acquire fixed assets, such as display cases, computer systems, or light fixtures? Your answer will determine what type of loan—long-term or short-term—you should request. Loans for inventory purchases, especially if the business is seasonal (selling Christmas crafts, for example), will generally be short-term

and will require repayment within one year or less. Short-term loans are also appropriate for facilitating the collection of outstanding accounts receivable. The bank anticipates that the borrower will be able to repay the loan quickly as the inventory is sold or the accounts are collected.

Intermediate-term loans, which require payment within one to five years, and long-term loans, payable within ten to fifteen years, are more appropriate for purchases of fixed assets. Repayment of these loans is not expected from the sale of the assets but, rather, from the earnings generated by the company's ongoing use of them, which will occur at a slower rate; hence, the bank's willingness to allow repayment over a longer period.

Bear in mind that commercial lenders are interested in offering funds to successful businesses in need of additional capital to expand and increase profitability. They are not particularly inclined to make loans to businesses that need the money to pay off existing debts.

Depending upon your credit reputation, short-term loans may be available with or without collateral. It is more likely that long-term loans will require adequate security, often necessitating a pledge of personal and business assets.

When and How Will the Loan Be Repaid?

The questions of when and how the loan will be repaid are closely related to the answers to how much money is needed and for what purpose. You will have to convince the lender that your proposed use of the borrowed money will generate the additional revenue needed to pay the loan during the repayment period. The banker will use judgment and professional experience to assess your business ability and the likelihood of your future success. The banker will also want to know whether or not the proposed use of the borrowed funds justifies the repayment schedule requested.

How Much Money Do You Really Need?

The lender will also be concerned that the amount of the loan be adequate because an undercapitalized business is more likely to get into financial trouble. Similarly, a lender will be reluctant to approve a loan that is excessive because the debt may create an unnecessarily high cash drain on the company. The loan should net the borrower the amount necessary to accomplish the desired goal, with a slight cushion for error, and no more. Estimating the amounts needed to finance building construction, conversion, or expansion (long-term loans) is relatively easy, as is estimating the cost of fixed-asset acquisition. On the other hand, working capital needs (short-term loans) are more difficult to assess and depend upon your type of business. To plan your working capital

requirements, it is important to know the cash flow of your business, present and anticipated. To help the bank in its evaluation, simply project all cash receipts and disbursements as they are likely to occur in each month.

The lender will also want to know if you have included in the loan request a suitable allowance for unexpected business developments. That is, does the loan proposal realistically allow for the vicissitudes of operating a business and provide for alternative resources to meet your obligation if the business expectations are not met? Or is the borrower stretching to the limit, leaving no margin for error, so that repayment can be made only if the proposed venture is entirely successful? In the latter case, the lender may consider the loan too risky.

What Kind of Collateral Do You or Your Business Have?

Certain kinds of loans, called "signature loans," will be made solely on the borrower's signature. More frequently, banks will require collateral to secure the loan. Acceptable collateral can take a variety of forms. The type and amount of collateral necessary in a given situation will depend on the particular bank's lending policies and the borrower's financial state. In general, banks will accept the following types of collateral as security for a business loan.

Promises to Pay by Endorsers, Comakers, or Guarantors

You may have to get other people to sign a note in order to bolster your credit. These people, known as sureties, may cosign your note as endorsers, comakers, or guarantors. The law makes some subtle distinctions as to when each of these sureties becomes liable for the borrower's debt, but in essence, sureties are expected to pay back the borrowed funds if the borrower fails to do so. The bank may or may not require sureties to pledge their own assets as security for their promise to pay upon the borrower's default. This will depend, to a great extent, on the surety's own financial situation.

Assignment of Leases

Assigning a lease as a form of security is particularly appropriate for a franchise. If the bank lends a franchise money for a building and takes back a mortgage, that mortgage may be secured by assigning to the lender the lease entered into between the franchisor and the franchisee that will occupy the building. If the franchisor fails to meet mortgage payments, the bank can directly receive the franchisee's lease payments to satisfy the franchisor's debt.

Warehouse Receipts

Banks will accept commodities as security by lending money on a warehouse receipt. Such a receipt is usually delivered directly to the bank and shows that the merchandise used as security either has been placed in a public warehouse or has been left on your premises under the control of a bonded employee. Such loans are generally made only on standard, readily marketable goods.

Security Interests

Equipment loans may be secured by giving the bank a lien on the equipment you are buying. The amount lent will likely be less than the purchase price. How much less will depend on the present and future market value of the equipment and its rate of depreciation. You will be expected to adequately insure the equipment and to properly maintain it and protect it from damage.

Real Estate Holdings

You may be able to borrow against the equity in your personal real estate holdings, as well as against those of the business. Again, you will likely be required to maintain the property in good condition and carry adequate insurance on the property for the benefit of the lender, at least up to the amount of the loan.

Accounts Receivable

Many banks will lend money secured by your business's accounts receivable. In effect, the bank is relying on your customers to pay off your note obligation to the bank.

Savings Accounts and Life Insurance Policies

Sometimes you may get a loan by assigning your savings account to the lender. Here, the lender will keep your passbook while notifying the bank that holds the savings account that, due to the debt, the account is not to be drawn upon during the term of the loan. Loans can also be made up to the cash value of a life insurance policy, but you must be prepared to assign the policy over to the lender.

Stocks and Bonds

Stocks and bonds may be accepted as collateral for a loan if they are readily marketable. Banks will likely lend no more than 75 percent of the market value of a high-grade security. If the value of the securities drops below the lender's required margin, the borrower may be asked to provide additional security for the loan.

Inventory

Business inventory, either on hand or to be acquired, can be used as security for short-term loans. This applies only to those works of art or craft that are owned and resold by the business, as distinguished from works consigned for resale. The lender will expect the loan to be repaid on a timely basis from the revenues generated by the sale of this inventory. Inventory may also be used as collateral for long-term loans when the lender establishes a "field-warehousing arrangement." In this situation, the inventory is segregated and identified as collateral for a loan and an employee, who is responsible to the lender, is placed in charge of the field warehouse.

Intellectual Property

Patents, copyrights, trademarks, and other forms of intellectual property may be used as collateral for a loan. There is an increasing body of case law surrounding the methods by which these assets are to be secured. Unfortunately, many lenders are unfamiliar with methods of valuing the potential worth of intellectual properties and, thus, may not be willing to attribute a meaningful value to them. If you plan to pledge your intellectual property as security for a loan, it would be beneficial for you to first attempt obtaining an appraisal of it. You should also contact an experienced intellectual property attorney because, if the transaction is not properly handled, you could lose some of your intellectual property rights.

WHAT ARE THE LENDER'S RULES AND WHAT LIMITATIONS APPLY?

When making long-term loans, the lender will be especially interested in the net earning power of the borrowing company, the capability of its management, the long-range prospects of the company, and the long-range prospects of the industry of which the company is a part.

Once the loan has been approved in principal, the bank will likely impose certain rules and constraints on you and your business. These serve to protect the lender against unnecessary risk and against the possibility of your engaging in poor management practices. You, your attorney, and your business advisor should evaluate all of the terms and conditions of the loan in order to determine whether they are acceptable. If the bank's requirements are too onerous, it may be appropriate for you to decline this loan and seek alternative financing. Never agree to restrictions to which you cannot realistically adhere. If, on the other hand, the terms and conditions of the loan are acceptable, even though they are demanding, it may be appropriate to take the loan. In fact, some

borrowers view these limitations as an opportunity to improve their management techniques and profitability.

The kinds of limitations imposed will, to a great extent, be the result of the bank's scrutiny of your company. If the company is a good risk, only minimum limitations need be set. A company that is a poor risk, of course, should expect greater limitations to be placed on it.

You are likely to encounter three common types of limitations:

Specific Repayment Terms

The bank will want to set a loan repayment schedule that accurately reflects your ability to earn revenues sufficient to meet the proposed obligation. Risky businesses can expect shorter terms, while proven enterprises may receive longer periods within which to repay the loan.

Use of Pledged Security

Once a lender agrees to accept collateral to secure a loan, it will understandably be keenly interested in your assurance that, should the need arise, the collateral will still be available to satisfy the debt. To this end, the lender may take actual possession of the collateral if it is stocks, bonds, or other negotiable instruments.

Of course, a bank is not likely to take physical possession of a business's inventory or fixed assets and remove them to the vault. There are other ways by which a bank can obtain possession of your fixed assets while allowing you to use them. For example, the lender could "perfect"—that is, legally establish—a "security interest" in your fixed assets by filing a financing statement in the appropriate state or county office. ("Security interest" is the legal term for a lender's rights in collateral.) Real estate mortgages are perfected by being recorded in the appropriate government offices; security interests in inventory can be perfected for most purposes by either filing a financing statement, establishing a field-warehousing system, or both. In these situations, the bank may impose restrictions on the use of the collateral and require that it be properly maintained and adequately insured. The bank may further limit or prohibit you from pledging the same collateral for any other business debts or loans.

Although this may sound reasonable, you should recognize that such restrictions could seriously hamper your ability to borrow additional funds if the need arises. For example, when inventory is used as collateral, you must find out exactly how much of your inventory is involved. A bank may ask for only a percentage of the total inventory to secure the loan. More likely, though, the bank's security interest will extend to all

of the company's inventory on hand at any given time, including any inventory acquired later. Herein lies the potential problem: The inventory's value may well exceed the amount of the loan that it secures. Nonetheless, you may find yourself in the position of not being able to use any of the inventory as collateral for any additional loans. In cases where this situation is likely to arise, consider alternative sources of collateral.

Required Periodic Reporting

To protect itself, a lender may require you to supply it with certain financial statements on a regular basis, perhaps quarterly or even monthly. From these statements, the lender can see if, in fact, the business is performing up to the expectations projected in the loan application. This kind of monitoring serves not only to reassure the lender that the loan will be repaid, but also to identify and help solve problems early on before they become insurmountable and threaten the business.

ANALYZING YOUR BUSINESS POTENTIAL

The lender may inquire into any number of other areas related to your business, but if you are aware of the general information of interest to a lender and can present this information clearly and articulately, you will greatly increase the chances of having the loan approved.

The lender will evaluate the business outlook for your company in particular and for your type of business in general in light of contemporary economic realities. Is it reasonable to expect that the proposed use of the loan will produce the anticipated increased revenues for your business? Your plan may appear viable on paper but may not be realistic given the broader economic situation within which your gallery or shop operates.

Financial Evidence

Remember that bankers prefer to make loans to solvent, profitable, and growing enterprises. They seek assurance that the loan will contribute to that growth because your ability to repay the loan is directly related to your success. As I have already mentioned, bankers generally will not lend money so a business can pay off existing loans.

To help the bank ascertain the financial health of your business, you will probably be asked to provide two basic financial documents: a balance sheet and a profit-and-loss statement. The balance sheet is a tool to evaluate your business's solvency. The profit-and-loss statement summarizes the business's current performance. These financial reports are the principal means of measuring your company's stability and growth

potential, so unless yours is a new venture, be prepared to submit reports for at least the past two or three years. Ideally, your CPA should prepare the documents so that they will be more credible in the event of an audit.

When interviewing loan applicants and studying financial records, the bank is especially interested in the business's recordkeeping methods, account receivable status, type of inventory, and fixed assets. All of this information has a bearing on the bank's assessment of your potential success.

General Information

The lender will want to know whether the company books and financial records are up-to-date, accurate, and in good condition. Haphazard recordkeeping not only fails to reflect the business's true financial state, but demonstrates poor managerial skills. For obvious reasons, banks are reluctant to back sloppily run businesses, viewing them as too risky.

The lender will also be interested in the current condition of your business accounts payable and notes payable. Are those obligations being paid on time? If you are not able to meet your existing debts, the lender will be hard-pressed to understand how you expect to be able to pay off a new loan. You may be seeking a loan to solve cash-flow problems you now have, as well as to increase earnings and bring past-due accounts current while adequately handling the added debt. If this is your situation, you might overcome a lender's skepticism by presenting a solid, well-thought-out business plan that clearly demonstrates how the new loan will boost revenues and reduce, rather than contribute to, the business's financial problems.

The lender will be interested in the size of your workforce. Does it seem adequate to maximize the business's potential, or does it seem excessive compared to other similar galleries or shops? The lender will also likely want to know the salaries of the owner/manager and the other employees to determine whether or not they are reasonable. Excessive salaries drain a company's resources and profits, which may adversely affect the company's ability to meet debt obligations.

You should also be prepared to discuss your company's insurance coverage, the status of your tax payments, and, if you sell work from samples or catalogs, whether there are order backlogs.

Accounts Receivable

A bank will be particularly interested in the number of customers that are behind in their payments to you and how far behind they are. The lender will also want to know what percentage of the total accounts

receivable is overdue. If any major account is behind in payments, the bank will want to determine the likelihood that this account eventually will be paid.

The status of accounts receivable is of special interest to a lender when the borrower is relying on those accounts to provide the cash flow needed to service the requested loan. You should also expect to be asked whether your business has an adequate cash reserve to cover questionable accounts and whether the accounts receivable have already been pledged as collateral. A lender that secures a loan with collateral that has already been pledged to a prior lender will, in most cases, be limited in its ability to foreclose on that collateral if the debtor defaults. The prior lender has the first right to liquidate the collateral; subsequent lenders will receive only those proceeds remaining after the prior debt is fully satisfied.

Inventory

Because your business involves the sale of goods, the bank will need to know the state of the inventory on hand. Is it in good shape or will it have to be marked down before it can be sold? Do you own the inventory, or do you have it on consignment? Banks consider unpledged owned inventory as a possible source of collateral and also as a source of future revenues. The bank may also be interested in the inventory turnover rate, which reflects the demand for your business's art and crafts and helps to verify your revenue projections.

Fixed Assets

Because fixed assets can be used to secure a loan, the bank will likely be interested in the type, condition, age, and current market value of your company's fixtures, vehicles, etc. Generally, art galleries and craft retail stores have few fixed assets unless the business owns the building in which it is located. You should be prepared to explain how these assets have been depreciated, their useful life expectancy, and whether they have been previously mortgaged or pledged as collateral to another lender. In addition, be ready to discuss any need or plans to acquire additional fixed assets. On the one hand, this need could mean additional debt obligations in the near future; on the other, it could explain and justify your projected growth.

OPTIONS FOR OWNERS OF NEW BUSINESSES

A new business will not be able to supply as much information in its loan application as an established business will be able to provide. While this will not necessarily preclude the loan's approval, it could make it more

difficult. However, you should be aware that new business loans only constitute approximately 5 percent of all business loans made.

This reluctance to finance unproven businesses, which is understandably frustrating to new business owners, is consistent with the traditionally conservative nature of banks, which have a fiduciary duty to their stockholders and depositors to disburse funds in a prudent, responsible manner. In light of the extraordinarily high failure rate of new businesses, and the fact that a new business generally cannot provide adequate financial data to evaluate its potential for success, the lender is hard-pressed to justify making these high-risk loans. Even when the new-business borrower offers more than adequate collateral to secure the loan, the request may be denied.

Banks are comfortable lending money and earning profits from the interest charged on their loans. They are not comfortable in the role of involuntary partner in the failing business of a delinquent debtor. Even though banks secure loans with a wide range of collateral, they understandably are not anxious to have to foreclose on that security. They are not in the business of selling art or crafts or of trying to collect a delinquent debtor's accounts receivable. Although banks try to protect themselves by lending only a fraction of the collateral's market value, they still may not obtain the full amount that they are owed in a "distress sale" of that collateral, as this type of sale traditionally attracts bargain hunters who will often buy only at prices well below true market value. With an understanding of these dynamics, a potential borrower may better appreciate a bank's hesitation in approving a loan for a new business.

Banks do, however, make some loans to new businesses. You will need to demonstrate a good reputation for paying debts and offer evidence of business and management skills. Perhaps you have firsthand knowledge and expertise in the type of gallery or retail shop you propose to establish as a result of having been previously employed in the same or a closely related field. If so, emphasize that. In addition, provide a sound business plan to support your projections. You can further improve your chances of obtaining a loan if you have invested personal money in the business, indicating your confidence in its success. Furthermore, you should show, if possible, that the business has a good debt-equity ratio (that is, the amount of debt is low compared to the amount of assets).

Even if your loan is refused initially, it is important to establish a good working relationship with a bank by keeping the banker apprised of ongoing progress and improvements. If the bank sees that your business is, in fact, succeeding, you will have opened the door for future financing should the need arise.

THE LOAN APPLICATION

Having analyzed your business in the terms you know are important to lenders, you are ready to develop the loan request. Although most lenders will require the application to include the same standard, essential information, they often differ as to the format. Some lenders may provide suggested formats; others may require a specific format. A simple application form and a conversation may be adequate for your local banker. The start-up business seeking substantial funds may be required to provide much more extensive documentation, including a detailed plan of the entire business. The actual content, length, and formality will depend on the lender's familiarity with your business, the amount of money requested, and the proposed use of the borrowed funds.

The business-loan applicant is typically asked to submit any or all of the following information:

- *Personal Financial Statements.* These will indicate the applicant's personal net worth and will help the lender evaluate creditworthiness and repayment capability, as well as identify potential sources of collateral.
- *The Current Year's Tax Return* (and the previous two years' returns). Include returns for the individual and for the business.
- *The Business's Financial Statements.* As I mentioned previously, ideally you should submit statements covering the previous two or three years. They should be prepared and authenticated by an independent CPA. The lender may also request cash-flow statements and profit projections.
- *A Business History.* This should include past profit-or-loss patterns, current debt-equity ratio, current and projected cash flow, and present and projected earnings.
- *A Business Plan.* This plan should explain the proposed use of the requested funds and how the loan will benefit the business. The length and content of the plan will vary according to the financial health of the applicant's business and the amount and type of loan applied for (see chapter 3). The lender may request other documentation depending on the circumstances—for example, if you are securing a loan against your house, the lender might request a title report.

THE LOAN AGREEMENT

The loan agreement itself is a tailor-made document—a contract between lender and borrower—that spells out in detail all the terms and conditions of the loan. The actual restrictions placed on the loan will be found in the agreement under a section usually entitled "Covenants."

Negative covenants are things that you may not do without the lender's prior approval, such as incurring additional debt or pledging the loan's collateral or other business assets to another lender as collateral for a second loan. Positive covenants spell out those things that you must do, such as carry adequate insurance, provide specified financial reports, and repay the loan according to the terms of the loan agreement.

Note that, with the lender's prior consent, the terms and conditions contained in the loan agreement can be amended, adjusted, or even waived. Remember: You can negotiate the loan terms with the lender before signing. True, the bank is in the superior position, but legitimate lenders are happy to cooperate with qualified borrowers.

Once the loan is approved and disbursed, you will have new obligations and liabilities. Of course, if all goes according to plan, the loan proceeds are invested, the business prospers, the loan is repaid on schedule, and all parties live happily ever after. However, the business world is fraught with uncertainty. If, for whatever reason, you are unable to meet the debt obligations, view the lender as a potential ally in solving the problem rather than as an adversary.

Bankers are not usually eager to exercise their right to foreclose on collateral securing a loan. In general, lenders prefer to work with a potentially defaulting debtor to help ease the burden so that the borrower can overcome the problems, stay in business, and reestablish the enterprise's profitability. Lenders likely have no experience in marketing the types of collateral involved, nor do they want to run a distress sale, which, at best, would probably bring in only a fraction of the money owed. Additionally, foreclosing against the business's assets further decreases the bank's chance of recovering any of the unpaid balance because the borrower, stripped of the means to carry on business, is likely to be insolvent and facing bankruptcy. Even if the lender can liquidate the collateral at its current fair market value, that value may be well below the value agreed upon when the loan was made. For these and other reasons, banks foreclose on collateral only as a last resort.

Therefore, through experience, lenders have learned to identify a variety of red flags that indicate the debtor is experiencing financial difficulty. For example, the alarm sounds when loan payments are made later and later each month or when the business's account shows increasingly more checks dishonored for insufficient funds. When the lender sees these signals, the account may be assigned to a separate department within the bank that assists borrowers in a variety of ways: Repayment terms can be extended, the amount of payment due each month can be temporarily reduced, or the bank may accept payment of interest only

until the business has overcome its difficulties. The bank may also offer advice on solutions to the problem, particularly if poor management is the source of the difficulties. If, in fact, you can catch up with your payments, the bank may be able to offer you a couple of months with no payments. Note that interest will still accrue on the unpaid amount and you may have to pay a fee for this service.

To what extent the bank will be willing to accommodate a delinquent debtor very often depends on the debtor's attitude and cooperative spirit. At the first sign of trouble, the borrower should notify the bank that there is a problem, explain what is being done to remedy the situation, and inform the bank on a regular basis of the progress being made. It is unreasonable to expect a bank to be sympathetic and make concessions if you have waited until the debt is long past due before attempting to discuss the problem. A bank is also not likely to be too sympathetic toward a borrower who fails to return phone calls or is always unavailable to discuss the problem.

A solid professional relationship with your lender can be an invaluable asset to your business, not only for procuring loans but for help in difficult times. The ultimate success and growth of your business may well depend on it.

5

GETTING PAID

In an ideal world, every one of your gallery or craft retail sales would be for cash at the time of sale. Unfortunately, we do not live in an ideal world, and a host of problems can and do arise when dealing with customers. Fortunately, there are several methods to deal with these problems, ranging from preventive action to initiating a lawsuit.

If you are fortunate enough to deal with people who always pay in cash on delivery, then this chapter may be of no concern to you. However, if you have experienced problems with or delays in payment or have had some totally uncollectible bills, here are some useful suggestions.

POINT-OF-SALE PAYMENTS
When payment is made by currency, check, or credit card, the prudent art gallery or craft retailer should determine whether the currency is authentic, whether the check is going to be paid by the bank, or whether the credit card will be honored.

Currency
Occasionally, it is simple to identify counterfeit currency—for example, if the counterfeiter has put George Washington on a five-dollar bill. Usually, however, the irregularities are much more subtle and identification is very difficult. The federal government is quite diligent when possible in alerting businesspeople to the presence of counterfeit currency in a particular area. However, the best way to avoid being stuck with a counterfeit bill is to keep your eyes open. It is a good idea not to accept any bill larger than fifty dollars.

Credit Card

To avoid credit card fraud, first compare the signature on the back of the card with the signature on the transaction slip. Even more important is to follow the credit card company's procedures carefully. If the company requires you to get authorization for all credit card sales over $50 be sure to get that authorization. Although the procedure may seem time-consuming and troublesome, it is well worth the effort. If you have made a credit card sale without following the correct procedure and the credit card has been stolen or is otherwise invalid, or if the buyer has exceeded the credit limit, you are likely to be stuck with the loss.

Personal Checks

The most frequent difficulty occurs with payments made by personal checks. The person who writes the check may be an imposter using someone else's checkbook, for example. Even if the individual writing the check is legitimate, other situations can prevent the check from being honored by a bank. One of the most common difficulties is insufficient funds to cover the check. If the amount of your sale is substantial, you might be wise to request a certified, cashier's, or bank-guaranteed check. This, however, may deter impulse purchases and, therefore, may not be practical for many art galleries and craft retailers.

If the person writing the check is known to the recipient, the risk of fraud is reduced. If, on the other hand, the sale is to a stranger, you should verify the purchaser's address and phone number with supporting pieces of identification, even if the information is printed on the check. Insist upon seeing at least two pieces of identification, one of which should have a photograph of the person writing the check. Do not accept as identification such items as a Social Security card, a library card, or any identification that can be easily obtained or forged. Also, be wary of an individual presenting a check from a bank well beyond the local area, vacationers notwithstanding.

Watch the person sign the check (presigned checks could have a traced signature), and compare that signature with the signatures on the two forms of identification. Only an expert can identify a good forgery, but you may be able to catch the clumsy attempts of amateurs.

To further protect yourself, accept checks only if they are made out to you and are written for the exact amount of the sale. Do not take checks made out to someone else and endorsed to you.

Another way to minimize the possibility of obtaining a bad check is to subscribe to a check-verification service. These businesses maintain computer logs of individuals and businesses that have bad checks writ-

ten to other service subscribers. By simply making a telephone call or entering the customer's driver's license number or other identifiers into the service's data bank, you can discover if the customer has a history of negotiating bad checks.

Despite all these precautions, some bad checks do slip through. In most states, it is a crime to obtain property with a bad check. If the person can be found, you can bring a lawsuit to recover the amount of the check. If you win the suit, most states will allow the recovery of damages and reasonable costs of litigation, including reasonable attorneys' fees. (See Lawsuit and Small Claims Court sections, later in this chapter.) A check returned for insufficient funds can be redeposited in the hope that the check will be covered the second time through. Some bad checks are simply the result of a miscalculation of account balance or of the buyer having received a bad check. It is always a good idea to make a phone call before filing a lawsuit!

INSTALLMENT SALES

When work is delivered to a customer, the seller generally has the legal right to demand payment in full at that moment. One exception to this rule, common to art and craft dealers, is the installment purchase, in which the buyer takes possession of the work before full payment is made. If your gallery or shop permits installment sales, you can offer at least two types of arrangements: a layaway plan or sales on credit.

The layaway plan is the safest as it requires the purchaser to make full payment before the work is delivered. The purchaser signs a written agreement that sets forth the terms of the layaway plan, which include:

- The full purchase price to be paid
- The amount of down payment, if any
- The amount of each installment payment and the date it is due
- Provisions for nonperformance, such as nonpayment by the buyer after a certain date or destruction of the work while still in the seller's possession
- Rate of interest charged on the credit purchase, if any
- Penalties for late payment

The sale on credit is less common. The purchaser takes possession of the work before full payment is made. For this, too, the purchaser should sign a written agreement covering the terms of the arrangement. The contract should include essentially the same terms as a layaway contract, except that it should reflect the fact that the purchaser has possession of

the work. The contract should require the purchaser to insure the work for the benefit of the seller during the term of the contract and should also include a provision permitting the seller to reclaim the work in the event of the buyer's default.

A dealer may legally protect its interest in the work by having the purchaser sign a Uniform Commercial Code Financing Statement (UCC-1) and filing it in the appropriate government office(s)—usually with the Secretary of State. The Uniform Commercial Code (UCC) is a body of commercial law that provides rules of commercial practice and has been enacted in every state and territory of the United States (except that Louisiana has not adopted Article 2 of the UCC). Article 9 of the UCC provides a method whereby dealers can give public notice of their interest in a work lawfully in the possession of a buyer or other party and sets forth the procedure for foreclosing the security interest in the event of default. You should consult with your lawyer when establishing your credit-sales program.

RENTAL SALES

Many art galleries and some craft retailers have established a rental-sales program that permits an individual to possess the work for a limited time before payment is due. This type of arrangement allows the individual to live with the work in order to decide whether or not they wish to purchase it or use it solely as a temporary decoration. The dealer has relinquished possession of the work to someone who has not paid for it and may never buy it. A written agreement is essential.

The contract should identify the work and should specify: the term of the agreement; the amount of each rental payment and the date it is due, including any initial payment; any late charges or other assessments; a provision regarding insurance coverage for the work; the purchase price of the work and terms if the rental is converted to a sale, including the applicability to the purchase price of any rental payments; the location of the work during the rental period; and default provisions. In addition, the dealer's interest in the work should be secured by use of a UCC-1 Financing Statement signed by the renter and filed in the appropriate government office(s) by the dealer.

IF PAYMENT NEVER COMES

Common sense, diligence, and attention to detail are always important attributes for any businessperson. When the economy is weak and money is tight, they become essential. Some deadbeats and uncollectible bills

will always exist, but with proper care and attention to prevention, you can keep these to a minimum. For the most part, careful screening of customers will minimize the need to collect payment for sales. In some instances, however, you may need to send follow-up bills or resort to legal remedies available to you either directly or through a collection agency.

If you have extended store credit or if work is on a rental program and you have legally established your security interest in the work, then you may regain possession of the work or payment for it by complying with the rules for foreclosure set forth in Article 9 of the UCC. Work with an experienced business lawyer when pursuing your remedies under the UCC.

If you have not established your security interest, there are essentially three other alternatives for you to obtain payment: a collection agency, a lawsuit, or a small claims court. If the amount is small enough, you may simply decide not to pursue collection. Needless to say, you should refrain from doing any future business with that customer. The amount you spent on the lost inventory should be deductible as a business loss.

Collection Agencies

One option might be to hire a collection agency to attempt to collect the debt. Collection agencies generally charge a commission of 10 to 30 percent of the recovered amount, though some agencies require an upfront fee and take a lower percentage, and still others charge a fixed fee.

Lawsuit

You could investigate a full-scale lawsuit to force payment. In many states a formal demand for payment must be made prior to commencing a lawsuit. Moreover, this option is practical only if the outstanding debt is relatively large since an attorney must be hired and will likely be quite expensive, particularly if the case proceeds all the way to trial.

The fees charged for filing a case may be $100 or more, depending on the jurisdiction, and must be paid when the case is started. The debtor must be served with notice of the suit, for which you often need to hire a process server—an expensive proposition. Most states permit alternative forms of service. For example, "constructive service" may be made by publication and/or mailing. Enlist the aid of an experienced litigation lawyer if you're contemplating this form of collection.

Even if the case is won, the buyer may still refuse to pay, and you'll have to initiate further proceedings to enforce payment—for example,

garnishing the debtor's wages, seizing the debtor's property, or placing liens on houses or bank accounts. All in all, the expense involved in a civil trial may amount to more than the debt itself.

Small Claims Court

A simpler and less expensive solution on small debts is to bring an action in small claims court. The name of this court and the rules may vary from state to state, but all of the systems are geared toward making the process as swift, accessible, and inexpensive as possible. In many states, hearings on small claim actions may even be held on weekends or evenings.

The major savings in a small claims court proceeding is due to the fact that, customarily, attorneys are not permitted in such courts, unless they represent themselves or a corporation. Even in states where attorneys are not specifically barred by statute, the court rules are set up in such a clear, comprehensible way that an attorney is usually not needed. Most small claims courts have staff members who will guide you through the pleading and practice.

The procedure in the hearing is quite simple. The judge simply hears both sides of the case and allows the testimony of any witnesses or evidence either party has to offer. Jury trials are never permitted in small claims court, although the defendant may be able to have the case moved to a conventional court if he or she desires a trial by jury.

However, not all actions can be brought in small claims court. As the name implies, only claims for small amounts can be made. For example, small is defined as $2,500 or less in Arizona and Oregon. Moreover, only suits for monetary damages are appropriate for small claims court; other forms of relief, such as an injunction (requiring or prohibiting certain action) or specific performance (which requires the terms of the contract to be performed), cannot be obtained there.

Once initiated, the small claims court process is relatively swift and inexpensive. Filing fees are generally around $50. In addition, in most courts the creditor is not responsible for informing the debtor that a suit has been brought. Instead, the clerk of the court will mail the notice to the defendant by certified or registered mail, and the creditor is charged a small fee to cover mailing costs. Other states require personal service, which is often handled by the sheriff's office for a fee.

An action in small claims court has some disadvantages. First, the judgment is often absolutely binding: Neither party may appeal. Where appeal is allowed, as in New York State, the party wishing to challenge the judgment must show that "substantial justice has not been done."

This is not easy. The other major disadvantage of small claims action is that the judgment may be uncollectible. In many states, the usual methods of enforcing a judgment, such as the garnishment of wages or liens against property, are unavailable to the holder of a judgment from small claims court. Some jurisdictions permit a small claims court judgment to be converted into a traditional judgment, but this process often requires the help of an attorney. In other states, such as New York, enforcement action can be taken only if the debt is the result of a business transaction and the debtor has three other outstanding small claims court judgments.

For the most part, care in selecting those with whom you do business will minimize the need to use legal means to collect payment for sales. If all other methods fail, however, small claims court is by far the least expensive and easiest way to obtain legal redress for a small outstanding debt. The drawbacks should be considered, however, before you decide to use it as a remedy.

BANKRUPTCY

Occasionally you may find that the person who owes you money has filed for protection under the bankruptcy laws. Or, due to extensive collection or other financial problems, you may find that filing for bankruptcy is the appropriate solution for your business.

There are two general categories of business bankruptcy: straight bankruptcy and reorganization. Creditors customarily receive more of the debt due in the case of a reorganization than they do in the case of a straight bankruptcy. Reorganization is feasible, however, only when a healthy business is suffering from a temporary economic reversal.

Straight Bankruptcy

Straight bankruptcy, also referred to as Chapter 7 of the Bankruptcy Code, provides for the prompt conversion of all of the bankruptcy filer's nonexempt property or assets to cash, from which the creditors are paid. In an "asset case," the creditor must file a claim within the time specified in the court's notice of filing, or the claim will be disallowed. In a "no-asset case," however, the creditor may not file a claim and there will be no recovery.

The Bankruptcy Code gives certain categories of creditors priority for payment, such as the U.S. government for taxes, employees for wages owed, and secured parties for the amount of their security interests. Each category of creditor must be paid in full before a lower-priority creditor may be paid at all. If there is not sufficient money to satisfy all creditors

in a particular category, the members of that group will receive proportionate shares.

In addition, not all of the bankrupt's assets are available for creditors—for example, a modest house, a holy book, and clothing are typically exempt. The list of exempt property varies from state to state.

After the bankrupt's nonexempt assets are completely distributed and the bankrupt has fulfilled all requirements of the Bankruptcy Code, the judge discharges—or wipes out—the bankrupt's debts. Some claims, however, cannot be discharged in bankruptcy. The claim of any creditor who was not notified of the bankruptcy and who, therefore, did not participate remains viable even after the proceeding has ended. In other words, if you do not claim a debt, you will still owe it. Similarly, certain judgments, such as those for wrongful acts and fraud, also cannot be discharged.

Reorganization

The second type of bankruptcy proceeding, the so-called Chapter 11 or reorganization, entails a different process. Rather than terminating the business, a Chapter 11 facilitates an orderly payment to creditors so that the business may survive.

When the Chapter 11 petition is filed, the creditors and debtor meet and the debtor proposes a reorganization plan. Any legal proceedings for debt collection other than the bankruptcy proceeding are frozen, and the bankrupt is given the opportunity to satisfy its creditors. The creditors may participate in drafting the plan. If a plan acceptable to all creditors is prepared in a timely fashion, it is presented to the bankruptcy judge. If the judge determines it is "fair and equitable," the reorganization plan is implemented.

In order to have the plan accepted by all the creditors, a secured creditor may be forced to take a less favorable position than the UCC would allow. Even though that may happen on occasion, a gallery or crafts retailer with a security interest is still far better off than a creditor who is unsecured. If the plan satisfies any one of the three following criteria, it will be judged "fair and equitable" to the secured creditors:

- The secured creditors retain their liens and receive future cash payments equal to the value of the security
- The secured parties retain a lien on the proceeds from the sale of their collateral
- The secured creditors receive the equivalent of their interests, such as cash up front or substituted collateral

If a Chapter 11 reorganization plan, even once it has been confirmed, proves unfeasible, the bankruptcy may be converted by the bankrupt to a Chapter 7 proceeding.

Individuals may file a so-called Chapter 13 bankruptcy. In this type of arrangement, any amounts earned over and above ordinary and necessary living expenses will be paid to a trustee for ultimate distribution to creditors.

6 FRANCHISES

Once established, a gallery or craft retailer may wish to expand its business in order to enlarge its market. Franchising can make it possible for those without the capital resources to branch out on their own. You may franchise an already successful operation by selling the rights and tools necessary to replicate the business in other locations. Galleries and craft retailers struggling with their independently owned businesses might find that buying into an existing franchise or augmenting inventory with a franchised product line will keep the doors open. Successful franchises can offer a proven, well-run format and a good support network that are reassuring to both potential franchisees and customers.

A franchise should be distinguished from a chain. In a chain operation, one business owns all of the outlets, which are run as a single network. In a franchise, the franchisor provides the plan, education, ongoing support, market research, and perhaps even the products to a franchisee who is an independent business operator.

Franchises generally fill a specific niche while providing the public with a marketable product or service. Many of these operations focus on customer service because much revenue is generated by repeat customers. The concept has been successful in several types of businesses, such as McDonald's in the fast-food business and Midas in the auto-repair business. In the art-and-crafts field, several picture-framing businesses and stained-glass operations, for example, have successfully applied the concept of franchising.

CREATING A FRANCHISE

If you have decided to franchise your business, you will need the following to ensure success:

- A well-established, profit-generating business that may be used as a prototype. Franchisors should take care not to permit franchisees to be located too close to one another so they will not compete with one another.
- Executives who understand the industry and consultants who understand the legal and business aspects of franchising. In order to ensure that you have top-quality franchisees, you may want to recruit from among present employees who are already familiar with you, your products, and the philosophy of your company.
- Adequate capital to launch the program and provide initial and ongoing support for franchisees.
- A unique and protectable trademark that has been registered on both the state and federal levels (see chapter 12 for more information on trademarks).
- Quality-control standards particular to your type of business.
- A franchisee training program.
- A support staff network for franchisees, such as a newsletter, monthly meetings, or a computer link, depending on your business.
- Thorough knowledge of the industry and understanding of the competition.
- Legal documents, prepared by experienced lawyers and accountants, complying with Federal Trade Commission (FTC) and franchising law regulations.

A typical franchise statute defines a franchise as an agreement by which: (1) a franchisee is granted the right to engage in the business of offering, selling, or distributing goods or services under a marketing plan or system formulated by a franchisor; (2) the operation of the franchisee's business pursuant to such a plan or system is substantially associated with the franchisor's trademark, service mark, trade name, logo, advertising, or other commercial symbol designating a franchisor; and (3) the franchisee is required to give to the franchisor a payment or something of value (in legal terms, a "valuable consideration") for the right to transact business in accordance with the marketing plan.

All companies that offer franchise opportunities are required to file with the appropriate regulatory agencies. They must also prepare extensive disclosure statements for publication in the Federal Trade Com-

mission's "Uniform Offering Circular." Among other things, the following twenty items must be presented in the disclosure statement:

1. The identity of the franchisor, its franchisees, and their track records
2. A description of the business experience of the franchisor's officers, directors, and managers
3. Particulars of any lawsuits in which the franchisor or its officers, directors, and managers have been involved
4. Details of any previous bankruptcies declared by the franchisor, its officers, directors, and managers
5. The initial franchise fee and any other initial costs required to obtain the franchise
6. Payments required after the franchise has opened, which will vary according to the agreement
7. Quality control restrictions, including authorized suppliers
8. Assistance available to the franchisee from the franchisor
9. Inventory restrictions, such as permission to sell only those materials supplied by the franchisor
10. Territorial restrictions and protections
11. A description of any restrictions on the customers with whom franchisees may deal
12. A list of the conditions under which the franchise may be repurchased or refused renewal by the franchisor, transferred to a third party by the franchisee, or terminated or modified by either party
13. Training programs available to the franchisee
14. Any celebrities or public figures involved in the franchise
15. Site-selection assistance offered to franchisee from franchisor
16. Statistical information about the number of existing franchises and number of projected future franchises, as well as the number of franchises terminated, not renewed, and repurchased by the franchisor in the past
17. The franchisor's financial statement
18. The extent to which the franchisee is required to participate in the operation of the franchise
19. The basis for any earnings promises made to the franchisee, including the percentage of existing franchises that have achieved the results promised
20. The names and addresses of other franchisees

PURCHASING A FRANCHISE

If you are interested in purchasing a franchise, check closely to see that the franchisor has complied with all of the steps outlined above.

Additionally, make sure the opportunities and returns you desire are actually being offered. Whether buying or selling, always have franchise plans double-checked by competent accounting and legal professionals.

For those craft retailers and galleries looking to augment their inventory with franchised products or to convert faltering ventures into franchises, a good resource is the Franchise Opportunity Handbook, published by the U.S. Department of Commerce. This book lists most registered franchise opportunities, with a brief description of the business, the franchise fee, and the relationship between franchisor and franchisee.

Additional information about franchises, including books, publications, tapes, and videocassettes, is available from the International Franchise Association, 1350 New York Avenue, NW, Suite 900, Washington, DC 20005. The International Franchise Association sponsors World of Franchising Expos across the country. For more information, write to: IFA Expos, c/o The Blenheim Group, 1133 Louisiana Avenue, Suite 210, Winter Park, FL 32789.

7 CONTRACTS

Contracts are a legal and practical necessity in every business. I cannot cover the entire field of contract law here, but I will discuss some of the fundamentals so that you will be aware of what you need to know to protect your art or craft gallery.

WHAT IS A CONTRACT?

A contract is a legally binding promise or set of promises between two or more parties. The parties can be either individuals or business organizations. If one or more of the parties fails to perform the promise or promises made by contract—usually called a "breach"—the law will provide remedies to the injured party.

The three basic elements of every contract are the offer, the acceptance, and the consideration. For example, a salesperson shows a customer an oil painting at your gallery and suggests that she buy it (this is the offer). The customer says she likes the painting and wants to buy it (the acceptance). They agree on a price (the consideration). This is the basic framework of a contract, but there are a great many variations on the theme.

Implied Contract

You enter into many contracts without thinking much about them. For example, the telephone company agrees to provide telecommunication services with the understanding that you promise to pay for those services under certain agreed-upon terms. Likewise, if you order three

limited edition prints from an artist, the promise to pay is implied in the order and is enforceable when the prints are delivered.

Implied contracts can often become sticky. For example, suppose an art show promoter asks you for a supply of posters by an artist whose work you have just begun publishing. You deliver several dozen. The promoter disposes of all the posters you send and is overheard commenting that it is the most attractive and best quality poster he has ever handled. Is there an implied contract to purchase in this arrangement? That may depend on whether you are normally in the business of giving away free samples of newly published posters. It would have been wiser for you to clearly specify the terms under which you were providing the posters, either orally or in writing.

Express Contracts

An express contract is one in which all the details are spelled out. For example, you might make a contract with a potter for six dozen hand-thrown mugs to be delivered to you on October 1, at a price of $3 per mug, to be paid within thirty days of receipt. This is fairly straightforward. If either party fails to live up to any material part of the contract, there has been a breach of contract. The other party may withhold performance of his or her obligation until receiving assurance that the breaching party will live up to the contract. If no assurance is received, the aggrieved party may have a cause of action for breach of contract.

If you had advertised availability of the mugs during the week of October 2, but the mugs were delivered on October 15, and time was an important consideration, you would not be required to accept the late shipment. However, if time were not a material consideration, the potter, even with the slight delay, has substantially complied with the terms of the contract and you would have to accept the delivery. Therefore, it is important to clearly identify those terms that are material to the contract.

Oral and Written Contracts

The best practice is always to get an agreement in writing, particularly for those contracts you enter into on a regular basis that are critical to the viability and smooth running of your business. Owners of many art and craft galleries prefer to do business strictly on the basis of a handshake, particularly with their artists and customers. With a handshake agreement, the assumption is that the business relationship is based upon mutual trust alone. Although there may be some validity to this, far too many trusting businesspeople have suffered adverse consequences because of their idealistic reliance upon the sanctity of oral contracts.

Even in the best business relationships, one or both parties might simply forget the precise details of the original oral agreement. Memories do fade. Or, both parties might have quite different perceptions about the terms of the agreement reached. When the agreement is put into writing, however, there is much less doubt as to the terms of the arrangement (although even a written contract may contain ambiguities if it is not drafted with considerable care).

Contracts are enforceable only if they can be proven. Proof of oral contracts typically centers around the conflicting testimony of the parties involved. If one of the parties is not able to establish by a preponderance of evidence that his or her version of the contract is the correct one, the oral contract may be considered nonexistent—as though it had never been made. The same result might occur if the parties cannot remember the precise terms of the agreement. It is a truism that oral contracts are not worth the paper they are written on.

The function of a written contract, therefore, is not only to make very clear the understanding of the parties regarding the agreement and terms of the contract, but also to prove that there is an agreement and contract.

Case Study

Let's evaluate these potential business situations for the hypothetical gallery owner Pat Smith to determine which arrangements constitute contracts and which are enforceable.

Smith has an impressive portfolio of work by the noted artist Pablo Picarro. At a cocktail party, Mr. Jones expresses to Smith an interest in Picarro's art. "It looks like the market value of Picarro paintings keeps going up," Jones tells Smith. "I'm going to buy one while I can still afford it."

Is this an enforceable oral contract? Does it meet the three criteria of a contract: offer, acceptance, and consideration? What are the terms of the offer—has a price been specified for a particular painting? No, Jones has not made a specific offer that Smith can accept. He has simply expressed an opinion and a vague intent.

Ms. Brown offers to pay Smith $4,000 for a Picarro sculpture that she saw at Smith's gallery several weeks ago. At the gallery, it was listed at $4,500, but Smith agrees to accept the lower price.

Is this an enforceable contract? Yes! Brown has offered to pay a specific amount for a specific piece, and Smith has accepted the offer. This is a binding, express, oral contract.

One day, Jones shows up at Smith's gallery and sees a particular print for which he offers $1,000. Smith accepts and promises to deliver a bill

of sale and an appropriate print disclosure form the next week, at which time Jones will pay for the print. An hour later, Brown shows up. She likes the same print and offers Smith $1,500 for it. Can Smith accept the later offer?

No. A contract already exists with Jones. An offer was made and accepted. The fact that the object has not yet been delivered or paid for does not make the contract any less binding.

Mr. Green discusses the kind of frame he would like Smith to put on a particular photograph Smith has just acquired. He offers to pay $5,000 for the photo if the final product is satisfactory to him. Green approves the framing and the matting material, and Smith completes the work, but Green refuses to accept the framed photo because it is not satisfactory to him.

Green's offer was conditional upon his satisfaction with the completed work. Smith understood that he would receive payment only if he produced something that met Green's subjective standards—a risky way to do business. There is no enforceable contract for payment until such time as Green indicates that the completed work is satisfactory.

Suppose, instead, that Green arrives at Smith's gallery and agrees that the framed photo is satisfactory. When Smith delivers the photo, however, Green says he has changed his mind and refuses to accept it. In this case, Green has breached his contract. The oral contract became binding at the moment he indicated the framed work met his conditions.

STATUTE OF FRAUDS

The Statute of Frauds was designed to prevent fraud and perjury. According to this statute, at least two types of contracts must be in writing if they are to be legally enforceable: (1) any contract that, by its terms, cannot be completed in less than one year; and (2) any contract that involves the sale of goods for over $500. This rule is narrowly interpreted, so if there is any possibility, no matter how remote, that the contract could be fully performed within one year, the contract need not be in writing.

For example, if a jeweler agreed to submit one piece of custom-designed jewelry to a craft retailer each year for a period of five years, the contract would have to be in writing because, by the very terms of the agreement, there is no way the contract could be performed within one year. If, on the other hand, the contract called for the jeweler to deliver five pieces within a period of five years, the contract would not have to be in writing to be enforceable because it is possible, although perhaps not probable, that the jeweler could deliver all five pieces within the first year. The fact that the jeweler does not actually complete performance

of the contract within one year is immaterial. So long as complete performance within one year is within the realm of possibility, the contract need not be in writing to be enforceable. It may be oral.

The Statute of Frauds, as set forth in Article 2 of the Uniform Commercial Code (UCC), further provides that any contract for the sale of goods valued at $500 or more is not enforceable unless it has been put into writing and signed by the party against whom enforcement is being sought. (The law defines "goods" as all things that are movable at the time of making the contract except for the money used as payment.)

Smith's sale to Green was for both goods and services, but because the goods involved were over $500 in value, the contract should have been in writing to ensure enforceability. If, however, the contract had been one of performance of personal services only—say, for framing performed by Smith using Green's materials—the UCC would not apply, and the contract would be enforceable whether or not it was in writing.

The fact that a contract for a price in excess of $500 is not in writing does not void the agreement or render it illegal. The parties are free to perform the oral arrangement, but if one party refuses to perform, the other will be unable to legally require performance of the agreement.

The real question becomes whether a particular contract involves the sale of goods for a price of $500 or more. For example, if a potter agrees to provide a craft retailer with all its pottery inventory for the coming year—whatever that may be—how is the price to be determined? Or, if a jeweler sells a number of pieces to a gallery, and the total purchase price exceeds $500 but the price of the individual works is less than $500, which price governs? In light of these possible ambiguities, the safest course is to put all contracts into writing. Most states have additional circumstances requiring contracts to be in writing, so you should contact your attorney before entering into any important oral contract.

NO-COST WRITTEN AGREEMENTS

You may feel you do not have the time, energy, or patience to draft contracts. After all, you are in business to sell art or craft works, not to formulate written contracts steeped in legal jargon. You may find that a supplier, artist, or craftsperson is willing to draft a satisfactory contract for you—but that is not very likely! Be wary of signing any form contracts: They will almost invariably be one-sided, with all terms in favor of whoever paid to have them drafted. As an alternative, you can hire an attorney to draft contracts for you. This might be worthwhile for substantial transactions, but for smaller ones, the legal fees may offset the benefits derived from having a written contract.

The UCC offers businesses a third and perhaps the best option: You need not draft any contract or rely on anyone else to do so. Remember, however, that the UCC applies only to the sale of goods. The UCC provides that where both parties are merchants and one party sends to the other a written confirmation of an oral contract within a reasonable time after that contract was made, and the recipient does not object to the confirming memorandum within ten days of its receipt, the contract will be deemed enforceable. A "merchant" is defined as any person who normally deals in goods of the kind sold or who, because of occupation, represents herself or himself as having knowledge or skill peculiar to the practices or goods involved in the transaction. Most businesspeople will be considered merchants.

It should be emphasized that the sole effect of the confirming memorandum is that neither party can use the Statute of Frauds as a defense, assuming that the recipient fails to object within ten days after receipt of the memorandum. The party sending the confirming memorandum must still prove that an oral contract was, in fact, made prior to or at the same time as the written confirmation. Once such proof is offered, neither party can raise the Statute of Frauds to avoid enforcement of the agreement—this is a specific exception to that law.

The advantage of the confirming memorandum over a written contract lies in the fact that it can be used without the active participation of the other contracting party. It would suffice, for example, to simply state: "This memorandum is to confirm our oral agreement." However, since you would then still have to prove the terms of that agreement, it would be useful to provide a bit more detail in the confirming memorandum, such as the subject of the contract, the date it was made, and the price or other consideration to be paid. Thus you might draft something like the following:

> This memorandum is to confirm our oral agreement made on July 3, 2000, in which you [craft artist] agreed to deliver to me [craft retailer] on or before September 19, 2000, three weavings, each approximately 2′ × 2′ in earth tones, for the purchase price of $600 each.

The advantages of providing detail in the confirming memorandum are twofold. First, in the event of a dispute, you could introduce the memorandum as proof of the terms of the oral agreement; and second, the recipient of the memorandum (and, for that matter, the party sending the memorandum) will not be able to claim any terms of contract other than those contained in the memorandum. For example, the retailer in

the preceding example would not be able to claim that the contract called for delivery of four weavings because the quantity was clearly stated in the written memo and was not objected to by the artist.

The retailer, however, could testify that the oral contract required the weaver to use synthetic fiber instead of natural fiber because this testimony would not be inconsistent with the terms stated in the memorandum. To prevent either party from adding or inventing terms that are not spelled out in the confirming memorandum, the memorandum should end with a clause requiring all other provisions to be contained in a written and signed document. For example:

> This is the entire agreement between the parties and no modification, alteration, or additional terms shall be enforceable unless in writing and signed by both parties.

If you use such a clause, be sure there are no additional agreed-to terms that have not been included in the written document. A court will generally be confined to the four corners of the document when trying to determine what was agreed to between the parties. An exception to this rule is that a court may allow oral evidence for the purpose of interpreting ambiguities or explaining the meanings of certain technical terms. The parties may also permit the other parties to introduce evidence of past practices in connection with the contract in question, in connection with other agreements between the parties, or even in connection with contracts between other parties.

To sum up, businesspeople should not rely on oral contracts alone since they offer little protection in the event of a dispute. The best protection is afforded by a written contract. If drafting a complete written contract proves too burdensome or too costly, the businessperson should submit a memorandum in confirmation of the oral contract. That at least surpasses the initial barrier raised by the Statute of Frauds. Moreover, by recounting the terms agreed upon in the memorandum, the businessperson is in a much better position later on to prove the oral contract.

ESSENTIALS OF THE WRITTEN CONTRACT

A contract rarely need be—nor should be—a long, complicated document written in legal jargon designed to provide a handsome income to lawyers. Indeed, a contract should be written in simple language that both parties can understand and should spell out the terms of the agreement. The contract should include the following five items:

1. The date of the agreement
2. Identification of the parties—the buyer and seller in the case of sale of goods or services
3. A description of the goods or services sold
4. Price or other consideration
5. The signatures of the parties involved

In addition to these basics, the agreement should spell out whatever other terms might be applicable: pricing arrangements, payment schedules, insurance coverage, consignment details, and so forth. A written document that leaves out essential terms of the contract presents many of the same problems of proof and ambiguity as an oral contract. Contract terms should be well conceived, clearly drafted, conspicuous (i.e., not in tiny print that no one can read), and in plain English so that all the parties can easily read and understand them.

DEALING WITH ARTISTS, CRAFTSPEOPLE, AND OTHER SUPPLIERS

U nless you intend to market only works you create, you will need to establish business relationships with artists, craftspeople, and other suppliers. If you have significant capital, you may be willing to purchase artwork outright and accept the risk that you may not sell it. This arrangement is common in Europe's fine-art galleries and throughout much of its craft industry. In the United States, however, it is more common for artists to consign their works for sale to art and craft galleries.

CONSIGNMENT

In consignment relationships, the artist or craftsperson retains ownership of the work until it is sold. The gallery or craft retailer promotes and handles the sale of the work and receives a portion of the sales price as a commission.

Artists and those who sell art usually view their relationship as a personal one—more like a marriage than a business venture. This sentiment generally results in a vague business relationship with the specific terms rarely put in writing. Unfortunately, like the modern marriage, the relationship between dealer and artist may eventually sour. As I stressed in chapter 7, without a written agreement, either party may find itself injured and without a remedy.

Recognizing the many potential problems inherent in the relationship between dealer and artist, most states have enacted consignment statutes modeled after New York's statute. New York was the first to adopt a

consignment statute designed to protect unwary artists from unscrupulous dealers. This law characterizes the relationship between the artist and dealer as principal and agent rather than debtor and creditor. This means that the artist retains title to the work while the dealer sells the work on behalf of the artist and holds proceeds from the sale in trust for the artist.

Regardless of whether the contract between them is written or oral, dealers' and artists' relationships are subject to the Uniform Commercial Code (UCC), which fills in contractual gaps and interprets the intent of the parties when disputes arise. Typically, those states with consignment statutes have exempted the relationship between dealers and artists from the UCC regulation that allows the dealer's creditors access to goods held on consignment. In many states, the dealer's creditors cannot attach an artist's consigned work or the proceeds from its sale, even if the dealer files bankruptcy, because both the artwork and the money are being held in trust.

Consignment statutes are designed to establish rules between the parties and, in some instances, to require written contracts. Some permit the parties to vary terms, while others mandate rigid adherence. For example, the New York statute permits the artist who is entitled to be paid on an installment sale to waive receipt of full payment before the dealer may retain any installments, provided that the waiver is in writing and that the artist receives the first $2,500 of installment payments within a twelve-month period. The California statute, on the other hand, prohibits any sort of waiver of the artist's rights.

Exclusivity

It is quite common for galleries and craft retailers to insist upon an exclusivity arrangement when contracting to market the works of an artist or craftsperson. Such an arrangement may grant the exclusive right to sell all of the artist's work within a particular geographical area, for example, or it may permit the sale of only certain of the artist's works. In exchange for the artist's grant of exclusivity, the gallery agrees to diligently promote and sell the artist's work. Occasionally, artists will demand minimum sales guarantees as a condition of the continued grant of exclusivity.

A common dispute in exclusivity arrangements is the meaning of "exclusive." Similar to the relationship of agent and seller in real estate transactions, the relationship between the dealer and artist may be characterized as either an "exclusive agent" relationship or an "exclusive power-to-sell" relationship. In an exclusive agent relationship, the dealer is the sole agent allowed to sell the artist's work. Under these terms, artists can sell their own works from their studios and owe the dealer

nothing because no agent was involved in the sale. In an exclusive power-to-sell relationship, any time an artist's work is sold, even if not from the gallery or retail shop of the dealer, the artist owes the dealer a commission. The dealer takes the position that he or she is entitled to this commission, especially when representing an unknown artist, because the capital and effort expended in promoting the artist may indirectly have resulted in the sale of the work.

While the relationship may seem as simple as the promise of a gallery or craft retailer to sell an artist's or craftsperson's work in exchange for a commission, rarely is the arrangement so elementary. Exclusivity arrangements are quite controversial because of numerous issues that are difficult to clarify. How are the geographical areas defined, for example? By zip code, municipal boundaries, commercial zones? Sometimes a single building has its own zip code. Artists and craftspeople also often feel that exclusivity arrangements deprive them of sales. The definition of "sale," for the purpose of the arrangement, is also subject to interpretation. Is a charitable donation to a museum, for example, considered a "sale?" What about bartering?

An exclusivity arrangement should be detailed, in order to clarify as many of these potentially ambiguous issues as possible. The parties should consider all questions that may arise during the relationship, negotiate how these situations will be handled should they arise, and create a written contract with provisions that represent their understanding.

The contract should answer at least these basic questions:

- Who are the parties?
- Is the dealer an individual or an organization?
- Must the dealer remain at a particular location?
- Can the dealer assign rights to another dealer?
- Does the artist's surviving spouse or children have any rights under the contract should the artist die?
- What will happen if the artist incorporates?
- What is the contract's specific term? What are the conditions and methods of termination? Is the relationship dependent upon a certain number of successful sales by the dealer or production of a certain number of works by the artist?
- Who pays for insurance?
- Who is responsible for packing and shipping? If the work is not all sold when the contract terminates, who is responsible for storage until the artist has reclaimed the work? Who pays for shipping and storage?

- Who pays for framing and, if the work does not sell, who owns the frame?
- What are the artist's rights with respect to copyright and reproductions?
- When and how is the artist to be paid and in what currency?
- If the sale is an installment sale, who is paid first, the artist or the gallery?

State consignment statutes deal expressly with many of these items. You should work with an attorney experienced in art and craft law to determine whether you are subject to such statutes, their requirements, and whether or not they are modifiable by contract. For more information on the business concerns you might want to address in your contract, see *The Crafts Business Encyclopedia* by Michael Scott, rev. ed. (San Diego: Harcourt Brace & Company, 1993).

Returning to the marriage analogy, a "prenuptial agreement" between the dealer and artist need not injure the personal relationship they enjoy, but it may be the only protection they have if the honeymoon ends. (For a sample artist-gallery consignment contract, see appendix A.)

ARTIST'S RIGHTS
Numerous state and federal laws encourage artists to feel secure when exercising their creative abilities. You should be aware of these laws and the limitations they may impose on your relationships with artists, craftspeople, and those to whom you sell. Carefully examine all contracts between you and those from whom you acquire the work you are selling to determine whether there are any contractual limitations or obligations on you or your customers.

Resale Royalties
There are often specific legal and contractual obligations when a gallery or craft retailer is reselling a work—for example, when selling a piece procured from a private collection rather than directly from the artist or craftsperson. In Europe, many countries have laws that require those who resell art to pay a certain amount from the resale to the artist or the artist's estate. The amount of this payment—called a "resale royalty"—varies from country to country, and the laws customarily impose the obligation only on sales that take place within that country.

The first jurisdiction in the United States to enact a resale royalty law was the city of Seattle. That law requires that when the city resells any artwork it acquires as part of its Art in Public Places program, a resale

royalty is to be paid to the artist or the artist's estate, provided that a current address for the beneficiary is on file with the city.

California has the only statewide resale royalties law. It provides that whenever a work of fine art is sold and the seller resides in California or the sale takes place in California, the seller or the seller's agent shall pay 5 percent of the sale to the artist, or to the artist's estate.

The California law has been the subject of numerous discussions and is still the principal prototype in the United States. For the purposes of the statute, an "artist" is defined as the person who created the art and who is, at the time of resale, either a citizen of the United States or has resided in California for a minimum of two years. "Fine art" is defined as "an original painting, sculpture, or drawing, or an original work of art in glass." The act does not apply to the initial sale of a work of fine art where the legal title to the work is vested in the artist; to the resale of a work of fine art for a gross sales price (or fair market value of property, including art taken in trade) of less than $1,000; or to the resale of the work for a gross price less than the purchase price paid by the seller. Also excluded from the act are sales that occur more than twenty years after the artist's death; resale of works by an art dealer to a purchaser within ten years of the initial sale of the work by the artist to a dealer, provided all intervening sales are between dealers; and to sales of works of stained-glass artistry where the work has been permanently attached to real property and is sold as part of the property.

Generally, the responsibility for paying the artist is with the seller, but when a work of fine art is sold at an auction or by a gallery, dealer, broker, museum, or other person acting as the seller's agent, the agent must withhold the 5 percent and locate and pay the artist or the artist's estate. If the artist cannot be located within ninety days, the royalty is transferred to the California State Arts Council. The Arts Council then must attempt to locate the artist. If the artist still cannot be located and does not file a written claim for the money within seven years from the date of the sale, the money becomes the property of the Arts Council for use in acquiring fine art for its Art in Public Places Program.

Many artists and craftspeople have established their own resale royalty arrangements by contractually requiring purchasers to pay a specified amount should the purchaser resell the work. Determine whether any work you are selling is subject to a resale royalty and whether you or the person with whom you are dealing has any resale royalty obligations. Check your contract with the supplier, artist, or collector and, if possible, any prior contracts they may have had regarding the piece, to determine whether you or the purchaser may have some ongoing financial

obligation to the artist or the artist's estate. You may also wish to obtain a representation or warranty regarding any ongoing royalty obligations.

MORAL RIGHTS

The unique relationship between an artist or craftsperson and the work created has given rise to a collection of rights known in Europe as the "droit morale" ("moral rights"). The notion began in France and has spread to more than eighty countries. It is embodied in the Berne Copyright Treaty (see chapter 11), to which the United States is a signatory. These rights are intended to provide the creative person with additional incentives for the creative act by protecting the integrity of the work and its creator's reputation. These moral rights include the right to create, the right of disclosure (i.e., to decide when the work is ready to be displayed), the right to withdraw (i.e., to remove a defaced work from display), the right to name attribution, and the right to preserve the integrity of a work.

Federal Moral Rights

In the United States, the Visual Artists Rights Act of 1990 (VARA) contains many elements of the European "droit morale." It applies to any work of art that is "a painting, drawing, print, or sculpture, existing in a single copy, or limited edition of 200 or fewer, signed and consecutively numbered," and to photographic images produced for exhibition purposes only as signed, numbered editions of 200 or fewer.

Among the rights protected by VARA is the right of paternity. The artist or craftsperson is allowed to claim "authorship" of a work he or she created. The artist or craftsperson also has the right "to prevent the use of his or her name as the author of the work of visual art in the event of distortion, mutilation, or other modification of the work which could be prejudicial to his or her honor or reputation."

Ordinarily, artists or craftspeople will not object to the use of their name in truthful statements that credit them with creating a work or that state that a piece is based on or derived from their work, in the absence of contractual provisions to the contrary. Similarly, the omission of an artist's or craftsperson's name from his or her work ordinarily is not actionable unless the omission amounts to a breach of contract or the work is covered by VARA or a state moral rights law. (For a list of state moral rights laws, see appendix B.)

Artists and craftspeople also have some rights to prevent their works from being altered, distorted, or destroyed. VARA is careful to exclude from prohibition any "modification resulting from passage of time or the

inherent nature of the materials" and "any modification which is the result of conservation, or of the public presentation, including lighting and placement of the work . . . unless caused by gross negligence."

The law also provides artists and craftspeople the right to "prevent any destruction of a work of recognized stature." The question of what constitutes "work of recognized stature" is determined, on a case-by-case basis, by the expert testimony of scholars, curators, gallery owners, craft retailers, and, presumably, collectors.

State Moral Rights

Several states have enacted statutes that protect the moral right of integrity. California law prohibits anyone, except an artist who owns and possesses the work he or she created, from intentionally defacing, mutilating, altering, or destroying a work of fine art. The act also provides that no person who frames, conserves, or restores a work of art shall deface, mutilate, alter, or destroy the work by any act constituting gross negligence.

Under New York law, the artist may bring an action for "just and valid reason" to prevent his or her name from appearing on or in connection with a work of fine art. "Just and valid reason" would include situations where the work has been altered, defaced, mutilated, or modified other than by the artist and damage to the artist's reputation is reasonably likely to occur or has already occurred as a result. New York also prohibits any unauthorized person from publicly displaying, publishing, or reproducing an altered work of fine art that is represented as the work of the artist or presented under circumstances in which the work would reasonably be regarded as being the work of the artist and, thereby, possibly damage the artist's reputation.

Like the California statute, the New York legislation provides an exemption for bona fide conservation, unless the conservator is negligent in performing the work. New York also provides that alterations resulting from the passage of time or from the inherent nature of the materials are not covered, unless they result from gross negligence. Changes in works prepared under contract for advertising or trade use are not violations of the act, unless the contract so provides.

As with resale royalties, galleries and craft retailers should carefully examine contracts between themselves and those from whom the work they sell is acquired, as well as any prior contracts, to determine whether there are any contractual limitations imposed on the dealer or that should be disclosed to the purchaser. VARA, state laws, and supplier contracts may all impose obligations on you and your customers. Care should be taken to be aware of these obligations.

IMPORT ISSUES

There are a number of issues you need to consider before importing art or crafts into the United States for sale in your gallery or shop.

First, you should determine whether the item you desire to import has been legally exported. Many antiquities, for example, may not be removed from the country of origin or from a country in which they have resided for so long as to become a "national treasure." You will also need to comply with the conditions of treaties, such as the UNESCO Convention on the Means of Prohibiting and Preventing the Illicit Import, Export, and Transfer of Ownership of Cultural Property. In addition, transporting certain items—for example, pre-Columbian art—over state lines or national boundaries may subject the transporter or others involved in the arrangement to criminal liability when the country from which the items were taken has declared its ownership of those items. Because of the complexity of the law, you should work with an experienced art lawyer when dealing with antiquities.

Customs duties are usually imposed on commodities imported into the United States, but works of art may enter the United States duty free. It is, therefore, essential to determine what is "art" for customs purposes. The law in this area is also quite complex, but there are some guidelines:

- In order for an item to qualify as duty-free fine art, it cannot be functional—therefore, most crafts do not qualify
- The work must be created by an artist and cannot be imported for the purpose of commercialization—for example, you cannot import a duty-free painting to be used as cover art on a magazine.
- Fine-art prints can enter duty free only if they are hand pulled from handmade plates
- Only the first twelve pieces of sculptured limited editions can enter the United States as duty-free art

Numerous other technical qualifications have evolved from legal cases and special-interest legislation. For example, functional crafts are generally not considered art but may still enjoy duty-free treatment under a special customs law known as the Generalized System of Preferences (GSP). This law was enacted to allow certain underdeveloped countries to have some of their commodities enter the United States without the imposition of tariffs. The countries on the GSP list change quite regularly, as do the duty-free commodities. It is essential that you consult with an experienced art lawyer when contemplating overseas purchas-

ing. Interestingly, with the exception of certain Native American items, there are no restrictions on the export of art from the United States.

Native American Works

Art dealers and craft retailers who handle Native American works should be aware of the laws that pertain to the sale of these items, such as the Native American Graves and Repatriation Act of 1990 and the Indian Arts and Crafts Act of 1935, as amended in 1990.

The Repatriation Act bans any trade in human remains and restricts the trade of certain other cultural items. Possible penalties include fines and up to a year in prison. The Arts and Crafts Act created the Indian Arts and Crafts Board as an agency under the Secretary of the Interior. The Board has adopted a certification mark that may be used by Native Americans to identify their newly created work. Civil and criminal penalties may be imposed for counterfeiting the Board's marks and misrepresenting works as the creations of Indian artists. The Board is also authorized to assist tribes and individual Indian artists in obtaining registration of their trademarks free of charge.

Some states, such as Michigan, New York, New Mexico, and Alaska, have enacted laws to inhibit counterfeit Indian art from being passed off as authentic work created by Native American artists. Some of these statutes, New Mexico's for instance, impose a duty on the dealer to make "due inquiry" in order to determine whether items represented to be created by Native Americans are, in fact, made by individuals who can legally make that claim.

You should, therefore, become familiar with the federal and state laws regulating Native American art, crafts, and other cultural property if your gallery or craft retail shop deals in these items. Here, too, working with an experienced art lawyer will be important.

Price Antidiscrimination

Congress has enacted legislation to prevent price discrimination in the sale of commodities such as art or crafts in interstate commerce; that is, sales across state lines or sales likely to affect someone in another state.

Galleries and craft retailers and their suppliers are free to choose to whom they will and will not sell, but, according to the Robinson-Patman Act, they cannot discriminate against buyers by charging different prices for identical items sold at nearly the same time without a good business reason. The Robinson-Patman Act also controls whether a supplier of merchandise (such as an artist or craftsperson) can refuse to deal with a customer (such as a gallery or retailer), accord or deny special

concessions and benefits to a customer, or sell only on the condition that the customer maintain a certain resale price structure.

A violation of the Act can occur under three conditions: first, as injury to a seller, if one seller attempts to price a competing seller out of business; second, as injury to the buyer, if a seller charges different prices to different buyers who then compete with each other in the same market; and, third, as injury at the customer level, if a seller prices a work so that the ultimate consumer may pay less in one case than the other.

The Act does not allow the paying of brokerage fees or the provision of merchandising allowances or services to a favored buyer. Under the Sherman Antitrust Act, a seller cannot control the buyer's resale pricing. In other words, the artist, craftsperson, or supplier can neither sell to a gallery at a price so low as to injure a competing gallery's business, nor cause injury to a gallery by imposing resale conditions that would hamper the gallery's competitiveness in the marketplace. In addition to preventing an artist, craftsperson, or supplier from discriminating against retailers, Robinson-Patman also prohibits a retailer from accepting low prices or other benefits that may injure a fellow retailer's competitiveness.

The Robinson-Patman provisions are enforced primarily by the Federal Trade Commission. The Department of Justice may also enforce Robinson-Patman prohibitions in conjunction with other antitrust actions against a probable violator. The most effective enforcement may be private suits brought by disgruntled galleries or craft retailers against a discriminatory artist, craftsperson, or other supplier. Such suits may avoid the bureaucratic backlog of government enforcement and involve the actual parties, which likely will result in more accurate and timely punishment for wrongdoing. Additionally, injured parties may be awarded triple damages and attorneys' fees.

Some states have enacted legislation similar to Robinson-Patman to prevent price discrimination in intrastate commerce.

9 CATALOG SALES

S elling through catalogs provides art galleries and craft shops with an opportunity to expand their markets. There are a number of ways to take advantage of catalog sales: by printing and distributing a catalog featuring your inventory, by pooling resources with others to produce a cooperative catalog, or by offering your items in somebody else's catalog.

CREATING YOUR OWN CATALOG

Publishing and distributing a catalog is, in essence, starting a new business. You should have a business plan, which includes an estimate of the total cost of the project—for example, the costs of photography, typography or desktop publishing, printing, binding, and mailing. Those who sell by direct mail also need to identify those to whom catalogs should be sent. For this, it is best to enlist the aid of a list broker who specializes in evaluating and managing lists of names for direct-mail marketing. A broker will customize mailing lists according to your specific needs. Once you have begun mailing, the lists must be kept "clean," which means keeping names and addresses current and periodically removing the names of those who have not been buying. Galleries and craft retailers should include regular customers on the list and collect, whenever possible, the names and addresses of visitors and browsers who wish to be on the mailing list.

The Federal Trade Commission (FTC) regulates the sale of merchandise through mail order. Because of the numerous problems consumers

have had with mail-order companies, the FTC is quite active in policing the market. Many of its rules deal with the availability of merchandise, shipping dates, price variations, and the like. Failure to comply with these technical rules will be deemed unfair trade practice, possibly subjecting the catalog merchandiser to FTC sanctions, such as injunctive relief and fines.

There are some interesting legal issues related to catalog selling. For example, an ad in a catalog is not considered an offer to sell the object depicted for the price designated; rather, it is considered an invitation for offers that may or may not be accepted by the advertiser. This is important because it means that you are not obligated to sell the work for the price specified if it becomes necessary for you to change the price. Be sure to prominently note in the ad that the price may be subject to change. It is not good business practice to advertise one price and actually charge a higher price. In fact, it may be unlawful to do this on a regular basis. The practice of promoting an item for one price but discouraging its purchase and selling higher priced items, referred to as "bait and switch," is unlawful under most state laws as consumer fraud.

Because many works of art or craft are unique or created in limited quantities, it is unlikely that the exact piece shown in your advertisement will be available for every purchaser. Make it clear that the prospective purchaser will probably be getting something substantially similar to the item advertised but not necessarily identical. Although there is no legal obligation to make purchasers aware of these potential inconsistencies, being fair generates goodwill.

Under FTC rules, when an ad is put into a catalog, the seller must have a reasonable basis to believe that the goods can be shipped within the time stated in the ad, but in no event shall this period be longer than thirty days. This means that you must have inventory on hand when the catalog is distributed or, at the very least, have ready access to the items depicted.

If it is necessary to revise a shipping date, you must have a reasonable basis for believing that you can deliver the merchandise on that new date, and you should inform the buyer. If the revised date for shipping the merchandise is within thirty days from the original scheduled shipping date, you must notify the buyer that the buyer will be deemed to have consented to the delay unless the buyer objects in writing. FTC rules require the seller to provide the buyer with adequate means of notifying the seller of any objection to a delay—either a postcard or a stamped, self-addressed envelope.

If the revised shipping date is more than thirty days from the original date the goods were to be shipped, or if you cannot provide a precise revised shipping date, then you must notify the buyer that the order will automatically be canceled unless you are able to ship within thirty days from the original shipping date, or unless you receive written notification from the purchaser consenting to a later or indefinite shipping date. You must also notify the buyer that the buyer may cancel the order at any time until the goods actually are shipped. This is true even when the buyer has consented in writing to the delay.

If you are still unable to ship the merchandise on the revised shipping date, then you must give the buyer a revised option to either extend the date of shipment or cancel the order.

COOPERATIVE CATALOGING

Cooperative cataloging provides a gallery with all of the advantages of catalog advertising while allowing it to share the costs with other galleries. The larger volume of the catalog may, in fact, bring down costs. In addition, the catalog may give all the participants wider exposure to markets they would not ordinarily have.

A co-op is a form of partnership, so you can work out a fair distribution of costs among yourselves. If the other members of the co-op do not fulfill their obligations, however, you may wind up having to pay all of the expenses. (See chapter 1 for a discussion of partnerships.) You should be careful to determine whether any of the other co-op members are in competition with you before entering into a cooperative venture.

SELLING THROUGH SOMEONE ELSE'S CATALOG

If an art or craft retailer sells work to a catalog company, the FTC rules would apply only to the catalog company, not to the retailer. There are, however, other risks for the retailer to keep in mind.

If, for example, the catalog carries a piece that is not delivered by the gallery or shop to the catalog company in accordance with the contractual obligation between the two, then the gallery or shop may be exposed to liability for breach of contract with the catalog company. In most instances, however, courts will not award damages to the catalog company for lost sales because it is almost impossible to prove with any accuracy the amount of sales the catalog company would have had if the contract had been properly performed. If the catalog company actually has sales that must be rescinded because a gallery or shop did not deliver merchandise when promised, then it will be able to specify the amount of sales lost and the amount of other expenses incurred as a

result of the breach. Similarly, a gallery or shop that delivers noncon-forming works to the catalog company may also be liable for breach of contract. Here, too, the amount of damage caused by the breach will be more easily established if the catalog company is actually in possession of orders that have been rescinded.

Craft retailers and galleries that offer items through catalogs will be relieved to know that, in 1992, the Supreme Court upheld its historical interpretation of state sales-tax codes. Under the ruling, catalog mer-chants are required to collect the sales tax only from customers residing in the company's home state or in any state where the company has a physical presence, such as a branch shop or a warehouse. Sales tax need not be collected from customers in states other than the ones in which the catalog company is located or has a substantial presence.

PEOPLE WHO WORK FOR YOU

There comes a time in the life of almost every art gallery or craft retail business when it is necessary to get help, be it brain or brawn. The first help needed is usually a bookkeeper or accountant who can handle taxes, payables, and the like. As things get a little hectic around the shop or gallery, you might then hire someone to help with packing, unpacking, or running errands. If selling is not your greatest talent, you may engage the services of a salesperson. If this salesperson is really good, you will soon have to hire more employees to keep up with the demand.

INDEPENDENT CONTRACTORS

If you hire a bookkeeper or accountant to go over your records once or twice a year, that person is most likely an independent contractor. An independent contractor is a person hired on a one-time or job-by-job basis. Although paid for their services by the hiring firm or individual, contractors are their own bosses and may even employ others to do the work for them.

You may need to provide some independent contractors with your "trade secrets" for purposes of assisting with your business. Be sure to include a provision in your contract with them that restricts their use or disclosure of your trade secrets without your prior written permission.

The fact that the person is independent, and not your employee, means that you do not have to pay Social Security, withhold income taxes,

provide workers' compensation coverage, or comply with the other myriad rules imposed on employers. More importantly, you are generally not liable for injuries to a third party resulting from the independent contractor's negligence or wrongful acts, even those that occur while the independent contractor is working for you. There are, however, some basic types of situations where, despite your innocence, an independent contractor can render you legally responsible for his or her wrongful acts:

- If an employer is careless in hiring an independent contractor—that is, if a careful investigation would have disclosed facts to indicate that the contractor was not qualified—the employer may be liable when the independent contractor fails to properly perform the job.
- If a job is so dangerous as to be characterized as "ultrahazardous" (a legal term) and is to be performed for the employer's benefit, then, regardless of who performs the work, the employer remains legally responsible for any injuries that occur during the performance of the work. Thus, an art or craft gallery desiring to have a fireworks display for a grand opening cannot escape liability by having independent contractors light the fuses or aim the rockets.
- An employer may be required by law to perform certain tasks for the health and safety of the community. These responsibilities are said to be "nondelegable"—that is, an employer cannot delegate them and thus escape liability for their improper performance. If, therefore, a nondelegable duty is performed by an independent contractor, the employer will remain responsible for any injury that results.

A good example of a nondelegable duty is compliance with the law (common in many states) that home owners and business owners are responsible for keeping their sidewalks free of dangerous obstacles. If a business owner hires an independent contractor to fulfill this obligation by removing ice during the winter, the business owner is still legally liable if someone is injured on the slippery sidewalk, even if the accident resulted from the contractor's carelessness. Another example of a nondelegable duty is found in the tax laws. A business owner is obligated to file an accurate return and pay the appropriate tax. The fact that an underpayment resulted from the carelessness of a CPA, who is an independent contractor, will not relieve the business owner from liability to the government. The business owner may, however, be able to recover any penalties and interest from the careless CPA.

EMPLOYEES

The second capacity in which someone can work for you is as an employee. This category includes anyone over whose work you exercise direct control—helpers, apprentices, salespeople, a bookkeeper who is a member of your staff, and so forth. The formation of this relationship entails nothing more than an agreement on your side to hire someone and an agreement by that person to work for you. Although a written contract is not necessary except in the case of employment for more than one year, I suggest that employment terms be put down in writing so that there is no misunderstanding later.

Employment Contracts

There must be a written contract specifying the term of employment if it will be longer than one year; otherwise, either party may terminate the relationship at any time. There is no prescribed form that the contract must take, but certain items should be considered.

The first is the term of employment. An employment contract may be either terminable at will or for a fixed duration. A contract that specifies a fixed period gives the employee some job security and creates a moral and contractual obligation for the employee to remain for the term. Of course, if the employee chooses to quit, or the employer chooses to fire the employee, the law will not compel fulfillment of the contract. Improper termination of a contract for a fixed period, however, will cause the party who is responsible for the wrongful act to be liable for damages.

The second item to specify is the wage. Unless you are a large employer (i.e., with forty-five or more employees), or are engaged in interstate commerce (i.e., with gross sales of $500,000 or more), you currently will not have to comply with federal minimum-wage laws. However, most states have their own minimum-wage laws with which you will have to comply. Beyond the requirements imposed by these laws, the amount of remuneration is open to bargaining.

If the contract does not specify a salary, the law will presume a reasonable wage for the work performed. If you hire a salesperson and the accepted salary in your region for a qualified salesperson is fifteen dollars per hour, then it will be presumed that the salesperson was hired for this amount unless you and that person have agreed to a different salary. Thus, you cannot escape paying your employees fairly by not discussing the amount they will earn.

In addition to an hourly wage or monthly salary, you may wish to offer an employee other benefits, such as health and life insurance or retirement

pensions. Some legal advice may be necessary here in order to take advantage of tax laws.

Third, it is often wise to spell out your employee's duties in the employment contract. This serves as a form of orientation for the employee and also may limit future conflicts over what is and what is not involved in the job.

Fourth, you may want your employee to agree not to work for someone else while working for you or, more importantly, not to compete with you at the end of the employment period. The latter terms must be carefully drawn to be enforceable. The agreement must be quite specific as to the kind of work the employee may not do; the restriction must apply within a geographic area no broader than that in which you actually operate; and it must apply for a reasonable duration (a three-year period has been upheld). Note that some states impose restrictions on noncompetition agreements. In Oregon, for example, a noncompetition agreement is unenforceable unless it was entered into either prior to or contemporaneously with the beginning of employment, or unless it became effective after a meaningful promotion. Some states refuse to uphold noncompetition agreements. For example, California law states that a noncompetition agreement is void as against its public policy.

The contract should also address the confidentiality of trade secrets—things such as customer lists, supplier lists, and unique sales techniques. A "trade secret" is defined in the Uniform Trade Secret Act as anything that provides its owner with a commercial advantage and that is a secret. The employee should acknowledge that the employer's confidential information is "proprietary information," whether or not it is protected or protectable under copyright, patent, trade dress, trademark, or any other federal or state law. Anyone who obtains a trade secret through improper means and exploits it may be prohibited from continuing to use it and may be liable for any provable damages caused to the prior employer. For this reason, your employment contract should specify that if the employee has been exposed to anyone else's trade secrets, he or she will not use them while working for you.

The employee should also acknowledge the confidentiality of your trade secrets and should agree not to use or reveal them without your prior written permission. It is customary to require employees who resign or who are terminated to return to the employer all materials containing any of the employer's trade secrets. You should conduct "exit interviews" to remind employees not to use or disclose your trade secrets after leaving your employ.

Finally, the employment contract should also specify the grounds for termination of the contract. If the contract is terminable at will, it should be clearly specified that the contract may be terminated either for specified grounds or at the will of the employer.

You are vicariously liable for the negligence and, sometimes, even the intentional wrongdoing of your employee when the employee is acting on your behalf. For example, if your employee is at fault in an automobile accident while on the job, you and your employee are both legally liable. It is wise to be extremely careful when hiring and to obtain sufficient insurance coverage for your additional exposure.

Financial and Legal Considerations

When hiring an employee, there are also local, state, and federal laws to consider. The requirements of these laws may vary dramatically, so consult with your lawyer, accountant, or bookkeeper when considering the following:

- A workers' compensation insurance policy for your employees in the event of on-the-job injury or occupational illness. State laws vary as to the minimum number of employees you must have before you are required to offer workers' compensation. The laws in most states provide that an employer who has failed to obtain or keep in force required workers' compensation insurance will be strictly liable, even in the absence of negligence, for on-the-job injury or illness, including not only medical expenses but also damages for pain and suffering, lost earning potential, and other damages that are a consequence of on-the-job injuries or illness.
- Withholding taxes—federal, state, and local. Here, too, the laws vary, so find out what is required in your locale.
- Social Security (FICA). There are some exemptions. Contact your nearby Social Security office to determine how they may affect you.
- Unemployment insurance—federal and state. These also include certain technical requirements for subcontractors, etc. You should check with your accountant or attorney to determine what these are.
- Health and safety regulations—federal and state.
- Municipal taxes for specific programs, such as schools or public transportation.
- Employee benefits, such as insurance coverage (medical, dental, legal), retirement benefits, memberships, parking, etc.
- Union requirements, if you or your employees are subject to union contracts.

- Wage and hour laws—both federal and state. These include minimum-wage and overtime requirements. In some states the law also regulates holidays and vacations, as well as the method of paying employees during employment and upon termination.
- Other forms of employment legislation, such as licensing requirements, that may apply to you, your employees, or your business.

As already noted, the requirements of these laws may vary dramatically from state to state. In addition, you should consult an attorney to find out whether any other forms of employment legislation, such as licensing requirements, apply to you, your employees, or your business.

Termination of Employment

Determining whether someone is an employee or an independent contractor is not always easy. The characterization is important because employers are responsible for income tax withholding, Social Security, workers' compensation, and the like, whereas one who merely hires an independent contractor is not.

There is another reason why the characterization may be important: If the individual working for you is merely an independent contractor, the contract between you will govern your respective rights of termination. On the other hand, if the individual is an employee, care must be taken not to become responsible for a wrongful termination when dismissing the individual. The liability for wrongful termination can be catastrophic to a small business.

Historically, an employee who was not under contract could be terminated for any reason whatsoever. Approximately thirty years ago, this right of absolute dismissal was challenged and the rule was modified. At that time, it was held that an employee could be terminated for the right reason or for no reason at all, but could not be terminated for the wrong reason. So, for example, an employee who was terminated for refusing to commit perjury before a legislative committee was entitled to recover against the employer for wrongful termination. The public policy of having individuals testify honestly was considered more important than the employer's right to control the employment relationship.

Courts have become even more protective of the rights of employees. In a 1983 case, *Novosel v. Nationwide Insurance Company*, the United States Circuit Court of Appeals held that the power to hire and fire could not be used to dictate an employee's political activity and that even a nongovernment entity is limited by the Constitution in its power to discharge an employee. The court, in essence, held that one's right to

exercise constitutionally protected free speech was more important than the employer's right to control an employee's conduct.

In an Arizona case, the state supreme court held that an employee who was terminated for refusing to "moon" fellow employees in a parody of the song "Moon River" during a company retreat was entitled to damages for wrongful termination. The public policy of protecting her right of privacy was deemed more important than the employer's right to terminate employees for disobedience.

Employers may not legally fire someone for any of the following reasons:

- Refusing to commit an unlawful act, such as committing perjury or participating in illegal price-fixing schemes
- Performing a public obligation, such as serving on a jury or serving in a military reserve unit
- Exercising a statutory right, such as filing a claim for workers' compensation
- Discrimination

A number of states have adopted legislation that restricts the employer's right to terminate a person's employment to those cases in which there was just cause. These laws also contain specific prohibitions on the termination of employment for "whistle-blowing," that is, notifying government authorities of wrongful acts by the employer, such as tax evasion, or notifying corporate officers of wrongful acts of the employee's immediate supervisors.

An employer should have a legend in the employee handbook that makes it clear that the handbook is not an employment contract. Oral statements by recruiters or interviewers might also be construed as imposing obligations on the employer. Employers often require that prospective employees sign a statement making it clear that the employment is "at will" and does not give rise to any contractual rights. If there is a probationary period after the hire, the employer should be careful to state that after the probationary period, the employee will become a "regular" or "full-time" employee, not a "permanent" employee. If an employee is characterized as permanent, she may have a claim that the employer agreed never to terminate the employment relationship.

In addition, any evaluation of the employee after the probationary period should be conducted fairly. When evaluations become merely pro forma, problems can and do arise. An employee may argue that she has received sparkling evaluations and is being fired for invalid reasons.

To avoid misunderstandings or disputes, the employer should use what has been characterized as "progressive discipline." The procedure begins with a verbal warning of concern about a performance problem. If the problem persists, disciplinary actions are taken progressively until termination is the only recourse left. The *entire* process should be documented in the employee's file.

When in doubt, an employer should contact an attorney with some experience in the field of employment relations. In this area, as with many others, preproblem counseling can prevent a good deal of time-consuming and costly litigation.

HAZARDS IN THE WORKPLACE

Research the potentially toxic effects of all substances used in the art or crafts you sell, whether or not they are labeled for toxicity. You should then disclose to your employees at the time of hiring any pertinent information regarding hazardous substances.

Congress and federal administrative agencies are becoming more active in regulating hazardous substances. You should also be aware that your state Workers' Compensation agency or the Occupational Safety and Health Administration (OSHA) may have passed special rules regarding specific workplace substances and activities. It is critical to obtain a lawyer's opinion as to whether any of these regulations apply to your gallery or shop. Your state's labor department may also be able to give you information regarding applicable workplace regulations.

Many manufacturers of art and craft supplies voluntarily have begun to label their materials with health and safety warnings. Several states, including California and Oregon, have enacted art-and-craft labeling laws. Advocates of a healthy workplace are actively lobbying for similar laws throughout the United States. In response to pressure from these groups, Congress enacted a federal law in 1988 entitled the Federal Art Hazard Bill, which became effective in 1990.

An employer should advise all new hires of all known hazards that may result from their jobs and should disclose the fact that there may be other undiscovered risks in handling the art or craft work. If you have an employment contract, include a paragraph containing such a disclosure and a statement of the employee's acknowledgment of the known risks. Include a similar statement in the employee handbook, if you have one.

While these documents would not provide a defense to a workers' compensation claim, they will sensitize employees to the need for caution in working with the toxic materials. Needless to say, you should take all precautions possible to protect the health and safety of your employees.

Discrimination

Galleries should be aware of the numerous state and federal prohibitions against discrimination on the basis of race, religion, creed, national origin, sex, age, disability, and the like. You should not only be aware of your employees' rights, but also those of your customers and suppliers. The law in this area is constantly changing, and an experienced attorney should assist you in establishing acceptable policies. He or she should review your advertisements for job applicants and your application forms. At a minimum, your employee handbook should have a section dealing with prohibitions against discrimination, a sexual harassment policy, and guidelines for dealing with customers, suppliers, and any other individuals encountered in the course of doing business.

Although an in-depth analysis of the various federal, state, and local antidiscrimination laws is beyond the scope of this book, a good rule of thumb is to treat everyone with the same respect and dignity with which you expect to be treated.

11 COPYRIGHT

A rt galleries and craft retailers must be sensitive to the complex legal rules surrounding copyright. These rules pertain not only to the art or craft works you market, but also to the advertising, catalogs, flyers, and posters you may use in your business.

Copyright law in the United States has its foundation in the Constitution, which provides in Article I, Section 8, that Congress shall have the power "to promote the progress of science and useful arts, by securing for limited time to authors and inventors the exclusive right to their respective writings and discoveries." The first Congress exercised this power and enacted a copyright law. The legislation was periodically revised by later Congresses, but no major changes were made until the Copyright Revision Act of 1976.

Prior to enactment of the 1976 law, unpublished works were protected by common-law copyright governed by state laws. This protection could vary considerably from state to state. Federal protection under the 1909 Copyright Act began by protecting a published work to which a copyright notice was attached. The Copyright Revision Act of 1976 preempts the field of copyright law—in other words, it is now the only legislation governing copyright. This law was significantly amended once again in 1989 when the United States became a party to the international copyright treaty known as the "Berne Convention."

The new law became effective on January 1, 1978, but it is not retroactive. Thus, works created by the same person before and after January 1, 1978, will be covered by copyright laws that have some fundamentally

different provisions. It is important to be aware of the basic differences and be aware of which law applies to a particular work.

Works created and sold prior to January 1, 1978, will be governed by the provisions of the 1909 Act. Works created, but not publicly displayed or offered for sale prior to January 1, 1978, are governed by the new law. What difference does it make? In many cases, it determines who owns the copyright in the work—the creator or the purchaser.

WHAT IS COPYRIGHT?

A copyright is actually a granting of five exclusive rights:

- To reproduce a work of art by any means
- To prepare derivative works
- To distribute copies of the work to the public
- To perform the work to the public
- To display the work to the public

First is the right to reproduce a work by any means. The scope of this right can be hard to define, especially when it involves photocopying, videotape, the creation of functional arts, etc. The copyright law makes it clear that customers should not be permitted to photograph work in a gallery or shop. You may request slides and photos from the artists to keep in your files and archives, but these works can be used only in promotional material and only if you obtained permission from the artist to do so. This permission, if provable, is enforceable.

Second is the right to prepare derivative works based on the copyrighted work. A derivative work is one that transforms or adapts the subject matter of one or more preexisting works—for example, a poster bearing the image of a piece of sculpture or a fiber piece containing designs that are in the public domain.

Third is the right to distribute copies to the public for sale or lease. Once a person sells a copyrighted work or permits uncontrolled distribution, however, the right to control the further use of that work usually ends. This is known as the "first sale" doctrine and does not apply if the work is merely in the possession of someone else temporarily—as in a rental or lease—or if the copyright owner has a contract with the purchaser restricting the purchaser's freedom to use the work. If the purchaser exceeds the restrictions, he or she may incur liability. However, the copyright owner's remedy may then be governed by contract law rather than copyright law.

Fourth is the right to perform a work publicly—for example, to broadcast a film or promotional video received from an artist on television or to show it in a lecture room or meeting room.

Fifth is the right to display the work publicly. Once the copyright owner has sold a copy of the work, the purchaser has the right to display that copy.

These rights are divisible, which means they can be transferred in whole or in part. If the copyright owner takes no special action upon selling the work, he or she is presumed to have retained all rights. If desired, however, the copyright owner may explicitly transfer any one or more of these rights.

WHO OWNS THE COPYRIGHT?

As a general rule, the creator of a work owns the copyright. The person who owns the copyright also automatically owns the exclusive rights. Under the old law, when a work was sold, ownership of a common law (prepublication) copyright passed to the purchaser unless the creator reserved the copyright in a written agreement. In other words, there was a presumption in the law that a sale included the work itself plus all rights in that work.

The Copyright Revision Act of 1976 reversed the presumption that the sale of a work carries the copyright with it. Today, unless there is a written agreement to the contrary, the creator retains the copyright when the work is sold.

The creators of a joint work are co-owners of the copyright in the work. A "joint work" is defined as "a work prepared by two or more authors with the intention that their contributions be merged into inseparable or interdependent parts of a unitary whole." Thus, whatever profit one creator makes from use of the work must be shared equally with the others, unless they have a written agreement that states otherwise.

The key point is the intent that the parts be absorbed or combined into an integrated unit at the time the work is created. The late Professor Melville Nimmer of UCLA Law School commented that, although such an intent must exist at the time the work is created, not at a later date, the authors do not necessarily have to work together, work during the same period, or even know each other. However, the joint-work definition does not include the situation where an artist creates a work, such as a piano solo, not intending that the work involve another artist, and later commissions lyrics. If there is no intention to create a unitary or indivisible work, each creator may own the copyright to his individual contribution.

In *Ashton-Tate Corp. v. Ross*, the Ninth Circuit Court of Appeals held that joint authorship was not established by the mere contribution of ideas and guidance for the user interface of a computer spreadsheet because joint authorship requires each author to make an independently copyrightable contribution.

It is important to understand the distinction between the sale of a work and the sale of the copyright in that work. If nothing is said about copyright when the work is sold, the artist retains the copyright. Your customers may not be aware of this, so you may wish to call it to their attention in the bill of sale. If a license of rights covered by copyright is granted, the scope of the rights being granted should be specified in writing. For example, if a collector is granted the right to photograph a painting for Christmas cards, can the image also be used to make posters? Generally, the answer is "no," but the drafter of the license should be clear in defining the boundaries of permissible uses.

Works Made for Hire

Works considered to be "works made for hire" are an important exception to the general rule that a person owns the copyright in a work he or she has created.

A "work made for hire" is defined as "a work made by an employee within the scope of his or her employment." This principle has been based on several grounds: (1) the work is produced on behalf of and under the direction of the employer; (2) the employee is paid for the work; and (3) the employer, having paid all the costs and bearing all the risks of loss, should reap any gain.

Some courts developed a doctrine whereby an independent contractor was considered to be a "special employee" for copyright purposes when a commissioning party had the right to exercise control over the work. This resulted in the commissioning party owning the copyright rather than the independent contractor. In 1989, the U.S. Supreme Court, in *Community for Creative Non-Violence (CCNV) v. Reid*, held that unless the party creating the work is an actual employee as that term is defined in the law, the copyright will belong to the creator rather than the commissioning party. The court left open the question of whether the work could be considered a joint work by virtue of the parties' intent.

If the creator is an independent contractor, the works will be considered works made for hire only if (1) the parties have signed a written agreement to that effect, and (2) the work is specially ordered or commissioned as a contribution to a collective work, a supplementary work (one that introduces, revises, comments upon, or assists a work by

another), a compilation, an instructional text, answer material for a test or a test itself, an atlas, a motion picture, or an audiovisual work. Thus, unless there is a contractual agreement to the contrary, the independent contractor owns the copyright.

Transferring or Licensing Copyright Rights

A copyright owner may sell the entire copyright or any part of it, or may license any right within it. The rights must be specifically identified and transferred through a written contract, which must then be signed by the copyright owner or the owner's authorized agent. A licensing contract must state the scope, duration, frequency, and type of use, and the like. Although a license authorizing a particular use of a work can be granted orally, such a license is revocable at the will of the copyright owner.

Oftentimes, an art gallery or craft retailer will become the licensee of, or assignee of ownership for, the creator's copyright. This allows the dealer to incorporate the artist's or craftsperson's copyrighted work into the dealer's work—for example, to include photographs of art or crafts in a catalog.

Both an assignment of ownership of copyright and a licensing agreement should be recorded with the Copyright Office. The cost to record a transfer is quite low and is a tax-deductible business expense. When the transaction is recorded, the rights of the assignee or licensee are protected in much the same way as the rights of an owner of real estate are protected by recording the deed. In a case of conflicting transfers of rights, if both transactions are recorded within one month of the execution, the person whose transaction was completed first prevails. If the transactions are not recorded within a month of the execution, the one who records first prevails. A nonexclusive license prevails over any unrecorded transfer of ownership. Before an assignee or a licensee can sue a third party for infringement, the document of transfer must be recorded.

Termination of Copyright Transfers and Licenses

It is not unusual for a copyright owner to transfer all rights in a copyright for a pittance, only to see the work become valuable at a later date. The 1976 Copyright Act offers a remedy for this injustice. It provides that, after a certain period has lapsed, the creator of the original work (or certain other parties) may terminate the transfer of the copyright and reclaim the rights. The creator then has a second chance to market and benefit from his or her work. This right to terminate a transfer is called a "termination interest."

In most cases, the termination interest belongs to the creator. If the creator is deceased and is survived by a spouse but no children, the surviving spouse owns the termination interest. If the deceased creator is not survived by a spouse, ownership of the interest belongs to any surviving children in equal shares. If the "decedent," or deceased, is survived by both spouse and children, the interest is divided so that the spouse receives 50 percent and the children receive equal shares of the remaining 50 percent.

If the termination interest is owned by more than one party, a majority of the owners must agree to terminate the transfer. Under the 1976 Act, the general rule is that termination may be effected at any time within a five-year period beginning at the end of the thirty-fifth year from the date the rights were transferred. If, however, the transfer included the right of publication, termination may go into effect at any time within a five-year period, beginning at the end of thirty-five years from the date of publication or forty years from the date of transfer, whichever occurred first.

A person wishing to terminate the transferred interest must serve an advance written notice on the transferee. This notice must state the intended termination date and must be served not less than two years and not more than ten years prior to the stated termination date. A copy of the notice must be recorded in the Copyright Office before the effective date of termination.

WHAT CAN BE COPYRIGHTED?

An "author," from the point of view of copyright law, is a creator—whether photographer, sculptor, writer, or craftsperson. Congress grants copyright protection to "original works of authorship fixed in any tangible medium of expression." Legislative comments on this section of the Act suggest that Congress chose to use "original works of authorship" rather than "writings" in order to have more leeway to legislate in the copyright field. "Originality"—as distinguished from "uniqueness"—requires that a work be created independently but does not require that it be the only one of its kind. In the past, the Copyright Office occasionally denied registration to works it considered immoral or obscene, even though it had no express authority to do so. Today, copyright registration is not refused because of the content of the work.

The 1976 Act expressly exempts from copyright protection "any idea, procedure, process, system, method of operation, concept, principle, or discovery." In short, a copyright extends only to the "expression" of creations of the mind, not to the ideas themselves. Frequently, there is no

clear line of division between an idea and its expression, but a pure idea—such as a concept for a work of art, as distinguished from the tangible art itself—cannot be copyrighted, no matter how original or creative it is.

Not everything in a copyrighted work is protected. For example, the title of a work cannot be copyrighted. Rather, it may sometimes be protected under the trademark laws (see chapter 12). A related issue is whether functional art, such as rugs, clothing, and the like, is copyrightable. If the aesthetics of the work can exist separately from and be identified independently of its function, then the aesthetic portion of the work is copyrightable. For example, the creator of slippers in the shape of animal feet was granted a copyright for the artistic portion (i.e., the feet design) of the functional item (i.e., the slippers themselves). Potters have obtained copyrights for the surface designs of their functional pottery, although not for the pottery itself.

Public Domain

Once the copyright on a work has expired, or has been lost through failure to comply with the notice requirement that existed prior to March 1, 1989, the effective date of the Berne Treaty, the work enters the public domain, and it can be used by anyone in any manner. A person can obtain copyright on a work derived from a work in the public domain if a distinguishable variation is created. This means, for example, that Rembrandt's painting, *Night Watch*, cannot be copyrighted, but a photograph of it can. As a result, no one would be able to copy the photograph, whereas anyone would be able to copy Rembrandt's original. The photograph is a copyrightable "derivative" work of a preexisting work.

Other examples of copyrightable derivative works include collages, photographs of photographs, film versions, and any other work "recast, transformed, or adapted" from the original. However, when registering the derivative work, you must disclose that it is based on a work in the public domain.

Compilations

Compilations are also copyrightable, as long as the preexisting materials are gathered and arranged in a new or original form. Compilations such as catalogs, magazines, pamphlets, or books can be copyrightable as a whole even though the individual contributions are individually copyrighted. However, the underlying facts or ideas upon which the compilation is based may not be protected if they do not satisfy the creativity requirement. For example, in *Feist Publications, Inc. v. Rural Telephone*

Service Company, Inc., the U.S. Supreme Court held that a phone book was not copyrightable because the alphabetical arrangement was not creative.

PUBLICATION

In copyright law, the concept of publication is different from what a lay person might expect it to be. Under the 1909 Act, it meant an unrestricted public display. "Publication," according to the 1976 Act, is "the distribution of copies of a work to the public by sale or other transfer of ownership, or by rental, lease, or loan."

A public performance or display of a work does not of itself constitute publication. Under the Copyright Act of 1909, when a person showed copies of a work to close friends or associates with the understanding that such copies were not to be further reproduced and distributed, the person had not published the work. A distribution of works to agents or customers for purposes of review and criticism also does not constitute a publication. Under this doctrine of limited publication, publication does not occur when a person displays work "to a definitely selected group and for a limited purpose, without the right of diffusion, reproduction, distribution, or sale."

The Copyright Revision Act of 1976 makes no specific reference to limited publication, but the statutory definition of publication requires a "distribution of copies or phonorecords of a work to the public." A congressional report explains that "the public" in this context refers to people who are under no explicit or implicit restrictions with respect to disclosure of the work's contents. It is, therefore, believed that the limited publication doctrine is continued under the new law.

DURATION OF COPYRIGHT

The Constitution permits Congress to grant copyright protection only "for limited times." The Sony Bono Copyright Term Extension Act, signed into law on October 27, 1998, provides that copyright exists throughout the life of the author plus seventy years. Under the 1976 Act, copyright existed throughout the life of the creator plus fifty years. If the work was created jointly, the copyright expires seventy years after the last author dies. For anonymous and pseudonymous works and works made for hire, the term is now 95 years from the year of first publication or 120 years from the year of creation, whichever expires first.

There are no longer renewals for copyrights on works created on or after January 1, 1978. The 1909 Copyright Act, however, granted a

creator copyright protection for a twenty-eight-year period, which could then be renewed for one additional twenty-eight-year period. Under the 1976 Act, copyrights granted under the 1909 Act and still in their first twenty-eight-year term as of January 1, 1978, continue for the remainder of the twenty-eight-year term and are automatically renewed for another forty-seven years, for a total of seventy-five years. Copyrights granted under the 1909 Act and in their second twenty-eight-year term as of January 1, 1978, automatically received an extension duration to create a term of seventy-five years from the date copyright was first obtained. In all cases, copyright terms end on December 31 of the given year.

Unpublished works that were fixed in a tangible medium prior to January 1, 1978, are in a special category with regard to the duration of copyright protection. Because they are unpublished, they are not covered by the 1909 Act. Because they were fixed in a tangible medium prior to January 1, 1978, they are not covered by the 1976 Act. Prior to the 1976 Act, these types of works were covered by common law, which protected them in perpetuity, but the 1976 Act extends federal protection for these works for the author's life plus fifty years. The Copyright Extension Act further extends protection for unpublished, unregistered works to a term of the life of the author plus seventy years.

The earliest date when such a copyright can expire is December 31, 2002. If the creator or owner of unpublished works publishes before that date, the term of copyright shall not expire before December 31, 2047.

CREATION OF COPYRIGHT

As I mentioned earlier, all copyrightable works are automatically protected by the federal copyright law as soon as they are fixed in a tangible medium, without the formal requirements of registration or deposit of copies.

Unpublished works can be registered with the Copyright Office and must be registered before an infringement suit can be filed. Care should be taken to disclose all material facts about the work in the registration. A prepublication registration can be made after the infringement, as long as the registration occurs before filing the suit. One of the advantages of early registration is that, after five years, the facts contained in the registration are presumed to be true. In the event of an infringement suit, this presumption, which will hold even after the work is published, can greatly simplify the copyright owner's preparation for trial and recovery of court costs and attorneys' fees.

Copyright Notice

The requirement that original works and all copies have a copyright notice affixed to them on publication is basic to both the 1909 Act and the Copyright Revision Act of 1976. The notice consists of the International symbol "©" or the word "copyright" or its abbreviation "Copr."; the name of the author (in the case of works made for hire, this is usually the employer); and the year of first publication. For example:

<div align="center">

Copyright 1998 by John Doe
or
© John Doe, 1998

</div>

The order of the words is unimportant.

Under the Copyright Act of 1909, a publication without notice caused the work to fall into the public domain, and once the rights were lost, they could not be retrieved. It was publication with notice that created a federal copyright under this law. Under the Copyright Revision Act of 1976, a federal copyright is created as soon as an original work is made in tangible form. Until 1989, however, the proper notice had to be attached at publication if you wished to retain a federal copyright after publication, though a savings clause was added. Section 405 provides that a copyright is not invalidated by publication without copyright notice under any of the following circumstances:

- The notice is omitted from a small number of copies distributed to the public
- The work is registered within five years of publication and a reasonable effort is made to add the notice to all works distributed in the United States after the omission is discovered
- The notice was omitted, intentionally or otherwise, in violation of an express written agreement that distributed copies would bear the required notice

The Copyright Office has indicated that the savings provision of the law may not be used if there has been an intentional omission of the copyright notice by the person claiming copyright protection, though in at least one case, an individual was allowed to use the savings provision where there had been an intentional omission of the notice.

After the 1989 amendment to the 1976 Act, notice is not required on works created or first published after March 1, 1989. Although notice is not required on works published after March 1, 1989, notice should still

be used even today to make others aware of your rights. One who copies a work, believing it to be in the public domain because there is no notice, is considered an "innocent" infringer. In this situation, the author whose work is copied cannot recover damages. In fact, the court might even allow the copier to continue using the work. The 1989 amendment provides that if notice is used, an infringer cannot then claim that the infringement was innocent.

REGISTRATION AND DEPOSIT

To register a copyright you must file an application form with the Copyright Register, Library of Congress, Washington, DC 20559. You must also deposit two copies of the work. Remember, if you have a copyright notice on your work, or if your work was published after March 1, 1989, even without a notice, you already have a copyright. Under the Copyright Revision Act of 1976, as amended, registration is necessary only: (1) as a prerequisite to commencing an infringement action; or (2) when the copyright owner wishes to take advantage of the savings provision of Section 405; or (3) if the Register of Copyrights demands registration of published works bearing a copyright notice (which is not likely to happen unless you have been in correspondence with that office).

The current law separates registration from the deposit requirements. Under the 1909 Act, registration involved filing a copyright application, paying a six dollar fee, and depositing two copies of the work itself or two photographs of the original. Fine prints came within the requirement of actual copies, and it was necessary to deposit two actual prints. Congress recognized the economic hardship this caused artists and the fact that many artists intentionally failed to take advantage of copyright protection because of the burdensome deposit requirement and, therefore, modified it. Now, the Register of Copyrights is allowed to exempt certain categories from the deposit requirement or provide for alternative forms of deposit.

For works of art and editioned prints with an edition size of 300 or fewer, two photographs of the work fulfill the deposit requirement. This basic requirement also applies to works published abroad when such works are either imported into the United States or become part of an American publication. Copies deposited at the Copyright Office are transferred to the Library of Congress or other federal libraries. A few deposit copies are transferred to university or public libraries.

You should send the completed registration form, a check, and the required number of copies of the work to the Register of Copyrights,

Library of Congress, Washington, DC 20559. You may wish to have an attorney teach you how to fill out the application, which is not as simple as it appears.

Although you can delay registration, there are at least three reasons why you should deposit the work and register the copyright (i.e., file the application) within three months of publication. First, the copyright law prohibits the awarding of attorneys' fees and statutory damages for infringements that occur before registration, unless registration took place within three months of publication. Second, if you deposit the required two copies of the work within three months but postpone sending the registration form and fee, the Copyright Office will require two more copies of the work when you eventually do send in the form and money. Finally, if the two copies are not deposited within the requisite three-month period, the Register of Copyrights may demand them. If the copies are not submitted within three months after demand, the person upon whom demand was made may be subject to a fine of up to $250 for each unsubmitted work. In addition, such person or persons may be required to pay the Library of Congress an amount equal to the retail cost of the work, or, if no retail cost has been established, the costs incurred by the Library in acquiring the work, provided such costs are reasonable. The copyright proprietor who willfully and repeatedly refuses to comply with such a demand may be liable for an additional fine of $2,500.

COPYRIGHT INFRINGEMENT AND REMEDIES

A copyright infringement occurs when an unauthorized person exercises any of the five exclusive rights protected by a copyright. The fact that the infringing party did not intend to improperly use protected rights or did not know that the work was protected by copyright is relevant only with respect to the penalty.

All actions for infringement of copyright must be brought in a federal court within three years of the date of the infringement. The copyright owner must prove that the work was copyrighted and registered, that the infringer had access to and used the copyrighted work, and that the infringer copied a "substantial and material" portion of the copyrighted work. In order to demonstrate the extent of the damage caused by the infringement, the copyright owner must also provide evidence that shows how widely the infringing copies were distributed.

The copyright owner must prove that the infringer had access to the protected work because an independent creation of an identical work is not an infringement. Infringement can occur even if a work was not

copied in its entirety, however, because any unauthorized copying of a substantial portion of a work constitutes an infringement.

If the expressions of ideas, rather than simply the ideas alone, are found to be similar, the court must decide whether the similarity is substantial and whether the work itself is copyrighted. This is done in two steps. First, the court looks at the more general similarities of the works, such as subject matter, setting, materials used, and the like. For this, there may be expert testimony. The second step involves a subjective judgment of the works' intrinsic similarity: Would a lay observer recognize that the alleged copy had been appropriated from the copyrighted work? No expert testimony is allowed in making this determination.

Hogan v. *MacMillan, Inc.*, a case in the late 1980s, held that the substantial similarity test applies even when the allegedly infringing material is in a different medium. George Balanchine choreographed the *Nutcracker* ballet, and his estate receives royalties every time the ballet is performed. MacMillan published a book of photographs that included sixty color pictures of scenes from a performance of the *Nutcracker*. In determining whether this constituted infringement, the Court of Appeals noted that the correct test is whether "the ordinary observer, unless he set out to detect the disparities, would be disposed to overlook them, and regard their aesthetic appeal as the same." Furthermore, the court noted, "Even a small amount of the original, if it is qualitatively significant, may be sufficient to be an infringement, although the full original could not be recreated from the excerpt."

Even before the trial, the copyright owner may obtain a preliminary court order against an infringer. The copyright owner can petition the court to seize all copies of the alleged infringing work and the negatives or masters used to produce them. To do this, the copyright owner must file a sworn statement that the work is an infringement and provide a substantial bond approved by the court. If the court seizes the works, the alleged infringer may object to the amount or form of the bond.

After the trial, if the work is held to be an infringement, the court can order the destruction of all copies, enjoin future infringement, and award damages. The copyright owner may request that the court award actual damages or statutory damages—a choice that can be made any time before the final judgment is recorded.

Actual damages are either the amount of the financial injury sustained by the copyright owner or, in most cases, the equivalent of the profits made by the infringer. In proving the infringer's profits, the copyright owner need only establish the gross revenues received for the illegal exploitation of the work. The infringer then must prove any deductible expenses.

The amount of statutory damages is decided by the court, within specified limits: no less than $500 and no more than $20,000. The maximum possible recovery is increased to $100,000 if the copyright owner proves that the infringement was willful. The court has the option to award the prevailing party its costs and attorneys' fees. As I have already mentioned, statutory damages and attorneys' fees may not be awarded if the copyright was not registered prior to infringement, unless the work was registered within three months of publication.

The U.S. Justice Department can also prosecute a copyright infringer. If the prosecutor proves beyond a reasonable doubt that the infringement was committed willfully and for commercial gain, the infringer can be fined and sentenced to jail. There is also a fine for placing a false copyright notice on a work, for removing or obliterating a copyright notice, or for knowingly making a false statement in an application for a copyright. A number of individuals have been imprisoned for large-scale copyright infringements.

Fair Use

Not every copying of a protected work is an infringement. The Copyright Act of 1976 recognizes that the creation and use of copies of a protected work "for purposes such as criticism, comment, news reporting, teaching (including multiple copies for classroom use), scholarship or research" can be considered fair use and, therefore, not an infringement. This is not, however, a complete list, nor is it intended as a definition of fair use. Fair use, in fact, is not defined by the Act. Instead, the Act cites four criteria to be considered in determining whether a particular use is or is not fair:

- The purpose and character of the use, including whether it is for commercial use or for nonprofit educational purposes
- The nature of the copyrighted work
- The amount and substantiality of the portion used in relation to the copyrighted work as a whole
- The effect of the use upon the potential market for, or value of, the copyrighted work

The Act does not rank these four criteria, nor does it exclude other factors in determining the question of fair use. In effect, the Act leaves the doctrine of fair use to be developed by the courts.

Photocopying

The limits of fair use are hotly debated in the area of photocopying. The Copyright Act provides that "reproduction in copies . . . for purposes such as criticism, comment, news reporting, teaching (including multiple copies for classroom use), scholarship, or research" can be a fair use. This, however, raises many questions. Reproduction of what? A piece of an image? More than half an image? An image no longer generally available? How many copies? To help answer these questions, several interested organizations drafted a set of guidelines for classroom copying in nonprofit educational institutions. These guidelines are not a part of the Copyright Act but are printed in the Act's legislative history. Even though the writers of the guidelines defined them as "minimum standards of educational fair use," major educational groups have publicly expressed the fear that publishers would attempt to establish the guidelines as maximum standards beyond which there could be no fair use.

As all this demonstrates, it is not easy to define what sorts of uses are fair uses. Questions continue to be resolved on a case-by-case basis. You should consult a lawyer when it appears that one of your works has been infringed or when you intend to use someone else's copyrighted work.

Exempted Uses

In many instances the ambiguities of the fair-use doctrine are resolved by statutory exemptions. Exempted uses apply in situations in which the public interest in making a copy outweighs the potential harm to the copyright proprietor.

Perhaps the most significant of these exemptions is the library and archives exemption, which basically provides that libraries and archives may reproduce and distribute a single copy of a work provided that (1) such reproduction and distribution is not for the purpose of direct or indirect commercial gain; (2) the collections of the library or archives are available to the public or available to researchers affiliated with the library or archives, as well as to others doing research in a specialized field; and (3) the reproduction and distribution of the work includes a copyright notice.

In the legislative history of the Copyright Act, Congress encouraged copying of films made before 1942 because these films are printed on nitrate film stock, which decomposes in time. Therefore, as long as an organization is attempting to preserve our cultural heritage, copying old films is allowed and encouraged under the fair-use doctrine.

The exemption for libraries and archives is intended to cover only single copies of a work. It does not generally cover multiple reproductions

of the same material, whether made on one occasion or over a period of time, and whether intended for use by one person or for separate use by the individual members of a group. Under interlibrary arrangements, various libraries may provide one another with works missing from their respective collections, unless these distribution arrangements substitute for a subscription or purchase of a given work.

This exemption in no way affects the applicability of fair use, nor does it apply where such copying is prohibited in contractual arrangements agreed to by the library or archives when it obtained the work.

Getting Information and Forms

If you desire more information, write to the Copyright Office, Library of Congress, Washington, DC 20559, and ask for a free copyright information packet.

TRADEMARKS

Trademarks may be used by galleries and craft retailers to identify work that meets their standards of quality and to protect their business identities. For example, many famous businesses, such as Tiffany, have protected marks that identify those works bearing them as being of a quality acceptable to that business. A unique name, symbol, or logo that identifies an art gallery or craft retail shop may also be a protectable trade or service mark.

Although modern trademark law is a relatively new development, its historical antecedent is found in medieval England. Craft guilds often required their members to place their individual marks on the products they produced so that if a product proved defective, the guild could trace it back to the responsible craftsman. Thus, the use of marks enabled the guild to maintain the integrity of its name. Merchants also would often affix marks to their products so that, should a product be stolen or misplaced, the merchant could prove ownership through the identifying mark.

The use of marks for purposes of identification would no doubt have worked quite well in an ideal society where all the citizens led principled and moral lives, but such was not the case. It is not surprising that unscrupulous merchants quickly realized there was easy money to be made from the use of another's mark, or one confusingly similar. Shoddy merchants could more readily sell their products by affixing to them the marks belonging to quality manufacturers.

In response to this problem of consumer fraud, the first trademark laws developed in the United States in 1870. Initially, the emphasis was

to prevent one person from passing off his or her product as that of another through the intentional use of a similar mark. Modern U.S. law focuses on whether one mark is sufficiently similar to another to cause confusion in the minds of the buying public. In other words, the emphasis has shifted from the subjective intent of a dishonest manufacturer or merchant passing off goods as those of another to the objective determination of consumer confusion.

Despite these developments, the essential purpose of trademarks and trademark laws has changed little since the days of the craft guilds. Trademarks still function primarily as a means of identifying the source of a particular product. Trademark laws are designed to enable the trademark proprietor to develop goodwill for the product, as well as to prevent another party from exploiting that goodwill—regardless of whether that exploitation is intentional or innocent.

WHAT IS A TRADEMARK?

A "trademark" is defined as any word, name, symbol, device, or any combination thereof, adopted and used by a person in commerce—or when a person has a bona fide (good faith) intention to use and subsequently does—which identifies and distinguishes his or her goods from those manufactured or sold by others, and indicates the source of those goods, even if that source is unknown.

A "service mark" is similar to a trademark, although it is used to identify the source of a service, such as art or craft sales, rather than a product. The trademark laws treat service marks in the same way as trademarks, and lawyers lump both under the term "trademarks" or the professional slang "marks."

A trademark owner may be a licensee, broker, or distributor. The phrase "use in commerce" means the bona fide use of a mark in the ordinary course of trade—rather than simply reserving the right to a mark. You can, however, reserve a mark prior to its use by filing an Intent-to-Use Application with the Patent and Trademark Office (PTO).

Fanciful, Arbitrary, and Suggestive Marks

A trademark must be distinguishable. In order to secure trademark protection, one must devise a distinctive mark. The most distinctive marks are those that are purely arbitrary or fanciful, that is, those that have no meaning or connotation other than identifying the source of a particular product. For example, the trademark "Kroma" to identify dichroic glass jewelry is fanciful. Trademarks that have another meaning, such as the trademark "Shell" to identify gasoline, are arbitrary. Such trademarks

are afforded substantial protection because the other meaning bears no resemblance to the product identified. Suggestive marks—marks that are somewhat descriptive of the product but also require some imagination in order to make the connection—are also protected by trademark laws.

Generic, Descriptive, and Prohibited Trademarks

Generic and descriptive trademarks are not considered distinctive. A generic trademark merely identifies the product for what it is. For example, the use of the trademark "Beer" used to identify beer is generic. Similarly, a descriptive mark merely characterizes the attributes or qualities of the product. For example, the trademark "Raisin Bran" simply describes the ingredients of the cereal it identifies.

Generic marks are never afforded trademark protection. In the *Leathersmiths of London* case in the mid-1980s, the question was whether the name "Leathersmiths of London" was a protected trademark. The court held that the word "leathersmith" is generic; that is, it describes someone who is in the business of working with leather and, therefore, is not entitled to trademark protection.

Descriptive trademarks, however, may be protected in limited circumstances. A descriptive mark may be protected if the proprietor of the mark can prove that the mark has acquired a secondary meaning, that is, when the public no longer connects the words of the trademark with their literal meaning but, rather, with a unique product or service. For example, *The Crafts Report* has probably acquired a secondary meaning as the mark of a particular publication that contains topical articles about business, legal, and marketing issues in the crafts industry.

Nevertheless, some trademarks, even though distinctive, are prohibited by statute or public policy if they are obscene, scandalous, or derogatory. In 1992, a group of Native Americans petitioned to have registration of the mark "Washington Redskins" canceled on the basis of its being derogatory toward Native Americans. Similarly, trademarks that are deemed deceptive and misleading, such as the mark "Idaho Potatoes" to identify potatoes produced in an area other than Idaho, are also denied protection.

PROTECTING A TRADEMARK

Common law is that body of law developed from court decisions rather than from state or federal statutes. Greater protection is secured through federal or state registration, but common-law protection will suffice and has the benefit of not requiring any interaction with governmental agencies.

In order to secure common-law trademark protection, the trademark must actually be used in commerce. A trademark is considered to be in use when it has been placed in any manner on the product or its containers or the displays associated with it, or on any of the tags or labels affixed to the product. Thus, it is not always necessary that the trademark actually be physically affixed to the goods. As long as the trademark is associated with the product at the point of sale and in such a way that the product can be readily identified as coming from a particular manufacturer or source, the trademark may be protected. Merely listing a trademark in a catalog, ordering labels bearing the trademark, using the trademark on invoices, or exhibiting trademarked goods at a trade show may not be sufficient in and of itself to constitute use since the use of the trademark would not be associated with the point of sale. To ensure trademark protection, the trademark proprietor would be well advised to physically affix the trademark to the product so that it is certain to bear the trademark when it is sold.

Common law protects a trademark proprietor against someone else's later use of a trademark that is confusingly similar. Generally, trademarks will be confusing if they are similar in sound or appearance, particularly if the trademarks are affixed to similar products or if products are marketed throughout the same or similar geographic areas.

On the other hand, if two products bearing similar trademarks are marketed in different geographic areas or are not used in connection with related products, there may not be any infringement. A business that distributes its products solely in the Northwest could probably innocently adopt and use a trademark already used by a business distributing its product solely in the state of Maine, provided the mark of the Northwest business does not adversely affect the value of the trademark used by the Maine company. A Northwest toy manufacturer could probably adopt and use a trademark used by a Northwest chain saw manufacturer. It is not likely that the use of the mark by the toy manufacturer would confuse chain saw purchasers; still, appropriation of another's trademark may be wrongful if the use, even by a noncompeting business, would dilute the value of the mark to the original owner.

Registration with the Principal Register

The federal statute governing trademarks is known as the Lanham Act. The Lanham Act does not grant trademark rights—those are secured by the common-law principles already discussed. Rather, it provides a central clearinghouse for existing trademarks via official registration.

The Trademark Law Revision Act (TLRA) of 1988 made substantive changes to the previous trademark laws. In addition, the trademark law was amended in 1996 to add a federal antidilution provision. Though the Lanham Act provides much of the skeleton of trademark law, these amendments add the needed detail to make the Lanham Act a more complete body of law. Note that there are two official registers for trademarks: the Principal Register and the Supplemental Register. The following sections on how to register a trademark apply to the Principal Register. A separate section later in this chapter describes what the Supplemental Register covers and how it may be used.

Prior to enactment of the TLRA, a mark could be registered only upon actual use in interstate commerce. This requirement was satisfied when an applicant sold a few units of the product bearing the trademark in an interstate transaction. A mark could essentially be reserved for later use by making a "token use" at the time of application. Unfortunately, the minimum token-use requirement allowed the registering of trademarks that might never be used and possibly prevented other proprietors from legitimately using the mark. This judicially sanctioned practice also clogged the federal register with unused marks.

Under the TLRA, token use is no longer permitted. Actual use of the mark is required in order for a trademark to be registered, though the filing of an application for a trademark based solely on a bona fide intention to use that mark in the future is now allowed. This reserves and protects a mark for a limited time and to a limited extent prior to its being used in commerce. If the mark is not actually used within a certain period of time, the trademark registration will be denied.

Applications Based on Actual Use

Once the proprietor has established a mark's actual use in commerce, the mark can be registered by filing an application with the Patent and Trademark Office. This process entails filling out an application, sending in a drawing of the mark, along with specimens of the mark as used in commerce, and paying the required fee, currently $245. If the examining officer at the PTO accepts the application, the trademark will appear shortly thereafter in the PTO's publication, the *Official Gazette*. Anyone who foresees a possibility of being injured by the issuance of the registration has thirty days from the publication of notice of the mark in the *Official Gazette* to file a written notice stating reasons for opposition. If nobody objects, or if the objections are found to be without merit, a certificate of registration is issued.

Applications Based on Intent to Use

Under the TLRA, a right to a particular mark can be preserved for future use through the so-called intent-to-use provision. This does not remove the requirement of actual use in commerce, which is still necessary for registration of the mark. Protection of a mark for future use can be accomplished by filing an application based on "bona fide intent-to-use" the mark in commerce. An Intent-to-Use Application should not be made merely for the purpose of reserving a mark. The good faith of the applicant to eventually use the mark in commerce will be determined from the circumstances surrounding the application and the applicant's conduct with respect to the mark. The history behind the statute's enactment suggests that the applicant's conduct concerning his or her "intent to use" the mark will be measured against standards accepted in the trade or business.

If the Intent-to-Use Application satisfies the requirements of the PTO regulations, it will receive approval for publication in the *Official Gazette*. Upon publication, a thirty-day period for opposition to registration of the mark begins. Those applications that go unopposed receive a "Notice of Allowance." The date this notice is issued is very important because the reservation of the mark is limited to a period of six months from the date of allowance, during which period actual use of the mark in commerce must begin or the trademark application will lapse.

If an applicant fails to commence using the mark in commerce within the six-month period, it is possible to obtain an extension for another six months. If submitted before the original six-month period expires, the extension is generally automatic upon application and payment of a fee. Four additional six-month extensions are also possible, but—in addition to an application and fee submitted before the current six-month period expires—these extensions require a showing of good cause as to why the extension should be granted, subject to the approval of the PTO. In no event can the period between the date of allowance and the commencement of use of the mark in commerce exceed thirty-six months.

In making a request for extension, the applicant must include the following: a verified statement of continued bona fide intent to use the mark in commerce; specification as to which classification(s) of goods and services the intent continues to apply to; and the required fee, which is currently $100 per extension, per classification of goods or services.

Once the mark is used in commerce, the applicant must file a Verified Statement of Use. If everything is in order, the mark will be registered for the goods or services that the Statement of Use indicates. The Commissioner of the PTO shall notify an applicant as to whether the

Statement of Use has been accepted or refused. An applicant will be allowed to amend the Statement of Use if the mark was not used on all the goods initially identified.

The TLRA generally prohibits assignment of Intent-to-Use Applications, which prevents individuals from applying for marks that they then intend to sell, so you should contact an attorney before attempting to sell such an application.

Constructive Use

An important concept found in the Lanham Act, which has been improved by recent amendments, is that of "constructive use." This concept, which has been called the cornerstone of the "intent-to-use" method, applies to use-based applications as well. When an application to register a mark is filed under the doctrine of constructive use, filing an application to register a mark constitutes use of the mark as of the filing date. Thus, a right of priority to exclusive use of the mark is created throughout the United States. This is true only if the mark is filed for registration on the Principal Register. The constructive-use doctrine does not apply to domestic (or foreign) applications on the Supplemental Register.

This doctrine creates a strong incentive to file for registration as early as possible in that it prevents others from acquiring the mark by simply using it before the applicant does. Constructive use greatly reduces disputes as to which party has priority, thus saving costs and limiting uncertainty in infringement or opposition proceedings.

Exceptions to the priority right of use are marks used prior to the applicant's filing date, Intent-to-Use Applications filed prior to the applicant's filing date, and actual use applications registered prior to the applicant's filing date. Another exception is an application for registration filed by a foreign applicant under certain specified circumstances.

Registration on the Supplemental Register

Registration on the Supplemental Register provides protection for individuals capable of distinguishing their marks from those of others but whose marks do not comply with the requirements for registration on the Principal Register; that is, the marks are merely descriptive, deceptively misdescriptive, geographically descriptive or misdescriptive, or a surname. Supplemental Register applications may be made directly if the applicant is sure that registration on the Principal Registry is unlikely, as, for example, when a mark is merely descriptive and has not achieved a secondary meaning or if the PTO has already refused to register the mark on the Principal Register.

Marks for the Supplemental Register are not published for scrutiny and possible opposition. They are, however, published as registered in the *Official Gazette*. If a person believes that he or she will be damaged by the registration of another's mark on the Supplemental Register, he or she may at any time petition for cancellation of the registration.

Applications filed on the Supplemental Register cannot be based on the intent to use the mark and do not enjoy the benefits of constructive use. For a mark to be eligible for registration on the Supplemental Register, the mark must be in lawful use in commerce, meaning a bona fide use in the ordinary course of trade.

BENEFITS OF REGISTRATION

Registration enables proprietors to use the symbol "®" or the word "registered," in conjunction with their marks, which may deter others from using them. Proprietors of marks that have not been federally registered are prohibited from using these symbols. Commonly, "TM" for trademark or "SM" for service mark is used in conjunction with an unregistered mark during the application period. These designations have no official status, but they do provide notice to others that the user is claiming a property right in the mark.

A second benefit is that registration on the Principal Register is evidence of the validity of the mark, the registrant's ownership of the mark, and the exclusive right to use the mark on identified goods in commerce.

Third, a registered trademark that has been in continuous use for five consecutive years generally becomes incontestable. By registering the trademark, the proprietor may secure rights superior to those of a prior but unregistered user if the original user does not object to the registrant's use within five years.

Under the current trademark law, registration remains in effect for a period of ten years and may be renewed in additional ten-year increments by filing an application at least six months prior to the expiration of the existing ten-year term. Registrations issued prior to November 16, 1989, received a first-term registration of twenty years, with subsequent registrations to be for ten-year renewals. Registrations that issue from applications filed after November 16, 1989, have a first term of only ten years, even though filed under the old law.

Obviously, registration of a trademark can be quite beneficial to a manufacturer who has invested time, money, and energy in developing a reputation for quality work. The total costs for trademark registration usually run about $1,000, not counting any artist's fees for drawings. You will find that an attorney who specializes in trademarks will be invalu-

able to you. He or she will be able to help you determine whether the benefits to be derived from registration justify the expenses. Also, your attorney can determine if there are any similar marks in existence, complete the application, and deal with any problems that may occur during its processing.

For attorneys who specialize in trademark work, consult the yellow pages of the telephone directory (look under Patent Agents or Trademark Attorneys) or ask your state bar association for some suggestions.

LOSS OF TRADEMARK PROTECTION

Some forms of use may result in the loss of a trademark. A number of well-known trademarks, such as "Aspirin," "Thermos," and "Escalator," have been lost as a result of improper usage—not by the manufacturers, but by consumers. Generally, trademark protection is lost because the mark becomes widely used in some way other than as an adjective modifying a noun. For example, the mark "Xerox" was in danger of becoming generic because it was being improperly used when, for example, people stated that they were "xeroxing" a document. Xerox vigorously policed misuse, pointing out that documents were "photocopied" using a Xerox machine. When a trademark is used as a noun or a verb, it no longer functions to identify the source of the product but rather becomes the name of the product itself. At that point, the mark becomes generic and not subject to protection.

Abandonment of a mark will also result in loss of protection. A trademark is presumed abandoned when it has not been used for three years. Token use is not sufficient to avoid abandonment.

INFRINGEMENT

The proprietor of a trademark in use that has been infringed can sue the infringing party either for monetary damages or for an injunction prohibiting the infringing use, or, sometimes, both. Monetary damages may be measured either by the plaintiff's losses resulting from the infringement or by the defendant's profits. In certain exceptional circumstances, where the defendant's conduct is willful and flagrant, the plaintiff might also be entitled to exemplary damages equal to three times the actual damages, as well as attorneys' fees.

The relevant sections under the Act allow remedies for infringement of marks that are in use. This precludes an intent-to-use applicant from suing for infringement because the applicant has not yet used the mark. The law permits anyone to sue for unfair competition if marks are likely to cause confusion, mistake, or deception as to the origin, sponsorship,

or approval of the complainant's goods or services with those of another. Under the Act, all remedies available for infringement actions are also available for actions of unfair competition, including injunctive relief, damages, and attorneys' fees.

ANTIDILUTION

In 1996, the federal trademark law was amended to provide special protection to famous marks. The statute does not define "famous mark," though case law likely will. Legislative history suggests that a "famous mark" is a mark that has been around for a long term and enjoys extensive notoriety.

In the past, it was possible to appropriate a mark for use on goods or services that did not compete with those of the mark's owner so long as there was no likelihood of confusion. As a result, it was possible, for example, to call a dog food *Cadillac* intending to suggest that it was an elite form of canine fare, despite the fact that the automobile manufacturer, Cadillac, did not have anything to do with the dog food. The likely intent of the dog-food company was to suggest that it was the "Cadillac" of dog foods and thus the top of the line. Today, this would likely be considered a dilution of the General Motors trademark "Cadillac," and would be forbidden. While antidilution statutes had been in effect in several states, they were not universal, until the 1996 federal statute protected famous marks. The remedies available for violations of the antidilution statute are comparable to those that are provided for trademark infringements.

STATE REGISTRATION

Trademarks can also be registered under state law, but protection does not extend beyond the borders of the state. The trademark proprietor may file a trademark application, along with documentation similar to that required by the Lanham Act. The number of specimens of the mark needed to complete registration and the registration fees will vary from state to state. Protection under state law can be broader than that found under federal laws. Remedies available under state law are also very likely to be different from those found under the federal statute. In some states, a state registration is a prerequisite to the availability of state remedies. It is important to remember that under the supremacy clause of the U.S. Constitution, if a conflict arises between federal and state trademark law, federal law will control.

ADVERTISING

A host of legal issues arise when planning an advertising program. A business may tout the qualities of its products or services in its ads or promotions, but those representations must be true. Most states have consumer protection laws, which, among other things, impose fines and other legal sanctions on businesses that engage in misleading advertising. The State Attorney General can also cause an offending advertisement to be withdrawn—as in the case of the false claim of several art auctions that the work being auctioned had been created "by starving artists." If your business activity extends beyond your state boundaries and either touches or affects another state, the Federal Trade Commission has jurisdiction over the advertising practices of your business.

When preparing an advertising program, work with an attorney skilled in advertising law to ensure that you have an effective program for selling your product or service that will not violate the rights of other businesses or individuals and expose your business to potential liability. A poorly drafted advertising program is likely to be more harmful than none at all.

COMPARATIVE ADVERTISING

It has become quite common for businesses to assert the merits of their products and services by comparing them to those of their competitors. A business is permitted to use the name of a competitor and describe the competitor's products in an advertisement—even though the comparison

will likely point out the competing product's or service's inferiority—as long as there is no likelihood a consumer would believe that the advertiser is selling the competing product or service, and as long as the statements made are accurate.

In a leading case, it was held that it was permissible for an advertiser to use the names of famous perfumes in an ad stating that the consumers who liked those perfumes would also like the advertiser's less expensive products. The court felt that there was no possibility that the consumer would be misled into believing that the expensive perfume manufacturer was advertising a cheaper "knockoff" scent. In addition, because the perfumes smelled the same, the statements made were felt to be accurate.

When, however, an advertiser intentionally or negligently makes untrue, disparaging remarks about the product or service of another business, the advertiser may be held legally accountable to the injured party. In a landmark case that fell under consumer protection laws, a famous art critic stated that a particular painting was a forgery, and as a result, the sale of that painting fell through. The painting's owner successfully sued the critic for the lost profits.

For a disparaging remark to be actionable, it must be both untrue and believable by a reasonable person. If the statement made is so outlandish as to be unbelievable, it is likely that the company whose product was disparaged will not be able to prove any injury. For example, if a craft retailer claimed that its competitor's products were so poorly constructed that they literally fell apart within the first week of use, this gross exaggeration would most likely not be actionable.

RIGHT OF PUBLICITY AND RIGHT OF PRIVACY

A company may use a celebrity to endorse its product, provided the celebrity consents to the endorsement. If not, the company may be liable to the celebrity for violating his or her right of publicity. The right of publicity is granted to those who commercially exploit their names, voices, or images, such as actors, singers, or the like. When manufacturers used look-alikes of Jackie Onassis, Woody Allen, and the rap group The Fat Boys for commercial purposes, liability was imposed.

People who have not achieved notoriety because of their commercial activities may have a right of privacy. Thus, if a person's name or likeness is used in an advertisement without permission, the person may have a claim. In one case, several employees of a bank were photographed while engaged in their day-to-day work. These photographs were displayed as part of the bank's promotional material for a trade show. When the employees, who were given the day off to attend the

trade show, saw their photos, they retained an attorney, who filed suit. One might conclude from this case that it is dangerous to give employees a day off to attend a trade show, but a more prudent conclusion would be that even bank employees, who are not entertainers, must grant permission for their names, voices, or likenesses to be used for advertising purposes.

If an individual's photograph is not the focal point of the advertisement but, rather, an incidental part, such as a head in a crowd or a member of an audience, then the individual's permission may not be required. It is a good idea, however, to get a signed photo release whenever possible from persons who will appear in your ad. The release should be worded so as to give your business permission to use the person's name, likeness, and, if relevant, voice, for any and all purposes, including advertising your business. This will protect you if, for example, the individual eventually becomes well known and you decide to use the photos that you obtained before the person became a star.

USE OF ANOTHER'S TRADEMARK

An advertiser may use the name or logo of another business within an ad as long as there is no likelihood that the consumer would believe the ad was sponsored by the company whose name or logo is being used. In other words, as long as there is no likelihood of confusion between your product and the name and logo belonging to another, you may use the other's trademark. Therefore, it would be permissible for your gallery's ad to contain a photograph of an opening with patrons holding bottles of Coca Cola, as long as it is clear from the advertisement that the Coca Cola Company is not sponsoring the ad. Similarly, a video advertisement may show a craft shop's delivery vehicle streaking through a metropolitan area and passing by several famous businesses.

Locations

Items of utility, such as buildings, parks, and other landmarks, are not copyrightable, so they may generally be used in advertising programs without the owner's permission. A business could advertise its product with a photograph of someone standing in front of the Empire State Building or the World Trade Center, for example. In a few cases, however, it has been held that a building that was architecturally unique, identifiable, and famous could enjoy the protection of "trade dress laws." Perhaps the distinction between an incidental use of a building as a backdrop and focusing on the prominent, identifiable architectural features of a building is significant.

Trade Dress

Package design as a form of advertising has been given special protection. Although the copyright laws do not protect functional items, such as a product's packaging, the courts have developed a form of protection known as trade dress. The design elements of a particular packaging design are protectable as long as they are not also functional, such as a lid or hanger.

The trade dress form of protection is automatic. Blue Mountain Greeting Card Co. developed a distinct and very identifiable line of greeting cards. These cards became quite well known and commercially successful. The Hallmark Greeting Card Company then designed a line of cards that were not identical to those of Blue Mountain but, in essence, appropriated the look and feel of the Blue Mountain cards. They were so similar that consumers would believe that the Hallmark cards were merely an extension of Blue Mountain's line. For this reason, the court held Hallmark liable for infringing on Blue Mountain's trade dress in the cards. The trade-dress doctrine has been extended beyond traditional packaging and has been used in a variety of cases, including the copying of a business's distinctive theme, wearable art, and a craft trade show's theme.

Individuals, too, can have distinctive styles that are protected. A California advertiser hired one of Bette Midler's backup singers to replicate Ms. Midler's distinctive vocal rendition of a song for a commercial. Ms. Midler sued and recovered for the knockoff under a California statute that protects, among other things, a celebrity's voice. When, however, a manufacturer hired a group that looked and sounded like the rap group known as The Fat Boys, New York's federal court held the manufacturer liable only for violating the celebrities' publicity rights since the New York publicity statute merely extends protection to one's "name, portrait, or picture."

WEB SITES IN CYBERSPACE

While the Internet is considered today's progressive multi-
media communications network, its genesis was in war
and turmoil. According to an article that appears in the
1995 *American Heritage*, the Web stands as a "monument to military
plans for fighting three wars." It actually began during World War II and
was initially funded by the Pentagon. This modest analytical system,
called "operations research," was initiated by military scientists and
civilian technologists for the purpose of analyzing antisubmarine tactics,
as well as antiaircraft batteries.

After the war ended and the Allies were forced to cope with the spread
of communism and the cold war, the military contracted for consulting
services from universities and think tanks. The jolt caused by the
Russian Sputnik resulted in a frenzy of activity in free-world universities,
as well as an increased focus on science and technology. Research funds
were made available for high-tech expansion. As computer capacity
expanded and the need for communication became more acute, the net-
work grew. University students became intrigued by the potential, and
the network expanded.

The Pentagon funded research for the purpose of creating smaller, more
powerful computers. These were intended to aid the war machine, but it
was clear that other benefits would be realized. The government agreed to
support a computer network that was intended, among other things, to
test the feasibility of shared use of the then supercomputers as a means of
providing greater military capability in a post–World War III scenario.

A network working group, consisting of university representatives, was created in the mid-60s to provide access to supercomputers to government researchers working on military contracts. By 1969, Vinton Cerf, the computer scientist who has been called the father of the Internet, began to play an active role in expanding the network. He developed the first network protocols, and the rest is history. In 1977, he became head of the Advanced Research Project Agency Network (ARPANET) within the Department of Defense. Among other things, he experimented with mobile links and discovered that a networked computer could accompany military expeditionary forces. Interestingly, Cerf is hearing disabled and communicating through e-mail is a means of accommodating his disability.

The first list server was created so science fiction devotees could communicate with one another, and the concept caught on. This frivolous use of the Web was initially discouraged, but, as the Web became ubiquitous, nonmilitary and nonresearch uses became commonplace. Today, the Web is as open and freewheeling as one can imagine. From adult entertainment to counseling, one can find almost anything on the Web. Businesses, families, and even individuals have created Web sites, which have become extraordinarily creative. From static and simple formulas to the most graphic and exotic interactive displays, the Web is today's most advanced form of mass communication. The most heavily traveled routes of today's information superhighways are in private hands, and the Web is no longer a military captive.

DOING BUSINESS ON THE WEB

It has become extremely popular for individuals and businesses to establish a presence on the World Wide Web. Elaborate home pages have been appearing with regularity not only for large multinational corporations, but also for smaller companies. Web sites have been created for retail shopping, bill paying, securities sales, airline bookings, and the like. In fact, the only limitations in cyberspace are the imaginations of users and the capacity of their equipment.

When the Social Security Administration and several private companies began putting financial data on the Web, problems arose. Despite the attempt to restrict access to this very sensitive information, individuals felt compromised. As a result of widespread public dissatisfaction with the availability of so much personal information, the Social Security Administration closed its personal data site, and many others involved also agreed to voluntarily cease making sensitive personal data available. Some other companies have decided that financial informa-

tion and other related personal data, such as magazine subscriptions, shopping habits, and the like, will not be disclosed on their Web sites. Unfortunately, not all businesses involved in information dissemination are cooperating, and since the arrangement is voluntary, there is no enforcement mechanism. The Internet will, therefore, continue to be a source of personal information for those who aggressively search for it.

Technology allows even the smallest business to create elaborate, interactive sites that attract a good deal of positive attention. Theories abound on what makes a Web site appealing. For some, interactive graphics are the key; others feel it is important to provide browsers with something of value to take with them, such as information or the opportunity to obtain souvenirs of the visit. Some music publishers provide samples of the music they handle, while visual artists may encourage visitors to download images displayed on their sites.

Intellectual Property Protection
The World Wide Web's popularity has raised significant questions regarding the extent of legal and intellectual property protection in cyberspace. One of the earliest cases involved the Church of Scientology and raised the question of whether U.S. copyright laws and state trade secrets laws are enforceable in cyberspace. In that case, a former church member was sued for posting copyrighted material he had received in confidence.

The court held that these traditional forms of intellectual property protection were indeed applicable in cyberspace. In addition, it was held that the Internet access provider could also be exposed to liability merely for permitting the infringing material to appear on the Web. As elsewhere, one who facilitates or aids in the commission of an infringing act may be liable as a contributory infringer. Congress later changed this result for Internet access providers that do not edit the content of posted material so that such providers are no longer exposed to liability.

The Church of Scientology also claimed that the wrongdoers misappropriated the church's trade secrets. It was alleged that the information posted on the Web by the former church member was confidential and protected under trade secret laws. The court rejected this argument, pointing out that once information is posted in cyberspace, it is no longer secret. As a result, anyone downloading that information would not be guilty of trade secret misappropriation.

Certainly, if a protected trade secret is posted on a Web site in violation of an agreement or in breach of one's duty to the owner of the protected information, then the act of posting would be wrongful and the

perpetrator would likely be liable for the improper activity. Cyberspace may be a new medium, but it is still a vehicle of communication and dissemination analogous to broadcasting on TV or publishing in a magazine.

Characterization of Web site names has also presented some vexing problems. It is unclear whether a domain name is merely an address used for the purpose of locating the site or whether that name may be characterized as a trademark. The problem is compounded by the fact that, while there is only one World Wide Web, each trademark is distinguished by the classification of goods or services it covers. There are thirty-four international classes of goods and eight international classes of services. When, for example, the American Bar Association, commonly referred to as the ABA, wishes to register its acronym as its domain name, will it be able to displace the American Booksellers Association—also commonly known as the ABA?

Generally, domain names are registered on a first-come, first-served basis. A procedure has been adopted for resolving conflicts favoring a party that registers its trademark with the U.S. Patent and Trademark Office prior to the second party's reservation of its domain name. This underscores the value of having a registered trademark (see chapter 12).

A number of cases have dealt with trademark issues in cyberspace. In those cases, the applicability of federal trademark law and the question as to which jurisdiction was proper for purposes of litigating the wrongdoing were considered. While the issues have not been definitively resolved, the trend appears to be in favor of extending trademark laws to cyberspace and holding infringers liable when their infringing activity can be accessed.

In one recent case, an enterprising individual residing in Illinois decided to register a number of popular business names as Web site domain names. When the business owners who had previously registered those names as trademarks attempted to obtain their company names as domain names, they were told that they were too late. The entrepreneuring registrant then offered to sell these companies the domain names for their own registered trademarks. The companies filed suit in California, alleging that the appropriation of the protected trademarks for commercial use as domain names by one who lacks authority from the trademark owner is an infringement. The court agreed and suggested that this outrageous conduct would result in liability. Moreover, the defendant in this case objected to being sued in California, stating that he was located in another state and that all his activity actually occurred within his home state. The California court made it clear that since the infringer was trying to "extort" money for sale of the marks from California, the case could be properly brought there.

At least one case appears to have taken a different stance regarding jurisdiction. In that situation, a Missouri restaurant bearing the same name as a restaurant in New York City established a Web site. The New York City company sued, alleging trademark infringement, and the court held that it was unlikely that the Missouri restaurant would cause the kind of market confusion necessary to establish trademark infringement. Once again, though, this is consistent with intellectual property law in general in that it would appear that, even in cyberspace, it will be necessary to establish a "likelihood of confusion" and that the infringer somehow appropriates business from the owner of the protected trademark before liability will be imposed.

A number of other issues have generated Web-based litigation. When Total News, Inc. decided to provide Web surfers the ability to compare data from several news sources—the *Washington Post*, CNN, and the like—certain problems arose. The other services filed suit, complaining that the visual presentation of their material was "framed" within the host's site and that their protected material was, thereby, being retransmitted without their permission. The case was settled before trial with Total News agreeing to refrain from "framing" the protected material and the plaintiffs agreeing to grant Total News licenses to link directly to their sites. This case was settled before trial and not decided by a court. The question of the legality of "linking," where one may jump from one site to another simply by clicking on an identifying icon or phrase, was raised but not resolved.

Internet Advertising

One of the most important distinctions of advertising on the Internet is the way cyberspace advertising reaches consumers. Ads in traditional advertising forums, such as magazines, newspapers, radio, and television, are intended to affect conduct in the future. It is hoped that readers will respond to a survey or purchase the product next time they go shopping. A radio or television advertisement may ask a consumer to actively contact a fulfillment center by phoning in an order. Internet shoppers, on the other hand, can instantaneously make a purchase.

Cyberspace may ultimately become a significant marketplace, but, as of this writing, only a very small percentage of total advertising revenue is collected via the Internet.

Advertisers should be aware that laws adopted to prevent deceptive advertising do apply in cyberspace. The Federal Trade Commission (FTC) requires certain disclosures in connection with certain forms of advertising, but these disclosures are easily lost in cyberspace. A disclosure can

be bypassed when hyperlinking from one site to another and required legends may be buried in text that users may just scroll through. In contrast, when a disclosure appears in a more traditional advertisement, the viewer sees the entire composite, and required disclosures are unlikely to be bypassed.

According to the FTC, it is a good idea to force Web site visitors to click through required disclosures when visiting an advertising site. However, thus far, this policy has only resulted in the FTC announcing that it will sue a Web site designer if that designer knows or should have known that the site violates the law. Users have not been pressed into having to read disclosures if they do not want to. The FTC periodically conducts Internet surf days in conjunction with State Attorneys General.

Some intellectual property practitioners suggest that businesses hire an attorney who has expertise in working with Web sites to conduct a so-called Internet-traffic and Web-content audit. This would include evaluating whether the appropriate permissions to display material have been obtained. For example, if copyrighted material is to be used, has the copyright owner granted permission for the work to be displayed on the Web? If a testimonial is to be displayed, then it is important to get written permission from the individual providing the testimonial.

Internet advertisers also need to determine whether their existing liability insurance covers their activity in cyberspace. Will your business be protected if your Web site crashes?

Since Web advertisements are, by definition, worldwide, it is meaningful to determine whether your site will subject you to liability elsewhere. As noted in chapter 13, comparative advertising is generally permissible and fairly common in the United States; other countries, such as Germany, are far more restrictive in what they permit in a comparative advertisement.

Obscenity

An industry that has been extremely active in cyberspace is adult entertainment. Such sites have proliferated with extraordinary rapidity. Sites include everything from static two-dimensional images and printed matter to interactive, real-time "cybersex." While some attempt has been made to restrict access to adults only, it has not been wholly successful. As a result, the U.S. Congress enacted the Communications Decency Act, and many states followed its lead. This legislation was aimed at, among other things, preventing children from gaining access to sexually explicit material. Owners of adult Web sites immediately filed challenges

to the legislation, and in June 1997, the U.S. Supreme Court, in *Reno* v. *ACLU,* unanimously declared some of the provisions of the Communications Decency Act to be unconstitutional. Justice John Paul Stevens, writing for the court, said:

> It is true that we have repeatedly recognized the governmental interest in protecting children from harmful materials. But that interest does not justify an unnecessarily broad suppression of speech addressed to adults. The government may not reduce the adult population . . . to . . . only what is fit for children.

Several state courts declared similar state legislation to be unconstitutional since a state cannot restrict Web communication that is likely to be transmitted across state lines. In fact, it is often impossible to determine the physical location of a Web site server, and material transmitted on the Web is intended to be communicated throughout all of cyberspace.

The amount of litigation that has resulted from activity on the World Wide Web suggests that care must be taken when establishing your presence in cyberspace. This new dimension gives rise to increased, and often desired, exposure, but the result can be devastating for a small business.

Even the simple act of advertising a product for retail sales could have serious consequences if you are not careful. For instance, even if you have obtained permission to advertise a copyrighted item for sale, you may still not have the right to scan an image of that item into your computer and put it on your Web site. It may be necessary for you to obtain permission to replicate the work in two dimensions before engaging in cyberspace promotional activities.

Downloading and reusing material from other Web sites may also expose a business to liability. *Playboy* magazine has announced that it is developing an invisible electronic "watermark" to place on the images it posts on its Web site in order to discourage anyone from attempting to capture and reuse those images without permission. The company is also going to use a device to police cyberspace in order to locate any of its marked images.

You have to recognize the fact that the Web is worldwide and that your material may find its way into jurisdictions and geographical regions that do not have copyright treaty relations with the United States. In this event, you may find that you have lost control of your protected work. While the World Intellectual Property Organization (WIPO) has

expanded the protection available for intellectual property with the WIPO Treaty of 1996 and the SIPO Performances and Phonograms Treaty, not all countries have implemented these treaties. At this writing, approximately one hundred countries belong to WIPO, yet few have ratified these treaties to expand protection for sound recordings, motion pictures, computer software, and other digitally transmitted literary works. Even when the treaties are in force, there is still some risk since the treaties are limited in scope. Additionally, not all countries can be expected to participate and enact these treaties without reservation. Some countries will certainly remain on the U.S. watchlist since they continue to disregard their current treaty obligations, and there is no reason to believe they will adopt the new WIPO treaties.

Server Protection

Web sites may serve as windows to your company's computer system. If, for example, your business hosts its site on its own server that is networked with your other business computers, hackers may gain access to your entire system. Some safeguards should be taken to prevent improper access and protect your business's valuable trade secrets.

Information you deem to be confidential and sensitive should be encrypted; that is, it should only be available through use of special software. Similarly, your system should always be protected by a password, and that "word" should not be obvious or simple. More sophisticated systems use "firewalls," which are electronic blocks preventing access to all but those who have the proper key. Many businesses now develop and install computer security devices. Consult an expert when designing your Web site in order to take advantage of the latest technology.

The popularity of the World Wide Web has been paralleled by the expanded use of e-mail. E-mail communications have become commonplace within many businesses. Internal, paperless transmissions of important messages throughout an office or plant help facilitate the day-to-day operations. Business handbooks and policy statements should deal with the proper use of e-mail. For instance, it has been held that repeated transmission of sexually or racially explicit e-mail messages by one employee to another may be deemed harassment, and, if not controlled by the employer, may render the employer liable as well. Furthermore, businesses should make it clear to their employees that e-mails sent and received by employees while at work are not confidential.

The external use of e-mail is also quite common, enabling users to transmit complex documents worldwide in a format in which the recipient may edit the document as well as simply review it. Here, too, secu-

rity is an issue to consider. If you are communicating with your attorney or doctor, is that transmission safe from uninvited inquisitors? Once again, there are vehicles available for security, such as encryption.

By proceeding with good judgment and consulting with experienced intellectual property lawyers who have been involved with new technology, you can remain on the cutting edge of cyberspace.

For more information you may wish to visit our Web site at *www.artisticlaw.com*.

CUSTOMER RELATIONS

Just as when dealing with artists, the gallery or craft retailer has certain rights and obligations when dealing with customers. In this chapter, I shall discuss several legal aspects of the relationship between you and your customers. For example, what should you do when you suspect a customer of theft? What is your responsibility to a customer who has left an item with you to be framed, mounted, or restored? What is your liability for misrepresentations made by your salesclerks or other agents? What disclosures must you make, by law, to purchasers of editioned art?

DEALING WITH SHOPLIFTERS

An art gallery that shows very large pieces of artwork and has an elaborate security system is unlikely to have a problem with shoplifters. Craft retailers and art galleries that display small items, however, should be particularly attentive to the possibility of theft.

When you suspect a person of theft, you must be very careful to determine that theft has actually occurred. A businessperson has the right to detain a person reasonably suspected of theft or failure to pay only long enough to investigate the suspected theft. Courts suppose that honest persons should be willing to help clear up any misunderstanding in this short period of time. If you detain a suspected thief against his or her will, you may be liable for false imprisonment. Also, you may not threaten, coerce, or publicly accuse the suspect. In most

states, the suspected thief must be detained before he or she has left the business premises. Of course, if the suspected person has actually stolen goods, there is no liability for having detained the thief.

PROPER CARE OF A CUSTOMER'S ITEM

The term "bailment" defines the legal arrangement where one is lawfully in possession of the property of another. Art galleries and craft retailers that provide framing or mounting or that conduct art restoration are "bailees" of the works in their possession for such services. The owner of the work is the "bailor."

The bailee (gallery or shop) is obligated to take reasonable care of the work while it is in its possession and to return it to the bailor (owner) in at least as good condition as it was in when it was received. If the work is not returned in at least its original condition, the bailee will probably be liable for negligence. The bailee may retain the work until it receives full payment for any services rendered at the bailor's request in connection with that work. This retention of possession is known as a "possessory lien." If the obligation is not paid in a reasonable time, the lien may be foreclosed and the property sold to satisfy the debt. The procedure for perfecting and foreclosing liens varies from state to state, and you should consult with a knowledgeable business lawyer before engaging in this type of transaction.

RESPONSIBILITY FOR YOUR AGENTS

The gallery owner or craft retailer is responsible for making sure customers know the extent of its agents'—its employees'—authority. The relationship between an art gallery or craft retail shop and its employees is covered by the law of "agency," set forth in the Restatement (Second) of the Law of Agency. Under these rules, the employer is known as the "master" and the employee is typically known as the "servant." The master will be held liable for the servant's wrongful acts when they occur within the scope of employment.

If an employee misrepresents the quality, value, or other attributes of a work of art or craft, the gallery or shop is liable to the buyer for the misrepresentation. The employer may ultimately hold the employee responsible for the wrongful act if it was not authorized. Obviously, if the employee is not economically in a position to make good the loss, the employer's rights against the employee may be worthless.

If an employee sells work and absconds with the money received in payment, the gallery or retailer will have recourse against the employee only if he or she can be found and has the resources to cover the loss.

Many employers obtain fidelity bonds on employees who handle money or valuable property. A "fidelity bond" is a guarantee by an insurance company that the company will pay for any loss sustained as the result of wrongful acts of a bonded employee. Your insurance broker should be able to assist you in obtaining bonding.

The gallery or shop's obligation to consumers for the wrongful acts of its employees extends only to those acts that occur within the scope of the employee's authority. Whether an act is considered to be within this scope is determined by the reasonable expectations of the customer and not by the actual authority granted by the employer. Thus, if a gallery or retailer instructs an employee not to extend credit and, in flagrant violation of this rule, the employee consummates a credit transaction, the employer is bound to honor the transaction. Once again, the employee may be liable to the employer for breach of duty, but the innocent purchaser cannot be required to rescind the credit transaction.

Transactions that are obviously outside the scope of an employee's authority will not result in employer liability. For example, a gallery or shop will not be responsible for the acts of an employee who loses his or her temper and assaults a customer, unless the shop was aware of a propensity to commit assaults and retained the employee in a position where his or her volatile temper could lead to customer injury.

DISCLOSURES REGARDING EDITIONED WORK

Dealers in editioned work are obligated by law to disclose certain information to help protect buyers from misrepresentations when buying those works, such as fine-art prints or editioned sculpture. Many states have enacted fine-print statutes; others have enacted "multiples" laws. Generally, these laws require the seller to provide the buyer with a certificate, invoice, or receipt that contains certain specific information regarding the work. The information required customarily includes:

- The name of the artist and the year the art was created
- Whether or not the edition is limited
- The present status of the plate or mold
- Whether the work has more than one edition and, if so, the edition of the work
- The size of the edition
- Whether the edition is posthumous
- Identification of the workshop or foundry where the edition was printed or cast

Most of the statutes also require information on the medium or process used, such as whether the print is an etching, engraving, woodcut, or lithograph, or whether the bronze is hot or cold cast, or whether the dealer does not know. Some states require disclosure of the method of affixing the artist's name to the multiple (whether signed, stamped, engraved, or molded) and provide that, unless disclosed, the number of multiples described as being in a limited edition shall constitute an express warranty that no additional numbered multiples of the same image have been produced. If the edition is limited, further disclosures are required, including the maximum number of releases, both signed and unsigned, the number of proofs allowed, and the total edition size.

Some statutes provide that describing the edition as an edition of "reproductions" eliminates the need to furnish further information. Unfortunately, only a few states, such as Oregon and North Carolina, define "reproduction."

All the states provide that a person violating these disclosure requirements shall be liable for the amount the purchaser paid. All allow for interest from the date of purchase. In the case of a willful violation, in some states, such as California, Hawaii, New York, and Oregon, the purchaser can recover three times that amount. (See appendix B for a list of state statutes.)

16

LIQUOR AND CONTROLLED SUBSTANCE LIABILITY

Think before you pour. Art galleries and craft retailers that serve alcoholic beverages at openings and other social events should be aware of the extent of their legal responsibility for intoxicated guests.

Liability for wrongful acts committed by intoxicated persons was initially imposed only on licensed servers of alcoholic beverages, such as tavern and restaurant owners. Today, however, social hosts and non-commercial providers, such as colleges, churches, hospitals, etc., are also being held liable—and the amount of liability is staggering. In one Michigan case, a tavern owner's insurance company settled a wrongful death claim for over $10 million. An Ohio bar and its owner were sued for $24 million by the widows of two men killed in a head-on collision. In Indiana, Notre Dame University was held liable for $53,000 due to its failure to exercise crowd control at a football game after which a drunken fan assaulted another fan in the parking lot.

Liability is dependent on the serving of alcohol to somebody who is obviously intoxicated or under the legal drinking age. This so-called dram-shop liability grew out of the temperance movement in the United States. In 1859, Wisconsin enacted the first such law, which required tavern owners to post a bond to compensate widows and orphans in the event of wrongful death and to pay all costs resulting from injuries caused by individuals who were drinking. Other states quickly followed suit, and, by the mid-1870s, eleven states had dram-shop laws. Today, most states have statutes regarding alcoholic beverage liability.

Maine's liquor liability act is one of the most comprehensive in the country. Its primary purpose is to prevent "intoxication-related injuries, deaths, and other damages." It specifies liability for negligent or reckless service to minors or to individuals who are already visibly intoxicated when served. There is a ceiling on the total damage award of $250,000, as well as some other procedural safeguards. The law permits those who serve liquor to offer proof of their adherence to what is known as "responsible serving practices," which include attendance at a server-education training course and responsible management policies, procedures, and actions. Laws similar to Maine's have also been adopted in other jurisdictions.

The liability of social hosts and noncommercial providers for the wrongful acts of their guests is a rather recent development. New Jersey was one of the first states in which a host was held liable. The court said that any loss in the conviviality of social gatherings was more than outweighed by the social interest in preventing drunken driving. Since this ruling, almost half of the states have imposed liability on those who do not make their living serving alcoholic beverages.

In some states, art galleries and craft shops that serve alcoholic beverages at openings may be required to obtain liquor licenses. Some states also require an annual fee and others allow a per-event license. Check with the authorities in your jurisdiction before serving alcoholic beverages to the public. You should also check your lease for contractual restrictions. Even if your jurisdiction does not require a license, you may still be subject to liability for the wrongful acts of intoxicated guests. This liability may also extend to those who use or share controlled substances, such as marijuana, cocaine, or prescription pharmaceuticals.

Insurance may be available for art galleries and craft retailers that serve liquor, but because of the increase in litigation, insurance companies have sharply increased their premiums; some have dropped liquor-liability coverage entirely. In some states, such as New Hampshire, Minnesota, and Massachusetts, state-operated insurance pools divide the risk among participating companies so that liability coverage will be available to all commercial servers. It is not clear whether an art gallery or craft retailer would fit into this category. You may wish to contact your insurance broker or state insurance department for more information.

Social host liability is less well defined and somewhat narrower than that imposed on commercial servers. Because the extent of liability is not clear and the risk is quite high, however, prudent individuals and businesses will take some precautions when dispensing alcoholic beverages. Try to ascertain the age of anyone to whom you will be serving an

alcoholic beverage, and ask for identification from anyone who appears to be under the age of twenty-one. It is somewhat more difficult to identify intoxicated guests, but you should refuse to serve anyone who appears to have had too much to drink. You and your staff should circulate among your guests at social functions and try to determine whether anybody has had too much to drink. You should also serve food along with any alcoholic beverage, as food slows down the body's absorption of alcohol.It is also a good idea at any gathering to provide nonalcoholic beverages for those who would prefer them. If a guest appears to be tipsy, you might suggest that he or she switch to the nonalcoholic drink. Individuals who have had too much to drink should be driven home, either by other guests or by taxi. Make the "one for the road" a nonalcoholic beverage.

BUSINESS INSURANCE

The insurance business originated in Lloyd's, a London coffee-house, sometime in the late seventeenth century. Lloyd's was a popular gathering place for seamen and merchants engaged in foreign trade. As Shakespeare pointed out in *The Merchant of Venice*, great profit can come from a successful sea voyage, but financial disaster can follow just as surely from a loss of ships at sea. These merchants knew from past experience that, despite their greatest precautions, such disaster could strike any one of them.

Through their dealings with the Italians, who already had a system of insurance, the merchants had become familiar with the notion of insurance, but there was no organized insurance company in England at that time. So, when these merchants were together at Lloyd's, it became a custom to arrange mutual insurance contracts. Before a ship embarked, the ship's owner passed around a slip of paper that described the ship, its captain and crew, its destination, and the nature of the cargo. Merchants who wished to be insurers of that particular ship would initial this slip and indicate the extent to which they could be held liable. The slip was circulated until the entire value of the ship and cargo was covered. This method of creating insurance contracts was called "underwriting."

Today, the term "underwriting" describes the formation of any insurance contract, regardless of the means employed in consummating it. Lloyd's of London still uses a method similar to that which originated in the coffeehouse, but most other insurance companies secure against loss out of their own financial holdings. The risks covered by insurance have

also changed. The original Lloyd's insurers dealt in maritime insurance only. Now, almost anything can be insured—from a pianist's hands to the Concorde jet.

Although your business may not be as perilous as that of the seventeenth-century merchant, it is not altogether free of risks. Even in rural areas, you may become the victim of burglary, and the forces of nature—fire, flood, earthquake—are undiscriminating in their targets. If you operate out of your home, you may already have homeowner's insurance, but your homeowner's insurance likely will not cover your commercial activities.

The financial success of a business often rests with one primary individual—the owner. The risk of lost earnings through the sickness or accident of an owner or essential employee is far too often overlooked. In addition, the sale of art or craft objects subjects you to virtually unlimited liability to anyone who may be injured by those works, no matter how careful you may have been in handling them. The potential magnitude of what this could cost you makes even the slightest chance of its occurrence a significant risk.

Many of these risks can be insured against through any number of insurance companies; however, public policy will not permit you to insure something unless you have what is called an "insurable interest." To have an insurable interest, you must have a property right, a contract right, or a potential liability that would result in a real loss to you if a given event occurs. This restriction is intended to minimize the temptation to cause the calamity against which you are insured. There is a joke in the insurance industry about two businessmen who meet at a vacation resort. One, when asked about his business, responds that things are "great." His art gallery had a fire and collected $20,000 from the insurance company. The other exclaims, "Think that's good? We suffered a windstorm loss and recovered $50,000!" The first businessman responds, "How do you start a windstorm?"

WHAT IS INSURANCE?

All insurance is based on a contract between the insurer and the insured whereby the insurer assumes a specified risk for a fee, which is called a "premium." The insurance contract, or "policy," must contain at least the following: (1) a description of whatever is being insured (the "subject matter"); (2) the nature of the risks insured against; (3) the maximum possible recovery; (4) the duration of the insurance; and (5) the due date and amount of the premiums. When the amount of recovery has been predetermined in the insurance contract, it is called a "valued"

policy. An "unvalued" or "open" insurance policy covers the full value of property up to a specified policy limit.

Insurance companies spread the risk among those subject to that risk through the amount of premium paid by each insured. First, the insurance company obtains data on the actual loss sustained by a defined class within a given period of time. State law regulates how the company defines the class. An insurance company may, for example, separate drivers with many accidents from drivers with few. Next, the company divides the risk equally among the members of the class. Then the company adds a state-regulated fee for administrative costs and profits. Finally, the premium is set for each individual in proportion to the likelihood that a loss will occur to him or to her.

Besides the method of determining premiums, state insurance laws usually specify the training necessary for agents and brokers, the amount of commission payable to them, and the kinds of investments the insurance company may make with the premiums.

The Contract

Even the documents that a company uses to make insurance contracts are regulated differently from state to state. Sometimes the state requires a standard form from which the company may not deviate, especially for fire insurance. A growing number of states stipulate that all forms must be in "plain English"—that is, there must be a specific average number of syllables per word and average number of words per sentence. Because of a federal ruling that insurance contracts are fraudulent if they exceed certain maximum averages, insurance companies have been forced to write contracts that an average person can understand (nevertheless, only insomniacs read insurance forms).

One frequent result of the language in which most insurance contracts are written is that the signed contract may differ in some respect from what the agent may have led the insured person to expect. If you can prove that an agent actually lied, the agent will be personally liable to you for the amount of promised coverage. Every state has an agency responsible for regulating insurance carriers operating within the state.

Most often, the agent will not lie but will accidentally neglect to inform the insured of some detail. For instance, if you want insurance for transporting work being returned to the artist, the agent may sell you a policy that covers transport only in public carriers—although you intended to rent a vehicle and transport the work yourself. In most states, the courts hold that it is the duty of the insured to read the policy before signing. If you neglected to read the clause that limits coverage

to a public carrier, you would be out of luck. Failure to read the policy is considered no excuse.

In other, more progressive states, this doctrine has been considered too harsh. These states will allow an insured to challenge specific provisions in the signed contract to the extent that they do not conform to reasonable expectations resulting from promises that the agent made. In the preceding example, it might be considered reasonable to expect that you would be insured when transporting art or crafts in the gallery's custody. If the agent did not specifically bring your attention to this limitation in the contract, odds are that you would have a good chance of not having that limitation apply to you in the event of a loss. One reason is that it is common for the insured to receive the policy only after the premium is paid, or only after a specific request is made.

Other states follow a different approach for contract interpretation and attempt to ascertain the intention of the parties. The first step in interpreting an insurance policy is to examine the text and context of the policy as a whole. If, after that examination, two or more conflicting interpretations remain reasonable, the ambiguity is resolved against the insurer. A court in these states will assume that parties to an insurance contract do not create meaningless provisions and will favor the interpretation that lets all provisions have meaning.

Of course, I would not advise waiting for an agent to point out unexpected variations, even in the most liberal state. You should read the contract with the agent. If it is unintelligible, ask the agent to list on a separate sheet all the important aspects before signing, and then keep that sheet with the contract.

Reforming the Contract

After the insurance contract has been signed, its terms can be reformed (revised) only to comply with the original agreement, from which the written contract may somehow have deviated.

Let's consider the case of a woman who inherited a pearl necklace. An appraiser, apparently hoping for a large fee, misled her and told her the pearls were genuine and, therefore, worth $60,000. Before having them shipped from the estate, the woman obtained insurance on them in the amount of $60,000 and paid a premium of $2,450. The description of the subject matter stated that the pearls were genuine. When the pearls were ruined after they arrived at the delivery terminal but before the woman received them, she tried to collect the $60,000.

In the course of the investigation of the accident, it was discovered that the pearls were not genuine but cultured pearls, and worth only

$61.50. Of course the insured could not collect $60,000 because no genuine pearls were lost or damaged. The worst of it was that she could not collect even $61.50 because the policy did not cover cultured pearls. The court emphasized that for reformation of the contract to be granted, there must have been something either included or omitted contrary to the intention of both parties. In this case, neither party ever intended to insure cultured pearls, so the court held that there never was an agreement and refused to create a contract insuring cultured pearls.

You might think that, in this case, the insured would at least get back her premium. She argued this, but lost again. The court reasoned that had the pearls been lost in transit instead of being destroyed, the actual value of the pearls would never have come to light. Therefore, the insurance company had indeed assumed the risk of paying out $60,000 and thus was entitled to the premium.

OVERINSURING AND UNDERINSURING

The outcome of this case does not mean that if an insured accidentally overvalues goods, he or she will lose coverage. Had the pearls been genuine but worth only $20,000, the woman would have recovered $20,000. Overinsurance does not entitle one to a recovery beyond the actual value of the goods. The actual value is the amount of insurable interest. To allow a recovery greater than the insurable interest would be to allow people to gamble with insurance policies.

Because, at best, you can only break even with insurance, you might think it would be profitable to underinsure your goods, pay lower premiums, and lose only if the damage exceeds the policy maximum. This has been tried without success.

An insured stated the value of his unscheduled property as $9,950 and obtained insurance on that amount. ("Unscheduled property" refers to an undetermined collection of goods—for example, all a person's clothes and furniture—that may change from time to time.) A fire occurred that caused at least $9,950 worth of damage. The insurance company investigated the claim and determined that the insured owned at least $36,500 in unscheduled property. The company refused to pay on grounds that the insured obtained the insurance fraudulently. The court agreed with the insurance company, stating that the intentional failure to communicate the full value of the unscheduled property rendered the entire contract void. Therefore, the insured could not even collect the policy maximum. All he could hope for at best would simply be to get his premiums back.

Although at first glance this decision may seem harsh, its ultimate fairness becomes apparent with a little analysis. The chance of losing $9,950 out of $36,500 is greater than the chance of losing $9,950 out of $9,950 simply because most accidents or thefts do not result in total losses.

The courts have various criteria for determining whether or not an omission or misstatement by the insured renders a policy void. In all cases, however, the omission or misstatement must be intentional or obviously reckless, and must be material to the contract. "Materiality" is determined by the degree of importance that the insurance company ascribes to the omitted or misstated fact. If stating the fact correctly would have significantly affected the conditions or premiums that the company would have demanded, then the fact is material. In the preceding case, had the full value of the unscheduled property been stated, the insurance company would either have required that the full value be insured or that a higher premium be paid for the limited coverage. Thus, the misstatement was clearly material.

UNINTENTIONAL UNDERVALUING

Many insurance contracts allow some undervaluation where it is not material and not intentional. This provision is designed to protect the insured from inflation, which causes property to increase in replacement value before the policy's renewal date. Considering the inflation rate, it is wise to reexamine your coverage each year.

A so-called coinsurance clause generally provides that the insured may recover 100 percent of any loss up to the face value of the policy, provided the property is insured for at least 80 percent of its full value. For example, if a gallery worth $100,000 was insured for $80,000 and suffered a $79,000 loss from a covered casualty, the insured would recover the full amount of the loss, or $79,000. If the gallery was insured for only $50,000, a formula would be used to determine the amount of recovery: Divide the amount of insurance coverage by the total value of the property and multiply the resulting fraction by the loss.

For example:

$$\frac{\$ \ 50,000 \ (\text{insurance})}{\$100,000 \ (\text{value of business})} \times \$79,000 \ (\text{loss}) = \$39,500 \ (\text{recovery})$$

You can see why it is important to carry insurance on at least 80 percent of the value of your property.

Scheduling Property

All insurance policies are limited to certain defined subject matter and to losses caused to that subject matter by certain defined risks. Once the risks are recognized, it is a simple matter to decide whether to insure against them or not. However, correctly defining the subject matter of insurance is tricky business. Mistakes here are not uncommon and can result in any one of us finding ourselves uninsured—like the woman with the pearl necklace.

The typical insurance policy will stipulate various exclusions and exemptions. For example, most homeowner and auto insurance policies cover personal property but exclude business property. If a gallery owner keeps artwork at home for personal enjoyment, are those pieces personal or business property? The answer depends on whether the person ever sells or displays any of these items. If any are sold or displayed, they may be considered business property.

In order to avoid a potentially tragic loss because of a technicality, the gallery owner may simply schedule the pieces that are held for personal enjoyment. "Scheduling" is a form of inventorying in which the insured submits a list and description of all pieces to be insured with an appraisal of their value. The insurer assumes the risk of loss of all scheduled works without concern as to whether they pertain to the business or not. Insurance on scheduled property is slightly more expensive than that of unscheduled property.

Many battles occur between the insurer and the insured over the value of objects stolen, destroyed, or lost. In anticipation of such battles, maintain records of sales to establish the market price of your art and craft work and keep an inventory of all works on hand. The value of art or craft work must be determined by an expert in the field—both when the policy is obtained and after a loss—but this will not always prevent the insurance company from contesting the scheduled value.

WHAT AND WHEN TO INSURE

Life and health are of the utmost value and should always be insured. Material goods should, of course, be considered for insurance as well. You should also consider whether it is appropriate for your gallery or shop to obtain "business interruption" insurance or "business overhead expense" insurance. Business interruption insurance is designed to reimburse lost earnings resulting from business interruption caused by specified risks, such as fire, storms, and the like. Business overhead expense insurance provides coverage for the loss or injury of an identified "key person." Customarily, there is a thirty-day waiting period after the loss or injury

before payments begin, and then a period of approximately two years within which overhead, such as salaries, rent, utilities, and the like, are reimbursed.

Four factors should be weighed to determine whether or not to obtain insurance. First, you must set a value on that which is to be insured. Material goods are valued according to the cost of replacement. If you keep a large inventory of art or crafts or if you own expensive fixtures, such as display cases, they should probably all be insured. The most elementary way to determine whether the value is sufficiently high to necessitate insurance is to rely on the pain factor: If it would hurt to lose it, insure it.

Second, you must estimate the chances that a given calamity will occur. An insurance broker can tell you what risks are prevalent in your type of business or in your neighborhood. You should supplement this information with your personal knowledge. For example, you may know that your gallery is virtually fireproof, or that only a massive flood would cause any real damage. Although these facts should be weighed in your decision, you should not be guilty of audaciously tempting fate, for, as the great tragedians have recounted, to scoff at disaster is to invite it. And if the odds are truly slim but some risk is still present, the premium will be correspondingly smaller in most cases.

The third factor is the cost of the insurance. Bear in mind that insurance purchased to cover your business is tax deductible. That means if you pay tax at a rate of 31 percent, Uncle Sam is theoretically paying for 31 percent of your premium.

Fourth, you must determine whether you are legally obligated to obtain certain insurance. For example, commercial leases customarily require the tenant to maintain liability insurance in specific amounts, with the landlord as an identified insured party. There may be a comparable provision in your mortgage. Some state artist-gallery consignment laws require the art gallery or craft retailer to insure the consigned work.

KEEPING COSTS DOWN

As I have already explained, the premiums charged by an insurance company are determined by state law. Nonetheless, it still pays to shop around. Insurance companies can compete by offering different packages of insurance and by hiring competent agents to assist you in your choice.

If there are enough art galleries, craft retailers, or similar businesses in your area, it may be possible for you to form a co-op insurance fund. To do this, you must estimate the total losses your co-op would sustain in the course of a year. Each member contributes a pro rata share, and the

money is put into a bank or other investment to collect interest. If a disaster occurs and the losses are greater than the fund, each member must contribute an additional amount to make up the difference. If there is money left over, it can be applied to the next year's coverage, thereby reducing the premiums for that year. Co-op insurance is cheaper than conventional insurance because it eliminates the insurance agents' commissions and the insurance company's profit, but before you form a co-op insurance fund, contact an attorney to be sure you comply with the regulations in your state.

PRODUCT LIABILITY

Although art galleries and craft retailers probably rarely think of themselves as liable for defective products, they may be. Every year, seemingly harmless works of art and craft are responsible for numerous injuries. For example, a glass artist sold a luminaria, beveled on one side, to a purchaser who hung it in the window as a sun catcher. Because of the bevel, the glass acted as a prism and started a fire that resulted in more than $500,000 in damage. Both the artist who created the work and the gallery that sold it were held responsible for the loss.

To understand the present-day liability law, it is useful to examine its roots. In 1804, a craftsman named Seixas went to a warehouse to buy some braziletto wood, supposedly a valuable wood. Mr. Woods, the warehouseman, sold Seixas peachum wood instead, which is virtually worthless. Neither party, apparently, knew the difference between braziletto and peachum. When Seixas discovered the error, he tried to return the worthless wood in exchange for braziletto or for a refund of his money. Woods refused because he had already given the money to the original owner of the wood. Seixas sued Woods and lost. Even though Woods had written braziletto on the invoice, he never warranted the wood as such.

This case can be aptly summed up in the Latin maxim *caveat emptor:* Let the buyer beware. This maxim was proven true time and again in both English and American court cases. Gradually, however, the pendulum began to swing the other way, and now the rule is *caveat seller:* Let the seller beware.

One of the harshest rules of early product liability cases was that only individuals who dealt with each other could have rights against each other. Injured consumers could not sue manufacturers unless the defective products were purchased directly from them; consumers could sue only the retailer with whom they had traded. So early on, the pattern was established that dealers were liable for injuries sustained as a result of defective products they sold. The current product liability law holds the producer as well as the seller of a product liable.

An art gallery or craft retailer might have the right to seek indemnification from the artist or craftsperson who created the defective work, but there are some practical limitations. For example, if the artist is insolvent or cannot be found, an indemnification claim may be worthless. Similarly, if the defect cannot be traced to the artist or maker—for example, a crack in a piece of pottery that could have occurred in the gallery or shop—no indemnification will be available.

The seller, regardless of his position in the chain of distribution, can be sued if he is negligent or if the product is "inherently dangerous." The courts struggled for some time over just what was and what was not inherently dangerous. Justice of the Supreme Court Benjamin Cardozo, in a landmark case involving the safety of an automobile, ruled that a product was inherently dangerous if injury to the owner was predictable in cases where the item was defective. Almost anything can be injurious if defective. Negligence suits have been brought for such seemingly innocuous items as a glazed mug, an art-glass vessel, and a piece of kinetic art.

This shift of the burden of responsibility from the buyer to the seller was a natural response to several factors. First, as products became increasingly more complex, it was no longer true that the buyer and seller were equally knowledgeable or ignorant. Second, it was felt that businesses were large enough to bear the immediate losses and ultimately could spread the risk over an even broader sector of society.

Because the majority of the products on today's market are mass produced by large manufacturers, the present rule reflects the economic reality of industry. Although this is not the economic reality of the fine arts and craft markets, you must learn to cope with these laws in a climate of litigious consumers and generous juries. It is better to learn about these problems while you can still protect yourself than when it is too late.

TYPES OF LIABILITY

In every product liability case, the plaintiff must prove that: (1) some injury occurred to him or her; (2) the injury was caused by some defect in the product; and (3) the defect was present in the product when the

defendant had control over it. You cannot control the first two conditions: Once a person takes possession of the product sold by you, you cannot stop him or her from being injured. You can, however, try to control the third condition by making sure that any item you sell is without defect.

There are two kinds of defects: mechanical defects, such as loose screws, faulty component parts, and so on; and design defects, such as instability, flammability, toxicity, tendency to shatter, etc.

Liability for Mechanical Defects

The scrupulous attention to detail that is usually characteristic of handcrafted goods almost precludes the possibility of a mechanical defect. If there is a mechanical defect, it will most likely occur in a component produced by someone else.

For example, a stained-glass lamp might contain a faulty electrical circuit that could cause serious injury to a user. Such a defect would be virtually impossible to detect, but, under the current rule of "strict liability," followed by a majority of the states, you can be held liable for defects that could not have been discovered or prevented by human skill, knowledge, or foresight. In this case, your protection is either insurance or your ability to sue the artist for indemnification, if that person can be found and is solvent.

If the right types of tests are made, many defects are detectable before an accident occurs. The courts have held that manufacturers (corporate or individual) have a duty to inspect and test their goods. Failure to adequately test has been held reason enough to impose large awards of punitive damages in addition to the actual damages.

Sophisticated testing procedures might prove to be too expensive for art galleries or craft retailers, but it would be prudent to require the artist or craftsperson to provide you with test results, if possible. I also advise you to design the best test you can for whatever you sell, even if it is only a good tug here and there and, most importantly, a record of the test and its result. This may serve to prove that you attempted to fulfill your duty to test the product. While this precaution might not protect you from product liability, it may result in reducing, if not eliminating, punitive damage awards against you. Rarely can an injured plaintiff prove that a defect was present when a product was purchased but must rely instead on inferences from the accident itself. If the jury is convinced that there is more than a fifty-fifty chance that the defect was there when the product was bought, the plaintiff will probably win But, if you come into court with a record of tests on your products, the odds might shift in your favor.

Besides keeping records of your tests, you should also keep records of your purchases of materials and devise some method of identifying the components in your product. That way, if you are sued for a defect in a component part, you can pass the liability on to the party really at fault. For example, if a stained-glass window collapses because the camming is inferior, you might be able to pass your liability on to the manufacturer of the defective cam.

Design Liability

Design defects can be divided into two categories: those that are a violation of a statute and those that are not. A 1959 case contains a good example of how far a court might go in defining a design defect not already defended by statute. A rather obese woman entered a store and sat in a chair of contemporary design that the store had on display for sale. The back of the chair curved elegantly into the seat, which in turn curved down and around to form the base of the chair. It was along these serpentine curves that the overweight customer slid onto the floor. The injury to her pride was aggravated by an injury to her spine. The court held that the shape of the chair was defective and awarded her $25,000 in damages.

In cases to determine liability for defective design, the courts have usually adhered to a common-sense criterion: If the product conforms to the state of the art when it was made, it will usually not be held defective. The state-of-the-art standard is the measure of how far technology in the field has advanced. The state-of-the-art standard is not the same as industry-wide standards. Industry-wide standards may be introduced in evidence, but these cannot be assumed to assure due care or adherence to state-of-the-art standards. The law will not allow an industry to adopt careless practices in order to save money or time when better, more protective methods are available.

A design may be defective if it does not meet the standards set forth in a statute. Some products are also covered by consumer protection law. A violation of these laws may carry criminal sanctions. In some jurisdictions, consumers injured by a product have proven their case merely by proving that a statute was violated in the production or sale of the product. The manufacturer then bears the burden of establishing that the injury was not the result of the statutory violation, which would be almost impossible in cases where the law had been enacted to prevent the very type of injury claimed. For example, putting small, lovely fastener beads on infants' toys in violation of state child safety laws for such toys would expose the toy maker, as well as the dealer who sold the toy, to liability if an infant choked on the beads.

Federal Laws

In addition to state legislation, there are at least three federal laws regarding liability that directly affect artists and craftspeople. The first is the Hazardous Substance Labeling Act, as amended by the Child Protection Act of 1966 and the Child Protection and Toy Safety Act of 1969. These statutes were passed in response to the staggering number of injuries and poisonings each year of children under age fifteen. Under the Hazardous Substance Labeling Act, as amended, the Federal Trade Commission (FTC) is empowered to name any potentially dangerous substance a hazardous substance. Such substances may not be used in any product that a child may have access to—that is, no amount of use or abuse by a child should make the product unsafe. Presently banned under this Act, for example, are jaquirty beans used in necklaces, jewelry, and dolls' eyes. (For a list of other hazardous substances, you should consult your local office of the FTC. The FTC's Web site address is: *www.ftc.gov/*.)

The second federal statute is the Flammable Fabrics Act. This statute empowers the FTC to establish appropriate standards of flammability for fabrics used in clothing and household products, including children's toys.

Finally, there is the Consumer Product Safety Act, a statute that empowers the FTC to regulate the composition, content, and design of consumer products, including works of art and craft. For example, the FTC has regulations for the use of architectural glass in doors, windows, and walls, and has banned the use of any lead-based surface coating materials (such as lead paint). This is a very volatile issue, and artists and craftspeople should check with the FTC to determine whether the materials they use in their work are subject to regulation. Galleries and dealers should obtain representations from the artists and craftspeople with whom they deal regarding their compliance with the laws. Although this may not exempt you from liability if, for example, the artist or craftsperson lies, it will likely prevent the imposition of punitive damages.

IF YOU ARE HELD LIABLE

If you are held liable for a defective product, you may in turn seek reimbursement from the artist or craftsperson for the amount paid in damages. This may involve another expensive lawsuit, and, if the person you bought the work from is broke, you are out of luck. There are two things you can do to protect yourself. You can incorporate (see chapter 1), or you can obtain liability insurance.

In general, liability insurance is affordable for the small business. Consult your insurance broker or agent to determine the rates in your

region. Many trade associations provide product liability insurance to their members for reasonable prices. Each dealer must then evaluate this cost against the risks of a lawsuit. You should know that the majority of these suits are settled or adjudicated for more than $100,000. You can claim the cost of this insurance as a business expense for tax purposes. Given these factors, if there is any reasonable expectation that a purchaser of your product could sustain personal injury from it, you should seriously consider obtaining product liability insurance.

Clearly, the area of product liability has evolved to a point where galleries and craft retailers are being held liable for injuries caused by their defective products. The doctrines appear to have evolved with an eye toward large businesses and mass-produced items, but the rules are applied with the same vigor to small galleries and craft retailers. Since a single lawsuit could ruin a small business, it is important to be aware of the potential risks involved and to take the necessary precautions.

RENTING COMMERCIAL SPACE

Although some art and craft sales are made from a dealer's home, the vast majority of work is sold through galleries or shops. If you are just starting out, you will likely need to rent commercial space. The terms and conditions of a commercial lease are much more subject to negotiation and pitfalls than residential leases, which are more tightly regulated in most states. Consult an experienced attorney before signing a commercial lease. The following are some of the things you will want to discuss together.

TERMS OF THE LEASE

The exact space to be rented should be specified in the lease in detail. Determine whether there is a distinction between the space leased and the actual useable space. Often tenants are required to pay rent on commercial space measured from "wall to wall," though after the area is built out, the resulting useable space may be significantly smaller.

If your space is in a shopping center and you share responsibility for common areas with other tenants, these responsibilities should be explained. Will you be responsible for cleaning and maintaining them, or will the landlord? When will the common areas be open or closed? What other facilities are available to you, such as restrooms, storage, etc.?

Another important item to specify is the cost. Will you be paying a flat monthly rent or one that will change based on your earnings at the location, as is often the case when stores lease space in a shopping center? Is there an escalator clause that will automatically increase your rent

based on some external standard, such as the Consumer Price Index, or the like? Evaluate the cost of the space by comparing it with similar spaces in the same locale. Do not be afraid to negotiate for more favorable terms.

If the space you are renting is in a mall that has an "anchor" tenant—for example, a major department store—determine whether your proximity to that tenant is important to your business. If so, you should negotiate for a provision that enables you to terminate your lease if the anchor tenant leaves and is not replaced by a comparable business.

Also, consider the period of the lease. If, for example, you are merely renting a booth at a trade show, you are concerned with only a short term. On the other hand, if you intend to rent for a year or two, it is a good idea to get an option to extend, because when you advertise and promote your business, your location is one of the things you will be telling people about. Moving can cause a lot of problems with the forwarding of mail and changing of telephone numbers. Besides, if you move every year or two, some customers may feel that you are unstable, and infrequent customers may not know where to find you after the lease period ends—worse still, they may find a competitor in your old space.

Long-term leases are recordable in some states. Recording, where permitted, is generally accomplished by having the lease filed in the same office where a deed to the property would be filed. (Check with a local real estate title company or real estate attorney for the particulars in your state.) It is a good idea to record your lease if you can, because then you will receive legal and other notices that are related to the property.

Find out whether or not there are restrictions on the activity you wish to perform on the leased premises. For example, the area may be zoned so as to prohibit you from engaging in retail sales. Insist on a provision that puts the burden of obtaining any permit or variances on the landlord. If you are responsible for permits and variances but are unable to obtain them, you should be able to terminate the lease without penalty.

Shopping malls frequently have restrictions in their leases designed to prohibit competitive operations. You should determine whether your gallery or craft retail store will sell merchandise that is also available from other stores in the same complex. Be clear about the scope of coverage. For example, craft retailers often handle wearable art and jewelry, which may run afoul of a prohibition against competitive sale of "upscale" clothing handled by boutiques. Do not sign a lease that will restrict you from opening another shop close to the one being rented.

Does the lease have restrictions on the time or location for making or accepting deliveries? If your business requires that you ship or receive

large, bulky items, your lease should contain a provision that will give you the flexibility you need.

Also, be sure the lease permits you to use any sign or advertising on the premises, or spells out any restrictions. It is not uncommon, for example, for historic landmark laws to regulate signs on old buildings. Some zoning laws prohibit signs in windows or in front of a building.

WHO PAYS FOR WHAT?

You should also be aware that extensive remodeling may be necessary for certain spaces to become suitable for your use. If this is the case, it is important to determine who will be responsible for the costs of remodeling. In addition, it is essential to find out whether it will be necessary for you to restore the premises to their original, preremodeled condition when the lease ends. This can be expensive or, in some instances, impossible.

The Americans with Disabilities Act (ADA) of 1990 requires places of public accommodation to be reasonably accessible. The law is broadly interpreted and includes virtually every form of business. The term "reasonable accommodation" is not precise, and thus it is important to determine what must be done in order to fulfill the requirements of this federal statute. Typically, approximately 25 percent of the cost of any covered remodel must be allocated to items that aid accessibility. These would include, among other things, levered door openers, Braille signs, larger bathroom stalls, wheelchair ramps, approved disability accessible doors, elevators, and the like. You should determine whether the cost of complying with the ADA will be imposed on the landlord, the tenant, or divided.

If you need special hookups, such as water or electrical lines, find out whether the landlord will provide them or whether you have to bear the cost. Of course, if the leased premises already have the necessary facilities, you should question the landlord to determine whether their cost is included in the rent or is paid separately.

In some locations, garbage pickup is provided by the municipality, but often renters are responsible for their trash disposal. In commercial areas, this can be quite expensive, so this expense should also be addressed in the lease.

Customarily, the landlord is responsible for the exterior of the building. The landlord is obligated to make sure the building does not leak during rainstorms and that it is properly ventilated. Notwithstanding this fact, it is important that the lease specifies who is responsible if, for example, the building is damaged and some of your inventory or fixtures

are damaged or destroyed. Will you have to take out insurance for the building, as well as its contents, or will the landlord assume responsibility for building insurance?

You should, of course, have your own liability policy for accidental injuries or accidents that occur on your leased premises. Find out whether you are also obligated to obtain liability insurance for injuries caused in portions of the building not under your control, such as common hallways and stairwells. You may also wish to have business-interruption insurance to cover your losses if, for example, your business is shut down by a natural disaster, such as an earthquake, hurricane, or tornado (see chapter 17).

SECURITY AND ZONING

A good lease will contain a provision regarding security. If you are renting space in a shopping complex, it is likely that the landlord will be responsible for external security, although this is not always the case. If you rent an entire building, it is customarily your responsibility to provide whatever security you deem important. Check that the lease will permit you to install locks or alarm systems if you are interested in having them.

Examine a potential business location carefully to determine exactly what you can do on the premises and whether the landlord or municipal rules will allow you to use the location for your intended purpose. If you plan to use the rental space as both your personal dwelling and your business location, consult your attorney first. The zoning laws in some jurisdictions permit individuals to live in only certain types of industrially zoned buildings, such as warehouses. Some jurisdictions permit a limited range of commercial activity in residentially zoned areas—for example, light manufacturing businesses, such as a craftsperson's or artist's studio; or professional services, such as a lawyer's, doctor's, or accountant's office. Rarely will these zoning exceptions permit ongoing retail activities.

SECURITY DEPOSITS

When the lease is first executed, landlords will often require new tenants to pay the first month's rent, the last month's rent, and a security deposit. Some state laws require landlords to keep security deposits in a special trust account during the term of the lease. These funds are available to the landlord if the tenant injures the property during the lease or fails to leave the premises in proper condition. Tenants who fulfill all of their obligations under the lease should be entitled to refunds of their deposits when their leases expire.

You should try to negotiate for the landlord to pay interest on all monies held as security, as well as on the prepaid last month's rent. Some states require interest to be paid on security deposits.

Most commercial leases require the tenant to pay and be responsible for all utilities. You should make these arrangements directly with the utility companies. The landlord should not be involved. Because public utilities are tightly regulated, it is highly unlikely that any negotiation between you and the public utility will be fruitful regarding deposits, rates, fees, or contractual arrangements.

LATE RENT

Most leases require the tenant to pay rent at the beginning of each month. Customarily, a lease will impose a penalty on the tenants for a late rent payment. You should try to negotiate for a fairly long grace period—ten or fifteen business days—before your rent is deemed late. Generally, the late charges are called "service charges" or something similar to avoid their being characterized as penalties or interest, either of which are subject to specific rules regarding disclosure and amount.

It is essential that every item agreed upon between you and the landlord is stated in writing. Many state laws provide that a long-term lease is an interest in land and can be enforced only if in writing. The writing may consist of several documents. For example, some shopping malls use a "master lease," which governs the rights and responsibilities of all tenants, as well as an individual lease, which deals only with the issues unique to the specific rental space. Landlords may also add rules and regulations to the lease that are binding on all tenants regarding, for example, parking, waste disposal, common areas, and the like.

TAX

Like all businesses, galleries and craft retailers must pay taxes on all income, whatever the source or form, whether ordinary income or capital gains. This chapter will focus on federal income tax. You should consult with a tax professional to determine state and other local tax liability, as well as your responsibility to collect and pay sales tax.

If you are doing business as a sole proprietor, you will report your business income on your personal return. A partnership files an informational return, and the partners report their proportional shares of profit or loss on their personal returns. Corporations are required to pay income tax on their taxable income; the shareholders/owners pay taxes only on the dividend income and salary they receive.

CAPITAL GAINS

"Net capital gain" is defined by the Internal Revenue Code (IRC) as the excess of net long-term capital gain (i.e., the excess of long-term capital gain over long-term capital losses) over net short-term capital losses (i.e., the excess of short-term capital losses over short-term capital gain). Thus, depending on the taxpayer's other gains and losses, a capital gain generally occurs when he or she sells or exchanges at a gain a capital asset held for more than one year. Capital losses are first used to offset capital gains in the year incurred. Any additional capital losses are deductible from ordinary income up to a maximum amount of $3,000 per year, although any excess losses can be carried forward to the following taxable year.

Traditionally, capital gains were taxed at low rates, creating an incentive to characterize income as capital gains rather than ordinary income. Today, taxpayers in the 31 percent tax bracket realize an 11 percent tax savings on long-term capital gains income. All other taxpayers, who fall within the 20 percent tax bracket, pay the same rate on both capital gains and ordinary income.

Because galleries and craft retailers deal almost exclusively in inventory, you generally will not realize capital gains income from your business operations. You might, however, realize a capital gain if a capital asset other than inventory is sold at a profit—for example, buildings, vehicles, or fixtures.

KEEPING TAXES LOW

Income in Installments and Deferred Payments

One way a business can spread income is to receive payment in installments. Care must be taken with the mechanics of this arrangement. If a business sells a product for a negotiable note due in full at some future date, or for some other deferred-payment obligation that is essentially equivalent to cash or that has an ascertainable fair market value, the business may have to report the total proceeds of the sale as income realized when the note is received, not when the note is paid off with cash. However, the IRC enables a taxpayer who sells property with payments received in successive tax years to report the income on an installment basis if the sale is properly structured. Under this method, tax is imposed only as payments are received. Check with your CPA for details.

Someone in a high tax bracket might wish to defer income until the future. For example, a commissioned salesperson could obtain an agreement from his or her employer that commissions paid would not exceed a certain amount in any one year, with the excess to be carried over and paid in the future. This would result in tax savings if, when the deferred amounts were finally paid, the salesperson were in a lower tax bracket.

There are drawbacks to deferred payments. These include the possibility that the party owing the money may not be willing to pay interest on the deferred sums and the possibility that that party could go broke before the debt is fully paid. One should consider these risks carefully before entering into a contract for deferred payments, because it might be quite difficult to change the arrangement if the need should arise.

Employee Compensation

For those who are doing business as C, or regular corporations (see chapter 1), payment of employee compensation is actually one of the most effective ways to minimize or eliminate double taxation. Rather than paying out corporate earnings to shareholders/employees as nondeductible dividends, the corporation can pay out high salaries and receive a business-expense deduction for the wages paid. Although an S corporation is not saddled with the double tax, the shareholders of an S corporation still benefit from a deduction for employee compensation because it decreases taxable income.

This deduction provides a potentially large loophole in the IRC, which Congress and the courts have all but closed by placing a limit on the amount of deduction—only that which is "reasonable compensation" may be deducted as a business expense. Reasonability, as always, depends on all the circumstances of the particular case. The courts consider factors such as the nature of the job, the size and complexity of the business, prevailing rates of compensation, the company's profitability, the uniqueness of the employee's skills or experience, the number of hours worked, the employee's salary as compared with the salaries of coworkers, general economic conditions, and the presence, absence, and amount of dividends paid.

The IRS frequently audits closely held corporations to determine whether they are attempting to avoid income tax by paying excessive salaries to shareholders/employees. Although most challenges are to salaries and benefits for stockholders, excessive compensation paid to a nonstockholder employee also has been successfully challenged by the IRS. If a salary is found to be excessive, no deduction will be allowed for the part of the payment that is excessive. Even though the employer cannot deduct the full amount paid, the employee must report and pay tax on the full amount received.

Usually, a new business is more concerned with underpayment than overpayment. Employees may work long, hard hours with little compensation in the hope of a brighter future. The IRS realizes this. In later years, when the business is profitable, employees can be compensated for the underpayment of former years by additions to their salaries. The base salaries and additional amounts must be reasonable in light of the past services performed and the compensation already received.

Compensations may also be fixed as a percentage of profits or earnings. Contingent plans of this nature may result in low salaries in lean years and above-average salaries in good years. The IRS accepts this as well, as long as, on the average, the salaries are not unreasonable; of

course, some premium is reasonable due to the risk assumed by the employee who accepts such a plan. Contingent plans are suspect, however, when used for owners/employees, because they can be used to avoid dividends in good years. A shareholder's/employee's reward for an increase in business should be a reasonable salary and increased dividends.

Spreading Income among Family Members

Business owners in high tax brackets may wish to divert some income directly to members of their immediate families who are in lower tax brackets by hiring them as employees. Adding dependent children to the payroll can result in a substantial tax savings because their salaries can be deducted as a business expense, and, at the same time, you are not required to withhold Social Security from the children's wages.

In addition, your child can earn the amount of the standard deduction without any tax liability (note that the rules are different for unearned income). You, as the taxpayer, can still claim a personal dependency exemption for the child if you provide over half of his or her support. The child, however, may not claim a personal exemption if he or she can be claimed by the parents on their tax return.

This salary arrangement is permissible as long as the child is under nineteen years of age or if the child is between the ages of nineteen and twenty-four and is a full-time student. There are three other restrictions on this arrangement:

1. The salary must be reasonable in relation to the child's age and the work performed.
2. The work performed must be a necessary service to the business.
3. The work must actually be performed by the child.

A second method of transferring income to members of your family is the creation of a family partnership. Each partner receives an equal share of the overall income, unless the partnership agreement provides otherwise. The income is taxed once as individual income to each partner. Thus, if you are the parent who heads a family business, you can break up and divert your income to your family members so that it will be taxed to them according to their respective tax brackets. The income received by children may be taxed at significantly lower rates, resulting in more income reaching the family than if it had all been received by the parent, who is presumably in a higher tax bracket than the children. The law stipulates, however, that if a child is under fourteen years of age

and receives unearned income from the partnership, any amount over $1,400 will be taxed at the parents' highest marginal rate.

Although the IRS recognizes family partnerships, it may subject them to close scrutiny to ensure that the partnership is not a sham. In addition, because partnership capital produces significant income and partners are reasonably compensated for services performed for the partnership, the IRS may opt to forbid the shift in income, in accordance with the Internal Revenue Code section that deals with distribution of partners' shares and family partnerships. That same section provides that a person owning a capital interest (or ownership interest) in a family partnership will be considered a partner for tax purposes even if he or she received the capital interest as a gift, if the gift is genuine and irrevocable.

Incorporating a Family or Setting Up an LLC
Some families have even incorporated or created family-owned limited liability companies (LLCs; see chapter 1). If the IRS questions the motivation for such an incorporation, the courts will examine the intent of the family members. If the sole purpose of incorporating was tax avoidance, the scheme will not stand. If the IRS successfully contends that the business entity should be disregarded, the IRS can reallocate income from the corporation or LLC to the individual taxpayer. This will be done, for example, if the corporation or LLC does not engage in substantial business activity and does not observe proper formalities, or if its separate status is not otherwise adhered to by the businessperson.

Tax Advantages and Disadvantages of Corporations and LLCs
A bona fide, or genuine, corporation or LLC may provide some tax advantages for the small business owner. As an employee, the owner can control his or her taxable income with a limited salary, and part or all of the income the entity receives from sales can be deferred. Although the corporation or LLC must recognize income whenever a sale is made, it can deduct the owner's salary as well as other business expenses.

Nevertheless, incorporation or creating an LLC is seldom advantageous for tax purposes. The Tax Reform Act of 1986 reduced individual rates so they are substantially in line with, or lower than, the entity rates for most taxpayers.

Additionally, there are some unavoidable legal and accounting expenses that will have to be paid by the corporation or LLC. If your business operates on very small margins, you should determine whether the possible tax savings to you justify the additional legal and accounting

costs associated with corporations or LLCs. The cost of payroll taxes, unemployment taxes, workers' compensation, and legal and accounting fees can be substantial. Also, use of the corporate form is no longer necessary for setting up a retirement plan.

Moreover, there are several potential business tax problems the businessperson should consider carefully before incorporating. Making use of a corporate form means that any distribution of profits to shareholders in the form of dividends will be taxed twice: once at the entity level as business income, and again at the shareholder level as personal income when profits are distributed to the shareholders or owner (although there is a small dividend deduction). Thus, although incorporation allows income to be shifted from the business person to other shareholders, such as family members, the shift occurs at the expense of double taxation. Obviously, it is important to consult with a CPA or tax advisor in order to determine whether the benefit of shifting income to a corporation outweighs the effects of double taxation.

Another option for the small enterprise is to organize as an S, or small, corporation (see chapter 1) and be taxed as a sole proprietorship or partnership. S corporation classification allows the owners to elect to be taxed much like a partnership and thus avoid double taxation. The tax law allows LLCs to elect to be taxed as entities (identical to C corporations) or to be taxed as if the business were still run as a sole proprietorship or partnership.

While creating a business entity may not provide tax benefits in some situations, and may even result in added expense, it still may afford you a liability shield. As I pointed out in chapter 1, many businesses are incorporated or created as LLCs for the sole purpose of obtaining limited liability for their owners, rather than for the tax treatment accorded business entities.

Taxes on Accumulated Earnings and Passive Investment Income

If a person incorporates or creates an LLC in order to postpone a significant portion of income, the IRS may impose an accumulated-earnings tax. The IRC allows a maximum accumulation of $250,000, which is not subject to the accumulated-earnings tax. Although, for corporations or LLCs whose principal work is in the fields of health, law, engineering, architecture, accounting, actuarial science, performing arts, or consulting, the maximum is $150,000. Accumulated earnings beyond these maximums must be justified as reasonable for the needs of the business.

Otherwise, they will be subject to a tax of 39.6 percent for the accumulated amounts, in addition to the regular corporate tax.

The IRC also imposes an additional tax on most types of "passive investment income," which is income retained by the corporation or LLC if the business entity is found to be a personal holding company. The current rate is 39.6 percent. This may occur if a majority of the corporation's income consists of copyright, book, movie, or other royalties; dividends; or personal-service contracts.

Also, if the owner sells his or her stock or ownership interest before the corporation or LLC has realized any income, the corporation or LLC could become a so-called collapsible corporation, causing the gain realized on the sale of the stock to be taxed at ordinary income rates.

QUALIFYING FOR BUSINESS DEDUCTIONS

Up until now, I have been discussing the various ways in which business owners can spread their taxable income or take advantage of lower tax rates by incorporating or creating an LLC. Another means of reducing tax liability is to make use of deductions. For this, you must keep full and accurate records. Receipts are a necessity. Even if your business is home-based, as are many start-up businesses, you should have a separate checking account and a complete set of books for all of the activities of your trade or business. A hobbyist or dilettante is not entitled to trade or business deductions, except against any income earned from that project.

Tax laws presume that a person is engaged in a business or trade, as opposed to a hobby, if a net profit results from the activity in question during three out of the five consecutive years ending with the taxable year in question. If the gallery or craft retailer does not have three profitable years in the last five years of working as such, the IRS may contend that the work merely constitutes a hobby, in which case the taxpayer will have to prove "profit motive" in order to claim business expenses. Proof of profit motive does not require proof that a profit would actually be made, but only of intention to make a profit.

The regulations call for an objective standard on the profit-motive issue, so statements of the taxpayer as to intent will not suffice as proof. The regulations list nine factors to be used in determining profit motive:

1. The manner in which the taxpayer carries on the activity (i.e., effective business routines and bookkeeping procedures)

2. The expertise of the taxpayer or the taxpayer's advisors (i.e., study in an area, awards, prior publication, critical recognition, membership in professional organizations, etc.)
3. The time and effort expended in carrying on the activity (i.e., at least several hours a day devoted to the activity, preferably on a regular basis)
4. Expectation that business assets will increase in value
5. The success of the taxpayer in similar or related activities (i.e., past successes, even if prior to the relevant five-year period)
6. History of income or losses with respect to the activity (i.e., increases in receipts from year to year, unless losses vastly exceed receipts over a long period of time)
7. The amount of occasional profits, if any
8. Financial status (wealth sufficient to support a hobby would weigh against the profit motive)
9. Elements of personal pleasure or recreation (i.e., if significant traveling is involved and little work accomplished, the court may be suspicious of profit motive)

No single factor will determine the results. The case of *Deering* v. *Blair* illustrates how the factors are used. Deering was the executor of the estate of Reginald Vanderbilt, whose financial affairs and residence were in New York. Vanderbilt had purchased a farm near Portsmouth, Rhode Island, because he was interested in horses, and he operated it as a business. The business produced little income, but Vanderbilt claimed business expenses of over $25,000 in each of three years. The court held that, despite the fact that he had several employees and advertised the farm's boarding and rental services, Vanderbilt's purpose in operating the farm was not to produce a profit. Rather, the land was used for pleasure, entertaining, exhibition, and social diversion. The fact that Vanderbilt did not rely on the income from the farm for his livelihood was also considered by the court in making its decision. The business deduction was thus disallowed.

In *Allen* v. *Commissioner*, however, the tax court decided that even though the ski lodge owned by the taxpayers and rented out during the ski season did not show a profit during the years in question, the lodge was operated as a business. The deduction was allowed, even though the Allens did not depend on the income from the lodge for their livelihood. They did, however, keep accurate records and did not use the lodge for their personal pleasure.

In *Engdahl* v. *Commissioner*, the tax court found a profit motive on the part of taxpayers who were considering retirement and wanted to supplement their income by operating a horse ranch. The court held that, despite a series of losses, the taxpayers had kept complete and accurate records reviewed by an accountant, had advertised the operation, took their horses to shows, and had worked up to fifty-five hours per week on the operation. Additionally, the assets of the ranch had appreciated in value. All of these facts showed that the taxpayers had a profit motive, and, therefore, the business-expense deductions were allowed.

Once you have established yourself as engaged in a business, all your ordinary and necessary expenditures for that business are deductible business expenses. This would include materials and supplies, work space, office equipment, research or professional books and magazines, travel for business purposes, certain conference fees, any agent commissions, postage, legal fees, and accountant fees.

One of the most significant and problematic of these deductible expenses is the work-space deduction. It is not uncommon for smaller businesses to be based at home for a variety of reasons, the most important of which is probably economic. The cost of renting a separate office is such that many small-business owners, especially in the start-up phase, are unwilling or unable to pay it. Others, of course, choose to work at home because it enables them to juggle work and family. Whatever the reason, taxpayers who wish to claim deductions for use of their homes as their place of business will have to do some careful planning.

Deductions for the Use of a Home in Business
For some time, the IRS did not allow deductions for offices or studios in homes. This policy was challenged in a case in which a physician managed rental properties as a sideline. The doctor's rental business was run out of an office in his house, and the space was used only for this particular business. When the physician deducted the expenses for the office in his home, the IRS disallowed the deduction, but the court was apparently convinced by the physical setup of the room that the doctor used it exclusively and regularly as an office in connection with his rental business. The court noted the room had no television set, sofa, or bed.

This decision now has been incorporated into the tax code. As a general rule, a business deduction is not allowed for the use of a dwelling that is used by the taxpayer during the taxable year as a residence. Use as a residence is defined as the use of the unit for personal purposes for more than fourteen days of the taxable year. But the IRC makes an

exception to this general rule in certain circumstances, allowing the tax-payer to take a deduction for a portion of a dwelling unit "exclusively used on a regular basis . . . as a principal place of business for any trade or business of the taxpayer," even if that business is not the taxpayer's primary source of income.

Exclusive and Regular Use

The exclusive and regular use exception applies to any portion of the residence used *exclusively* and *on a regular basis* as the owner's *principal place* of conducting that business.

The qualifications for this exception, typically, are strictly construed by the IRS and the courts. The requirement of exclusivity means that the taxpayer may not mix personal use and business use; in other words, an office that doubles as a storeroom for personal belongings, a laundry room, a guest bedroom, or the like will not qualify as an office for tax purposes, and a taxpayer may not deduct such space as an office. However, there has been a recent liberalization of this rule in some parts of the country where the courts have held that a studio or an office can exist in a room that has a personal use so long as a clearly defined area is used exclusively for business.

It is important to remember that generally the IRS functions on a regional basis. Except for issues that have been reserved for decision by the national office, each IRS office is independent and makes its own decisions until the U.S. Supreme Court or Congress makes a decision that applies nationally. That is why the decision by a circuit court in one area may not apply elsewhere.

The requirement regarding regular use means that the use of the room may not be merely incidental or occasional. Obviously, there is a gray area between regular and occasional. Perhaps some business own-ers just starting up can use this rule as an inducement to overcome tem-porary bouts of laziness or ennui, for if you are planning on deducting any expenses for your office, you must keep working to satisfy the regu-larity test.

Like the regularity requirement, the rule regarding the principal place of business has been vague and interpreted differently. In *Meiers v. Commissioner*, the plaintiff owned a self-service laundromat. Mrs. Meiers managed the business, supervised the five part-time employees, and per-formed other managerial and bookkeeping functions. She spent only about an hour a day at the laundromat and two hours a day in her office at home. The office was used exclusively for activities related to busi-ness. The tax court ruled that since the laundromat was the "focal point"

of the business, any deduction for an office in the home should be disallowed. The Court of Appeals for the Seventh Circuit reversed that decision, holding that rather than using the focal point of the business as the basis of its decision, the tax court should have looked to the principal place of the taxpayer's activities. Managerial decisions were made from the office and a conscious decision was made *not* to create an office at the laundromat itself. For these reasons, the office-at-home deduction was allowed.

In 1993, however, the Supreme Court held in *Soliman* v. *Commissioner* that home-office deductions were not available where the taxpayer performed the services or delivered goods outside of the home and income was not directly generated at home.

The Taxpayer Relief Act of 1997 expands the definition of a taxpayer's principal place of business to include the place where administrative and management activities are conducted, if there is no other fixed location for the accomplishment of such tasks, effective in 1999. For instance, an artist who rents studio space could take the home-office deduction if the administrative aspects of the business, such as contacting galleries regarding sales, ordering supplies, and the like, were conducted from the home office.

In another case, the tax court disallowed a claim for an office-at-home deduction despite a unique argument. In *Baie* v. *Commissioner*, the taxpayers operated a hot-dog stand some distance from their home. Because the stand measured only ten feet by ten feet, some of the food preparation and storage was done at home. The ruling by the tax court was based on the fact that the kitchen and storage areas were not used exclusively for business purposes. The taxpayers argued that they were actually engaged in a manufacturing operation at home, and, therefore, the office-at-home section of the IRS code did not apply. The court held that the statute included such an operation and the deduction was not allowed.

Another tax court decision denying the office-at-home deduction was *Moller* v. *United States*. The taxpayers were a husband and wife who claimed a deduction for the area of their home used to manage their investments. The court held that in order to qualify as a trade or business, the business must consist of the active buying and selling of securities, with income derived therefrom. The Mollers, however, derived their income from the dividends and interest resulting from holding securities for a long time. This, the court held, did not rise to the level of carrying on a trade or business.

When the office is in a structure separate from the principal residence, the requirements for deductibility are less stringent. The structure must be used exclusively and on a regular basis, just as an office in the home itself. However, when the office is in a separate structure, it need only be used "in connection with" the business, not as the principal place of business.

When taxpayers use a portion of their homes for storage of business materials (as well as for business), the requirements for deductibility of the storage area are also less stringent. The dwelling must be the sole fixed location of the business and the storage area must be used on a regular basis for the storage of the business equipment or products. The room used for storage need not be used entirely or exclusively for business, but there must be a "separately identifiable space suitable for storage" of the business-related materials.

Is the Office-at-Home Deduction Worthwhile?

If a taxpayer meets one of the tests outlined above, the next question is what tax benefits can result. The answer after close analysis is frequently, "Not very many." An "allocable portion" of mortgage interest and property taxes can be deducted against the business. These would be deductible anyway as itemized deductions. The advantage of deducting them against the business is that this reduces the business profit that is subject to self-employment taxes.

Of course, a taxpayer who lives in a rented house and otherwise qualifies for the office-at-home deductions may deduct a portion of the rent that would not otherwise be tax deductible. The primary tax advantage comes from a deduction for an allocable portion of repairs, utility bills, and depreciation. Otherwise, these would not be deductible at all.

To arrive at the allocable portion, take the square footage of the space used for the business and divide that by the total square footage of the house. Multiply this fraction by your mortgage interest, property taxes, etc., for the amount to be deducted. How to determine the amount of allowable depreciation is too complex to discuss here, and you should discuss this with your accountant or tax advisor.

The total amount that can be deducted for an office or storage place in the home is artificially limited. To determine the amount that can be deducted, take the total amount of money earned in the business and subtract the allocable portion of mortgage interest and property taxes, and other deductions allocable to the business. The remainder is the maximum amount that you can deduct for the allocable portion of repairs, utilities, and depreciation. In other words, your total business

deductions in this situation cannot be greater than your total business income minus all other business expenses. The office-at-home deduction, therefore, cannot be used to create a net loss, but disallowed losses can be carried forward indefinitely and deducted in future years against profits from the business.

Besides the obvious complexity of the rules and the mathematics, several other factors limit the benefit of taking a deduction for a studio or office in the home. One of these is the partial loss of the "nonrecognition of gain" (tax-deferred) treatment that is otherwise allowed when a taxpayer sells a personal residence. The Taxpayer Relief Act of 1997 allows homeowners to exclude up to $250,000 of gain ($500,00 for joint filers) from income, with some restrictions. This deferral of gain, however, is not allowed for the portion of the house that was used for business purposes. The taxpayer must pay tax on that portion of the gain from the sale.

For example, if you have been claiming 20 percent of your home as a business deduction, when you sell the home you will enjoy a tax deferral on only 80 percent of the profit. The other 20 percent will be subject to tax because that 20 percent represents the sale of a business asset. In essence, for the price of a current deduction you may be converting what is essentially a nonrecognition, or tax-deferred, asset into trade or business property.

Another concern is that by deducting for an office in the home, the taxpayer effectively puts a red flag on the tax return. Obviously, when the tax return expressly asks whether expenses are being deducted for an office in the home, the question is not being asked for purely academic reasons. Although only the IRS knows how much the answer to this question affects someone's chances of being audited, there is no doubt that a "yes" answer does increase the likelihood of an audit.

Given this increased possibility of audit, it does not pay to deduct for an office in the home in doubtful situations. Taxpayers who lose the deduction must pay back taxes plus interest or fight in court. If you believe that your office at home could qualify for the business deduction, you would be well advised to consult with a competent tax expert who can assist in calculating the deduction.

Other Professional Expenses

As mentioned earlier, deductible business expenses include not only the work space, but all the ordinary and necessary expenditures involved in the business. "Current expenses," items with a useful life of less than one year, are fully deductible in the year incurred. Writing utensils

and stationery, postage, and telephone bills are all examples of current expenses. Commissions paid to salespeople, as well as fees paid to lawyers or accountants for business purposes, are generally deductible as current expenses. The same is true of salaries paid to others whose services are necessary for the business.

Many expenses cannot be fully deducted in the year of purchase but can be depreciated. These kinds of costs are called "capital expenditures." For example, the cost of equipment, such as a fax machine, computer, photocopier, or pickup truck, all of which have useful lives of more than one year, are capital expenditures, and cannot be fully deducted in the year of purchase. Instead, the taxpayer must depreciate, or allocate, the cost of the item over the estimated useful life of the asset. Although the actual useful life of professional equipment will vary, fixed periods have been established in the IRC over which depreciation may be deducted.

In some cases, it may be difficult to decide whether an expense is a capital expenditure or a current expense. Repairs to machinery are one example. If you spend $200 repairing your delivery van, this expense may or may not constitute a capital expenditure. The general test is whether the amount spent restoring the vehicle adds to its value or substantially prolongs its useful life. Since the cost of replacing short-lived parts of a vehicle to keep it in efficient working condition does not substantially add to its useful life, such a cost would be a current cost and would be deductible. The cost of rebuilding your van's engine, on the other hand, significantly extends its useful life. Thus, such a cost is a capital expenditure and must be depreciated.

For many small businesses, an immediate deduction can be taken when equipment is purchased. In 1999, up to $18,500 of such purchases may be "expensed" for the year and need not be depreciated at all. This amount will increase to $25,000 by 2003.

Travel and Entertainment Expenses

Galleries and craft retailers frequently travel to shows to acquire works for their inventories. On a business trip, whether within the United States or abroad, ordinary and necessary expenses may be deductible if the travel is solely for business purposes. Transportation costs are fully deductible, except for "luxury water travel," as are costs of lodging while away from home on business. Business meals and meals consumed while on a business trip are deductible up to 50 percent of the actual cost. If the trip primarily involves a personal vacation, you can deduct business-related expenses at the destination, but you may not deduct the transportation costs.

If the trip is primarily for business but part of the time is personal vacation, the expenses for business and pleasure must be separated. This is not true in the case of foreign trips if any one of the following exceptions applies:

- The taxpayer had no control over arranging the trip
- The trip outside of the United States was for a week or less
- Less than 25 percent of the time is spent in nonbusiness activity
- A personal vacation was not a major consideration in making the trip

If claiming one of these exceptions, be careful to have supporting documentation. If the exceptions do not apply, then expenses for the trip abroad must be allocated according to the percentage of the trip devoted to business rather than vacation.

The IRS tends to review very carefully any deductions for attendance at business seminars that also involve a family vacation, whether inside the United States or abroad. In order to deduct the business expense, you must be able to show, with documentation, that the reason for attending the meeting was to promote production of income. Normally, a spouse's expenses will not be deductible. It is wise to make the spouse a partner, employee, or a member of the board of the corporation or management committee of the LLC.

Whether inside or outside of the United States, the definition of what constitutes "a business stay" is essential in determining a trip's deductibility. Travel days, including the day of departure and the day of return, count as business days if business activities occurred on such days. If travel is outside the United States, the same rules apply if the foreign trip is for more than seven days.

Any day you spend on business counts as a business day even if only a part of the day is spent on business. A day in which business is canceled through no fault of yours counts as a business day. Saturdays, Sundays, and holidays count as business days even though no business is conducted, provided that business is conducted on the Friday before and the Monday after the weekend, or on one day on either side of the holiday.

Entertainment expenses incurred to develop an existing business are also deductible in the amount of 50 percent of the actual cost. You must be especially careful about recording entertainment expenses, however. The amount, date, place, type of entertainment, business purpose, substance of the discussion, the participants in the discussion, and the

business relationship of the parties being entertained should be recorded. Keep receipts for any expenses over $75. Also keep in mind the stipulation in the IRC that disallows deductibility for expenses that are "lavish or extravagant under the circumstances." Unfortunately, no guidelines have yet been developed as to the definition of "lavish or extravagant." If you buy tickets to a sporting, cultural, or other event for business entertaining, only the face value of the ticket is allowed as a deduction. If you purchase or lease a skybox or other luxury box seat, the maximum deduction now allowed is 50 percent of the cost of the nonluxury box seat.

The IRS is taking a closer look at cruise-ship seminars and now requires you to attach two statements to your tax return: the first statement substantiates the number of days on the ship, the number of hours spent each day on business, and the activities in the program; the second statement must come from the sponsor of the convention to verify the information in the first statement. In addition, the ship must be registered in the United States, and all ports of call must be located in the United States or its possessions. The deduction is also limited to $2,000 per individual per year. Again, the key to taking this sort of deduction is careful planning, documentation, and substantiation.

Keeping a logbook or expense diary is probably the best line of defense with respect to business expenses incurred while traveling. When on the road:

- Keep proof of the costs
- Record the time of departure
- Record the number of days spent on business
- List the places visited and the business purposes of your activities
- Keep copies of all receipts in excess of $75 for transportation, meals, lodging, etc.
- If traveling by car, keep track of mileage
- Log all other expenses in a diary

Businesspersons may also take tax deductions for their attendance at workshops, seminars, retreats, and the like, provided they are careful to document the business nature of the trip. Accurate recordkeeping is the first line of defense for tax preparation. Note that it is no longer possible to deduct for investment seminars or conventions, as opposed to business conventions.

Charitable Deductions

The law provides that an individual or business can donate either money or property to qualified charities and take a tax deduction for the donation. Individuals are afforded more favorable deductions for donations of money or property they own than are artists donating their own creations or businesspeople who donate property out of their inventory, such as a gallery donating a painting.

The tax law requires independent appraisals of donated property in a form prescribed in the IRC. In addition, if the taxpayer receives any benefit from the charity, the amount deducted must be reduced by the fair market value of the benefit received. Benefits could include, for example, attendance at museum openings, merchandise such as books, tapes, or CDs, and the like.

Since this area can be quite technical, you should consult your tax advisor before making any charitable donations. In addition, there have been some abuses on the part of charities that resulted in misappropriations of donated funds. If you have any question about the validity of a particular charity, you should contact your State Attorney General's office or the local governmental agency that polices charitable solicitations in your area.

Grants, Prizes, and Awards

Individuals who receive income from grants or fellowships should be aware that this income can be excluded from gross income and thus represents considerable tax savings. To qualify for this exclusion, the grant must be for the purpose of furthering the individual's education and training. Furthermore, if the grant is given as compensation for services or is primarily for the benefit of the grant-giving organization, it cannot be excluded. Amounts received under a grant or fellowship that are specifically designated to cover expenses related to the grant are no longer fully deductible. The expense deduction is allowed only if the recipient is a degree candidate and is limited to the amounts used for tuition, fees, books, supplies, and equipment. Amounts designated for room, board, and other incidental expenses are included in income.

The above rules apply to income from grants and fellowships. Unfortunately, the Tax Reform Act of 1986 also puts tighter restrictions on money, goods, or services received as prizes or awards. Previously, the amounts received for certain awards were excluded from income if the recipient was rewarded for past achievements and had not applied for the award. Examples of this type of award are the Pulitzer Prize and the

Nobel Prize. Under the present law, any prizes or awards for religious, charitable, scientific, or artistic achievements are included as taxable income to the recipient unless the prize is assigned to charity.

Health Insurance

Self-employed persons may deduct a percentage of the amount paid for medical insurance for themselves, their spouses, and their dependents. The percentage is 45 percent in 1999. This amount will gradually increase to 100 percent by 2007.

Insurance Premiums

Shareholders in a corporate gallery or retail shop, regardless of whether it is a C or S corporation, may obtain some survivors' benefits through a contract known as a "buy-sell agreement." This type of agreement essentially provides a mechanism for the purchase of a shareholder's stock by either the corporation or the other shareholders in the event of a shareholder's death or disability, or, in most cases, his or her desire to sell out.

Insurance is frequently used to fund the death and disability portions of these agreements. The corporation agrees to purchase the shareholder's stock with the insurance proceeds in the event of the shareholder's death or disability. If the corporation owns the policy, it may deduct the cost of the premiums paid.

There are a variety of ways of structuring these arrangements, and you should consult a financial planner or insurance salesperson, as well as your tax adviser and lawyer, when developing these arrangements in order to determine which one will best serve your objectives. Also, periodically review your plan with your attorney so that it reflects the constant changes in tax and business laws.

TAXABLE AND TAX-EXEMPT BENEFIT PLANS

Statutory Plans

Statutory, tax-exempt benefit plans are available for accident and health coverage, child care, group term-life insurance, profit sharing, pension, and contributory savings plans, to name a few. Even though the myriad rules and regulations are tedious, the plans are worth consideration. If a plan conforms to the rules, employer contributions are immediately deductible as business expenses but not taxable to the employees as income. Employees are taxed only when they receive payments from the plan. Even more important, in the case of some retire-

ment plans, no tax is imposed on the investment growth of funds deposited in the plan.

Separate rules and requirements that are extremely complex cover each type of benefit plan. All plans must meet the following requirements in order to be deductible:

- At least 90 percent of the employees who are not highly compensated must be eligible to participate in the plan. These employees must be entitled to at least 50 percent of the highest benefit provided to any highly compensated employee under this plan or any similar plan.
- At least 50 percent of the employees eligible to participate in the plan must be other than highly compensated employees.
- Eligibility requirements cannot be rigged to favor highly compensated employees.

A highly compensated employee is an employee who owns 5 percent of the business, or receives compensation in excess of $75,000 annually, or receives over $50,000 and is in the highest-paid group of employees for the year, or is an officer and receives more than $45,000 in compensation annually. Of course, if a small business had more highly compensated employees than other employees, a plan could not meet the 50 percent test, even if everyone received identical benefits. An alternative plan for eligibility will qualify a plan if the percentage of non-highly compensated employees eligible for the plan equals or exceeds the percentage of highly compensated employees eligible for the same or all similar plans.

A statutory plan also must meet a benefits requirement so that the average benefit received by non-highly compensated employees must equal or exceed 75 percent of the average benefits received by highly compensated employees under the same or similar plans.

In determining the required eligibility percentages, the following employees may be excluded: temporary and part-time employees; employees who are under twenty-one years old; employees covered by collective bargaining agreements (unions); employees who are nonresident aliens and who receive no U.S. taxable income; and employees who have been on the job less than one year (six months in the case of medical benefits).

Here are some sample guidelines for statutory plans:

- Contributions by employers to health and accident plans are generally tax exempt only if they provide continuing extensions of coverage for

various specified time periods. Amounts received to compensate an employee for loss of income due to illness or injury are taxable as income. When an employee receives payment for medical expenses, the amount received is not taxable income unless the employee is already receiving compensation from another source or takes an income tax deduction for the medical expenses. The employee is also not taxed on amounts received to compensate for injury due to permanent loss of use of a body part or function or permanent disfigurement.

- If a plan provides assistance for child or other dependent care, the aggregate amount excluded from the employee's income cannot exceed $5,000 in the case of either an individual parent or a husband and wife together. If an employee receives $2,500 of tax-free child care assistance, the spouse is eligible to receive only an additional $2,500 in tax-free assistance.
- An employer may provide up to $50,000 dollars of tax-free, group term-life insurance for each employee. Premiums on coverage exceeding $50,000 in face amount are taxable to employees, unless the employee contributes to the plan with his or her own taxable income.
- An employee may receive up to $5,250 in tax-free educational assistance per year from a funded educational-assistance program.

Qualified Plans

Qualified plans include pension, profit-sharing, and stock-bonus plans. Retirement benefits may also be provided under qualified plans.

Qualified plans must be separately funded and administered under rules designed to guarantee, to the extent possible, that retirement funds cannot be reached, tampered with, squandered, or mismanaged by the employer. There are also vesting requirements so that employees can rely on the plans without worrying about forfeiture due to excessively long employment period requirements.

Eligibility and benefit rules, similar to those for statutory plans, exist to assure nondiscrimination in qualified plans. Different employer contribution amounts to various plans are allowed based upon an employee's value and years of service, but special rules prevent and remedy top-heavy plans in which accumulated contributions on behalf of highly compensated employees exceed those for other employees.

The rules for qualified pension, profit-sharing, and stock-bonus plans are too numerous to summarize here. Maintenance of a qualified plan is impossible without specialized professional help—financial planners, business advisors, and skilled business attorneys.

Cafeteria Plans

Cafeteria plans have nothing to do with employee lunchrooms. Under a cafeteria plan, an employer may set up a "menu" whereby an employee is allotted a certain amount of benefit credit and can choose from various combinations of plans or receive additional taxable income. The amounts allocable to elected benefit plans are not taxable to the employee. In this way, an employee can tailor a benefits program to best meet his or her individual circumstances. Fringe benefits and educational assistance plans may not be included in cafeteria plans.

Fringe Benefits

Certain fringe benefits may be provided tax free to employees, for example, employee discounts, subsidized cafeterias, parking facilities, on-site athletic facilities, etc. Generally, these benefits must be of no additional cost to the employer or be worth so little that the administrative cost of keeping track of them exceeds the value of the benefit.

Shareholders/employees of C corporations can take advantage of all of the above fringe benefits as employees. S corporation shareholders generally cannot avail themselves of certain fringe benefits, fully deductible health insurance at the corporate level, dependent care plans, or group term-life plans.

TAX SHELTERS

Although they generate much interest, tax shelters do not ordinarily relieve a taxpayer of the obligation of paying tax; rather, they utilize loopholes in the tax law to postpone or defer tax liability. They accomplish this in one of two ways: (1) by accelerating deductions in the early years of investment, rather than matching deductions with the income as it is generated; and (2) by increasing the basis upon which the tax benefits are calculated without increasing the cash cost of the investment. Although shelters may be very advantageous to the taxpayer, Congress and the IRS are extremely diligent in closing such loopholes as they are exploited, so you should update your benefit packages regularly.

One type of tax shelter available to galleries and craft retailers involves an investment tax credit for qualified rehabilitation expenditures, such as restoring an historic structure. This is one of the few shelters that Congress appears to favor. It is a means by which the legislature can encourage rehabilitation activities it deems beneficial.

The amount of investment tax credit is 20 percent for certified historic structures and 10 percent for other qualifying structures. The taxpayer deducts the tax credit directly from taxes owed. To qualify, most

buildings must be nonresidential at the time rehabilitation begins; however, certified historic buildings can be either residential or nonresidential. The building also must have been placed in service before the beginning of the rehabilitation, and it must have been substantially rehabilitated, with 50 percent or more of the existing external walls retained as external walls. Also, the taxpayer must elect to use a straight-line method of depreciation rather than accelerated methods. For certified historic structures, approval of the rehabilitation must be obtained from the Secretary of the Interior.

There may be other ways to structure tax shelters and to reduce one's tax liability. Creative lawyers and accountants are devising new schemes as the tax laws are continually changing. Plan your tax strategies carefully, and you can save significant amounts of money.

ESTATE PLANNING

All art and craft gallery owners should give some thought to estate planning and take the time to execute a will or other estate plan. Without a will, there is simply no way to control the disposition of one's property after death. Sound estate planing may include transfers outside of the will, which will avoid the delays and expenses of probate, as well as certain types of trusts.

Successful estate planning is complex. Proper planning will require the assistance of a knowledgeable lawyer and, perhaps, also a life insurance agent, an accountant, a real estate, art, or business appraiser, or a bank trust officer, depending on the nature and size of the estate. This chapter is intended to introduce you to the basic principles of estate planning, alert you to potential problems, and prepare you to work with your estate planners.

THE WILL

A "will" is a legal instrument by which a person directs the distribution of property in his or her estate upon death. The maker of the will is called the "testator." Gifts given by a will are referred to as "bequests" (personal property) or "devises" (real estate). The recipients of the bequests or devises are called "beneficiaries."

Certain legal formalities are required to create a valid will, and they vary from state to state. A few states also have special provisions known as community property laws, which would, for example, characterize property acquired during marriage as owned by both spouses. Most states

allow only formally witnessed wills; that is, the instrument must be in writing and signed by the testator in the presence of two or more witnesses. Other states allow either witnessed or unwitnessed wills. If a will is entirely handwritten by and signed by the testator, it is known as a "holographic" will.

A will is a unique document in two respects. First, if properly drafted it is "ambulatory," meaning it can accommodate change—for example, apply to property acquired after the will is made. Second, a will is "revocable," meaning that the testator has the power to change or cancel it before death. Even if a testator makes a valid agreement not to revoke the will, the power to revoke it remains, though liability for breach of contract could result.

Generally, courts do not consider a will to have been revoked unless it can be established that the testator either (1) performed a physical act of revocation, such as burning or tearing up a will, with intent to revoke it; or (2) executed a valid later will that revoked the previous will. Most state statutes also provide for automatic revocation of a will in whole or in part if the testator is subsequently divorced or married.

To amend a will, the testator must execute a supplement, known as a "codicil," which has the same formal requirements as those for creating a will. To the extent that the codicil contradicts the will, those contradicted parts of the will are revoked.

PAYMENT OF TESTATOR'S DEBTS

When the property owned by the testator at death is insufficient to satisfy all the bequests in the will after all debts and taxes have been paid, some or all of the bequests in the will must be reduced or even eliminated entirely. The process of reducing or eliminating bequests is known as "abatement," and the priorities for reduction are set according to the category of each bequest. The legally significant categories of gifts are generally as follows:

- Specific bequests or devises, that is, gifts of identifiable items ("I give to X all the furniture in my home")
- Demonstrative bequests or devises, that is, gifts that are to be paid out of a specified source, unless that source contains insufficient funds, in which case the gifts will be paid out of the general assets ("I give to Y $1,000 to be paid from my shares of stock in ABC Corporation")
- General bequests, that is, gifts payable out of the general assets of an estate ("I give Z $1,000")

- Residuary bequests or devises, or gifts of whatever is left in the estate after all other gifts and expenses are satisfied ("I give the rest, residue, and remainder of my estate to Z")

The property not governed by a will is called "intestate property," and is usually the first to be taken to satisfy claims against the estate. If the will contains a valid residuary clause, there will be no such property. In this case, residuary bequests are the first taken. If more money is needed, general bequests will be taken, and lastly, specific and demonstrative bequests will be taken together in proportion to their value. Some states provide that all gifts, regardless of type, abate proportionately.

DISPOSITION OF PROPERTY NOT WILLED

If the testator acquires more property after signing the will but before death, the disposition of such property will also be governed by the will. If such property falls within the description of an existing category in the will ("I give all my stock to X; I give all my real estate to Y"), it will pass along with all similar property. If it does not, and the will contains a valid residuary clause, the property will go to the residuary legatees. If there is no such clause, this property will pass outside the will to the persons specified in the state's law of "intestate succession."

When a person dies without leaving a valid will, the person is said to have died intestate. The property of a person who dies intestate is distributed according to the state law of intestate succession, which specifies who is entitled to what parts of the estate. In general, intestate property passes to those persons having the nearest "degree of kinship" to the decedent (deceased). An intestate's surviving spouse will always receive a share, generally at least one-third of the estate. An intestate's surviving children likewise always get a share. If some of the children do not survive the intestate, the grandchildren of the intestate may be entitled to a share by representation. "Representation" is a legal principle that specifies if an heir does not survive the intestate but has a child who does survive, that child will represent the nonsurviving heir and receive that parent's share in the estate.

If there are no direct descendants surviving, the intestate's surviving spouse will generally take the entire estate or share it with the intestate's parents. If there is neither a surviving spouse nor any surviving direct descendants of the intestate, the estate may be distributed to the intestate's parents or, if the parents are not surviving, to the intestate's siblings by representation. If there are no surviving persons in any of these categories, the estate will go to surviving grandparents and their direct

descendants. In this way, the family tree is constantly expanded in search of surviving relatives. The laws of intestate succession make no provision for friends, in-laws, or stepchildren. If none of the persons specified in the law of intestate succession survive the testator, the intestate's property ultimately goes to the state. This reversion of property to the state in the absence of legal heirs is known as "escheat."

State law will often provide a testator's surviving spouse with certain benefits from the estate even if the spouse is left out of the testator's will. Historically, these benefits were known as "dower," in the case of a surviving wife, or "curtesy," in the case of a surviving husband. The historical concepts of dower and curtesy are in large part a result of the law's traditional recognition of an absolute duty on the part of the husband to provide for the wife. Modern laws are perhaps better justified by the notion that most property in a marriage should be shared because the financial success of either partner is due to the efforts of both. In place of the old dower and curtesy, modern statutes give the surviving spouse the right to elect against the will and, thereby, receive a share equal to at least one-fourth of the estate. Here again, state laws vary—in some states, the surviving spouse's elective share is one-third.

ADVANTAGES TO HAVING A WILL

A will affords one the opportunity to directly distribute one's property and to give gifts conditionally, when that is preferred. For example, if an individual wishes to donate certain property to a specific charity but only if certain conditions are adhered to, a will can make such conditions a prerequisite to the donation.

A will permits the testator to nominate an "executor"—called a "personal representative" in some states—to watch over the estate. If no executor is named in the will, the court will appoint one. A will also permits the testator to give property to minors and regulate the timing and uses of the property given (e.g., funds to be used exclusively for education). If the testator has an unusual type of property, such as antiques, art, or publishable manuscripts, it is a good idea to appoint joint executors, one with financial expertise and the other with expertise in valuation of antiques, in art, or in publishing.

Some provision should be made in the will for resolving any deadlock between joint executors. For example, a neutral third party might be appointed as an arbitrator, directed to resolve any impasses after hearing both sides. It is also advisable to define the scope of the executor's power by detailed instructions.

A lawyer's help will be necessary to set forth all of these important considerations in legally enforceable, unambiguous terms. It is essential in a will to avoid careless language that might be subject to attack by survivors who are unhappy with the will's provisions. A lawyer's help is also crucial to avoid making bequests that are not legally enforceable because they are contrary to public policy (e.g., a bequest that states that if the beneficiary gets married, the bequest is void).

TAXATION

In addition to giving the testator significant posthumous control over division of property, a carefully drafted will can greatly reduce the overall amount of estate tax paid at death. The taxing structures I will discuss here relate to federal estate taxation. State estate taxes often contain similar provisions, but consult your lawyer regarding the specifics of your state's laws.

The Gross Estate

The first step in evaluating an estate for tax purposes is to determine the "gross estate." The gross estate includes all property over which the deceased had significant control at the time of death, for example, certain life insurance proceeds and annuities, jointly held interests, revocable transfers, and interests in business.

Under current tax laws, the executor of an estate may elect to value the property in the estate either as of the date of death or as of a date six months after death. The estate property must be valued in its entirety at the chosen time. If, however, the executor elects to value the estate six months after death and certain pieces of property are distributed or sold before then, that property will be valued as of the date of distribution or sale.

Fair market value is defined as the price at which property would change hands between a willing buyer and a willing seller when both buyer and seller have reasonable knowledge of all relevant facts. Such a determination is often very difficult to make, especially when items such as artwork are involved. Although the initial determination of fair market value is generally made by the executor when the estate tax return is filed, the Internal Revenue Service may disagree with the executor's valuation and assign assets a much higher fair market value. For instance, in 1979, the IRS claimed that Jacqueline Susann's diary had an estate tax value of $3.8 million as a literary property. The diary, which neither Susann nor her executor had considered particularly valuable, had been destroyed by the executor pursuant to Susann's directions.

When an executor and the IRS disagree as to valuation, the court will decide the matter. In most cases, the burden will be on the taxpayer to prove the value of the asset. Thus, expert testimony and evidence of the sale of the same or similar properties will be helpful, as in cases involving original manuscripts and drawings. In general, courts are reluctant to determine valuation by formula.

Generally, estate taxes must be paid when the estate tax return is filed (within nine months of the date of death), although arrangements may be made to spread payments out over a number of years if necessary. It is not uncommon for executors to be forced to sell properties for less than full value in order to pay taxes. This can be avoided by obtaining insurance policies, the proceeds of which can be set up in a trust.

The Taxable Estate

After determining the gross estate, the second step in evaluating an estate for tax purposes is figuring the taxable estate. The taxable estate is the basis upon which the owed tax is computed.

The law allows a number of deductions from the gross estate in determining the amount of the taxable estate. Typical deductions include funeral expenses, certain estate administration expenses, debts and enforceable claims against the estate, mortgages and liens, and, perhaps most significantly, the marital deduction and the charitable deduction.

The marital deduction allows the total value of any interest in property that passes from the decedent to the surviving spouse to be subtracted from the value of the gross estate. The government will eventually get its tax on this property and its appreciated value when that spouse dies, but only to the extent such interest is included in the spouse's gross estate. This deduction may occur even in the absence of the will specifically making a gift to the surviving spouse; as mentioned earlier, state law generally provides that the spouse is entitled to at least one-fourth of the overall estate, regardless of the provisions of the will.

The charitable deduction refers to the deduction allowed upon the transfer of property from an estate to a recognized charity. Because the definition of a charity for tax purposes is quite technical, it is advisable to insert a clause in the will providing that if the institution specified to receive the donation does not qualify for the charitable deduction, the bequest shall go to a substitute qualified institution chosen by the executor.

Once the deductions are computed, the taxable estate is taxed at the rate specified by the Unified Estate and Gift Tax Schedule. The unified tax imposes the same rate of tax on gifts made by a will as on gifts made during life. It is a progressive tax, meaning that the percentage paid in

taxes increases with the amount of property involved. The rates rise significantly for larger estates, for example, from 18 percent where the cumulative total of the taxable estate and taxable gifts is under $10,000, to 55 percent where the cumulative total is over $3 million. Tax credits are provided by year according to the tax schedule. Federal estate tax is also reduced by state death tax credit or actual state death tax, whichever is less. Gift and estate tax credits result in a $650,000 exemption, which is available to every estate. This exemption will increase to $1 million by 2006. There is an additional exemption for families with qualifying businesses or farms, allowing a total exemption of $1.3 million. These exemptions, combined with the unlimited marital deduction, allow most estates to escape estate taxes altogether. In estates in excess of $10 million, the unified tax credit begins to decline.

Distributing Property Outside the Will

Property can be distributed outside of the will by making "inter vivos," or living gifts (made during the giver's lifetime) either by giving the gift outright or by placing the property in trust. The main advantage to distributing property outside of the will is that the property escapes the delays and expense of "probate," which is the court procedure by which a will is validated and administered. There used to be significant tax advantages to making *inter vivos* gifts rather than gifts by will, but because the estate and gift tax rates are now unified, only a few advantages remain.

One advantage is that if the *inter vivos* gift appreciates in value between the time the gift is made and death, the appreciated value will not be taxed. If the gift were made by will, the added value would be taxable because the gift would be valued as of the date of death (or six months after). This value difference can represent significant tax savings for the heirs of someone whose business suddenly becomes successful and rapidly increases in value.

The other advantage to making an *inter vivos* gift is the yearly exclusion of $10,000 per recipient. For example, if $15,000 worth of gifts were given to an individual in one year, only $5,000 worth of gifts would be taxable to the donor (who is responsible for the gift tax). A married couple can combine their gifts and claim a yearly exclusion of $20,000 per couple. The yearly exclusion will be adjusted for inflation starting in 1999.

Gifts made within three years of death used to be included in the gross estate, in accordance with the theory that these gifts were made in contemplation of death. Recent amendments to the tax laws, however, have done away with the three-year rule for most purposes. The three-year

rule is still applicable to gifts of life insurance, to certain transfers involving stock redemptions or tax liens, and to certain complex valuation schemes.

Gift-tax returns must be filed by the donor for any year in which gifts made to any one donee exceed the yearly exclusion. It is not necessary to file a return if gifts to any one donee amount to less than the yearly exclusion; however, if it is possible that the valuation of the gifts might be questioned by the IRS, it may be a good idea to file a return anyway. Filing the return starts the three-year statute of limitations period. Once the statute of limitations period has expired, the IRS is barred from filing suit for unpaid taxes or for tax deficiencies due to higher government valuations of the gifts. If a taxpayer omits includable gifts amounting to more than 25 percent of the total amount of gifts stated in the return, the statute of limitations is extended to six years. There is no statute of limitations for fraudulent returns filed with the intent to evade tax.

In order to qualify as an inter vivos gift for tax purposes, a gift must be complete and final. Control is an important issue. If a giver retains the right to revoke a gift (not made in trust), the gift may be found to be "testamentary" in nature—that is, created by the will, even if the right to revoke was never exercised—and, therefore, is not inter vivos. The gift must also be delivered. An actual, physical delivery is best, but a symbolic delivery may suffice if there is strong evidence of intent to make an irrevocable gift—for example, the donor gives the gift's recipient the only key to the safe containing the gift.

Another common way to transfer property outside the will is to place the property in a "trust" that is created prior to death. A trust is simply a legal arrangement by which one person holds certain property for the benefit of one or more others. The person holding the property is the "trustee." Those for whose benefit it is held are the "beneficiaries."

To create a valid trust, the giver must identify the trust property; make a declaration of intent to create the trust; transfer property to the trust; and name identifiable beneficiaries. If no trustee is named, a court will appoint one. The "settlor," or creator of the trust, may also be designated as trustee, in which case segregation of the trust property in a separate account or trust satisfies the delivery requirement.

Trusts can be created by will, but these testamentary trust properties will be probated along with the rest of the will. To avoid probate, the settlor must create a valid inter vivos trust. Generally, in order to qualify as an inter vivos trust, a valid interest in property must be transferred before the death of the creator of the trust. If the settlor fails to name a beneficiary for the trust or make delivery of the property to the trustee

before death, the trust will likely be termed testamentary—that is, to be disposed of after death. Such a trust will be deemed invalid unless the formalities required for creating a will were complied with.

A trust will not be termed testamentary simply because the settlor retained significant control over the trust, such as the power to revoke or modify the trust. For example, when a person makes a deposit in a savings account in his or her own name as trustee for another and reserves the power to withdraw the money or revoke the trust, the trust will be enforceable by the beneficiary upon the death of the depositor, providing the depositor has not in fact revoked the trust. Many states allow the same type of arrangement in authorizing joint bank accounts with rights of survivorship as valid will substitutes.

Property transferred under one of these arrangements is thus passed outside the will and need not go through probate. However, even though such an arrangement escapes probate, the trust property will probably be considered part of the gross estate for tax purposes because the settlor retained significant control. In addition, if the deceased settlor created a revocable trust for the purpose of decreasing the share of a surviving spouse, in some states the trust will be declared illusory—in effect, invalid. The surviving spouse is then granted the legal share not only from the probated estate, but from the revocable trust.

Life insurance trusts can be used for paying estate taxes. The proceeds will not be taxed if the life insurance trust is irrevocable and the beneficiary is someone other than the estate, such as a friend or relative acting in an individual capacity (not a representative or agent of a corporation) or the business. This is especially important for entrepreneurs because, without a life insurance trust, their survivors might be forced to sell estate assets for less than their real value in order to pay estate taxes.

PROBATE

Briefly described, "probate" is the legal process by which a decedent's estate is administered in a systematic and orderly manner and with finality. The laws governing the probate process vary among the states. One of the principal functions of probate administration is to provide a means to transfer ownership of a decedent's probate property. Accordingly, probate administration occurs without regard to whether the decedent died testate (with a will) or intestate (without a will).

Probate property consists of the decedent's solely owned property as of the date of death. Property jointly held by the decedent and another person with the right of survivorship (for example, a residence owned jointly by a married couple or stock certificates held jointly with right of

survivorship) passes to the survivor and is not a part of the decedent's probate estate. Likewise, the proceeds of life insurance on the decedent's life are not part of the probate estate (unless the estate is the designated beneficiary). It is, therefore, possible for a wealthy individual to die leaving little or no probate property.

In the course of probate administration: A decedent's will is admitted to probate as the decedent's "last" will; someone (sometimes referred to as the "personal representative," "executor," or "administrator") is appointed by the court to take charge of the decedent's property and financial affairs; interested persons are notified of the commencement of probate administration; information concerning the decedent's estate is gathered; probate property is assembled and preserved; debts and taxes are determined, paid, and/or challenged; claims against the decedent's estate are paid and/or challenged; conflicting claims of entitlement to the decedent's property are disposed of; and, at the conclusion of the process, remaining estate property is distributed to the appropriate persons or entities. While probate administration is pending, distributions of the decedent's property are suspended to allow creditors, claimants, devisees, and heirs the opportunity to protect their respective rights.

HOW TO FIND A
LAWYER AND
AN ACCOUNTANT

Most galleries and craft retailers expect to seek the advice of a lawyer only occasionally for counseling on important matters, such as whether or not to incorporate or what to do when they are sued. If this is your concept of the attorney's role in your business, I recommend you reevaluate it. Most small galleries and craft retailers would operate more efficiently and more profitably in the long run if they had a relationship with a business attorney similar to that between a family doctor and his patient—that is, an ongoing relationship that allows the attorney to get to know the business well enough to engage in preventive legal counseling and assist in planning. This type of relationship with your attorney will make it possible to *avoid* problems.

If your business is small or undercapitalized, you are most likely anxious to keep operating costs down. You probably do not relish the idea of paying an attorney to get to know your business if you are not involved in an immediate crisis. However, it is a good bet that a conversation with a competent business lawyer right now will raise issues vital to the future of your gallery. There is good reason why large, successful businesses employ one or more attorneys full time as in-house counsel. Ready access to legal advice is something you should not deny your business at any time, for any reason.

An attorney experienced in representing art galleries or craft retailers can give you important information regarding the risks unique to your business. Furthermore, a lawyer can advise you regarding your rights and

obligations in your relationship with present and future employees; the rules that apply in your state regarding the hiring and firing of employees; permissible collection practices; and so forth, as I have mentioned throughout this book. Ignorance of these issues and violation of the rules can result in financially devastating lawsuits and, in some situations, even criminal penalties. Each state has its own laws covering certain business practices, and a competent art or craft lawyer is your best source of information on many state laws that will affect the running of your business.

What is really behind all the hoopla about preventive legal counseling? Are we lawyers simply seeking more work? Admittedly, as businesspeople, lawyers want business, but what you should consider is this economic reality: Most legal problems cost more to solve or defend after they arise than it would have cost to prevent their occurrence in the first place. You do not want to sue or be sued if you can help it. Litigation is notoriously inefficient and shockingly expensive. The legal fees and costs involved in a trademark infringement case, for example, may exceed $100,000. Pretrial procedures run into the thousands of dollars for most cases. The cost of defending a case filed against you or your business is something you have no choice but to incur, unless you choose to default, which is almost never advisable.

The lawyer who will be most valuable to your young business will not likely be a Raymond Burr or Robert Redford character but, rather, will be a meticulous person who does most of his or her work in an office, reviewing your business forms, your employee contracts, or your corporate bylaws. This person should have a good reputation in the legal community, as well as in the business community.

One of the first items you should discuss with your lawyer is the fee structure. You are entitled to an estimate, but unless you enter into an agreement to the contrary with the attorney, the estimate is just that. Business lawyers generally charge by the hour, though you may be quoted a flat rate for a specific service, such as incorporation or registration of your trademark. You will probably pay over $150 per hour for an attorney's services, but if the firm has a good reputation, it more than likely employs a well-trained professional staff that can reduce the total amount of time required.

FINDING A LAWYER

If you do not know any attorneys, ask the owners of other galleries or craft retailers whether or not they know any good ones. You want either a lawyer who specializes in art law or a general practitioner who has many happy galleries or craft retailers as clients.

It is a good idea to hire a specialist or a firm with a number of specialists. Although it is true that you may pay more per hour for the expert, you will not have to fund his or her learning time, and experience is valuable. In this regard, keep in mind that it is uncommon for a lawyer to specialize in business practice and also handle criminal matters. Thus, if you are faced with a criminal prosecution for the death of an employee, you should be searching for an experienced criminal defense lawyer.

Finding the lawyer who is right for you is like finding the right doctor—you may have to shop around a bit. Your city, county, and state bar associations may have helpful referral services. Find out who is in the art law section of the state or county bar association, if it has one, or who has served on special bar committees dealing with art law reform, or check with the law school in your area to find out who teaches a course in the field. You can also consult the *Martindale-Hubbell Law Directory* in your county law library. The mere fact that an attorney's name does not appear in the book should not be given too much weight, however, because there is a charge for being included in this directory and some lawyers may have chosen not to pay for the listing. You may also wish to search the World Wide Web. Many attorneys have established Web sites, and the better ones usually have extensive résumés on the firm, as well as a list of the areas of law in which the firm has expertise. It may also be useful to find out whether any articles covering the area of law with which you are concerned have been published in scholarly journals, continuing legal education publications, or trade publications such as *NICHE Magazine* or *The Crafts Report*, and whether the author is available to assist you.

After you have compiled a list of attorneys who might suit your needs, it is appropriate for you to talk with them briefly to determine whether you would be comfortable working with them. Do not be afraid to ask about their background and experience and whether they feel they can help you with your specific concerns. Some lawyers will bill you for the initial consultation, so be sure to ask about this when making your appointment.

Once you have completed the interview process, select the person who appears to best satisfy your needs. The rest is up to you. Contact your lawyer whenever you believe a legal question has arisen. Your attorney should help you identify those questions that require legal action or advice and those that require business advice. Generally, lawyers will deal only with legal issues, although they may help you to evaluate business problems. You should be aware that you are likely to be charged for

all consultations, even though they may only be brief telephone calls, but the investment is well worth it.

I encourage my clients to call me at the office during the day or at home in the evening. Some lawyers, however, may resent having their personal time invaded. Some, in fact, do not list their home telephone numbers. You should learn your attorney's preference early on.

You should feel comfortable confiding in your attorney. The attorney-client relationship is such that this person will not disclose your confidential communications; in fact, a violation of this rule, depending on the circumstances, can be considered an ethical breach that could subject the attorney to professional sanctions. Take the time to develop a good working relationship with your attorney. It may well prove to be one of your more valuable business assets.

FINDING AN ACCOUNTANT

You will also need the services of a competent accountant to aid with business structuring, tax planning, and filing periodic and annual tax returns. The task of finding a Certified Public Accountant (CPA) with whom your business is compatible is similar to the task of finding an attorney. You should ask around and learn which accountants are servicing galleries or shops similar to yours. State or local professional accounting associations may also provide a referral service or point you to a directory of accountants in your region. Interview prospective accountants to determine whether you feel you can work with them comfortably and effectively and whether you feel their skills are compatible with your business needs.

Like your attorney, your accountant can provide valuable assistance in planning the future of your business. In both cases, it is important to work with professionals you trust and with whom you are able to relate on a professional level.

APPENDIX A:
GALLERY CONSIGNMENT
AGREEMENT

BETWEEN : _____ ("Artist")

Phone: (_____) _____
Fax: (_____) _____

AND : _____ ("Gallery")

Phone: (_____) _____
Fax: (_____) _____

Recital

Whereas, Gallery wishes to sell Artist's work (the "Artwork") on consignment;

Agreement

Now, THEREFORE, in consideration of the mutual covenants contained herein, the parties agree as follows:

1. **Consignment.** Artist hereby consigns to Gallery, subject to the terms of this Agreement, the Artwork listed on the initial, signed Inventory Sheet which is a part of this Agreement and attached hereto as Exhibit A and incorporated herein. Additional Inventory Sheets

(signed by Artist and Gallery in duplicate) will be incorporated into this Agreement if both parties agree to consignment of additional works.

2. Duration of Consignment. Artist and Gallery agree that the initial term of consignment for each piece of Artwork is to be _____ (____) months. Thereafter, consignment shall continue until this Agreement is terminated pursuant to Section 12 hereof.

3. Representations and Warranties of Artist. Artist hereby represents and warrants to Gallery that s/he is the creator of the Artwork; s/he is the sole and exclusive owner of all rights granted to Gallery in this Agreement, and has not assigned, pledged or otherwise encumbered the same; the Artwork is original; s/he has the full power to enter into this Agreement and to make the grants herein contained; and the Artwork does not, in whole or in part, infringe any copyright or violate any right to privacy or other personal or property right whatsoever, or contain any libelous or scandalous matter or matter otherwise contrary to law.

4. Responsibility for Loss or Damage. For the purposes of any liability of Gallery, the value of the Artwork shall be the amount Artist would receive if the Artwork had been sold. Should Gallery be responsible hereunder for loss or damage to any Artwork and pay Artist such value, the Artwork shall become the property of Gallery.

5. Pricing, Gallery's Commission, Terms of Payment.
5.1. Unless Artist and Gallery agree otherwise in writing, Gallery shall sell the Artwork only at the retail price specified on the Inventory Sheet(s).
5.2. Gallery's commission shall be sixty percent (60%) and Artist shall be paid the remaining forty percent (40%) of the sales price of each piece of Artwork sold.
5.3. Payment to Artist on all sales made by Gallery shall be within forty-five (45) days after the date of sale of the Artwork. On installment sales, the proceeds received on each installment shall be paid to Artist and Gallery according to their respective percentage shares. In the event that the Artwork is subsequently returned to Gallery for a refund, Artist shall promptly return to Gallery any fee s/he received or, at Gallery's discretion, Gallery may deduct such amount from the next payment due Artist.

5.4. Gallery may purchase any piece of Artwork at a price equal to the share of the sales price to which Artist would be entitled if the sale had been made to a third party. Payment for any such purchase by Gallery shall be made to Artist within forty-five (45) days of such purchase.

6. Accounting. Gallery shall maintain accurate books and records reflecting its gross sales and the amount due Artist. Artist, at her/his own expense, shall have the right to examine, during regular business hours and upon reasonable notice, Gallery's records that reflect payments due Artist. In the event such an examination of Gallery's records results in the determination that the amount of payments was miscalculated by more than ten percent (10%) and resulted in a deficiency, then the amount of the miscalculation, including interest at ten percent (10%) per annum, and the cost of such examination (including all reasonable attorney and accounting fees incurred for such examination), shall be paid by Gallery to Artist in the monthly statement following such examination.

7. Transportation Responsibilities. Packing and shipping charges, insurance costs, other handling expenses, and risk of loss or damage incurred in the delivery of Artwork from Artist to Gallery, and in their return from Gallery to Artist, shall be the responsibility of, and borne by, Artist. Gallery accepts responsibility for the transportation of work while in Gallery custody.

8. Removal of Artwork. Gallery shall not be liable to Artist for loss of or damage to a piece of Artwork if Artist fails to remove the work within a period of thirty (30) days following the date set forth herein for such removal or within a period of thirty (30) days after notice to remove the Artwork has been sent by certified mail to Artist's last address known to Gallery. Failure to so remove a piece of Artwork shall terminate the trust relationship between Gallery and Artist.

9. Title. Each of the Artworks is trust property in the hands of Gallery, which is a trustee for the benefit of Artist until such Artwork is sold to a bona fide third party, or, if the Artwork is bought by Gallery, until the full price is paid to Artist. Upon any such sale, the proceeds of the sale (including any unpaid receivables) are trust property in the hands of Gallery, which is a trustee for the benefit of Artist until the amount due Artist from the sale has been paid to Artist. The trust relationship

described above imposes no duty greater than that expressly provided above and does not give rise to any other fiduciary relationship.

10. Promotion. Gallery may display Artworks in whatever manner Gallery believes appropriate, at its sole discretion. Gallery shall promote the sale of the Artworks in such manner as it determines, at its sole discretion. When requested, Artist agrees to assist in the promotion of the sale of the Artworks either by providing, at Artist's sole expense, good quality photographs or slides, or in any other way reasonably requested by Gallery.

11. Reproduction. Artist hereby grants Gallery the right to photograph the Artwork and use such photographs for publicity and promotional purposes.

12. Termination of Agreement. Notwithstanding any other provision of this Agreement, but subject to Section 4, this Agreement may be terminated at any time by either Gallery or Artist by means of a thirty- (30) day written notification of termination from either party to the other. In the event of Artist's death, the estate of Artist shall be considered to be Artist for purposes of the Agreement. After the notification of termination has been received, Gallery and Artist shall settle all accounts according to the usual process and time limits in this Agreement.

13. Assignability. This Agreement or the rights, responsibilities or obligations granted or assumed in this Agreement may not be assigned by either party hereto, in whole or in part.

14. Notices. All notices required by this Agreement shall be made in writing, postage prepaid, certified mail, return receipt requested, or by facsimile transmission to the addresses or numbers first given above, or by hand delivery. Notice shall be deemed received two (2) days after the date of mailing or the day after it is faxed or hand delivered.

15. Attorneys' Fees. In the event that action, suit, or legal proceedings are initiated or brought to enforce any or all of the provisions of this Agreement, the prevailing party shall be entitled to such attorneys' fees, costs, and disbursements as are deemed reasonable and proper by an arbitrator or court. In the event of an appeal of an initial decision of an arbitrator or court, the prevailing party shall be entitled to such attorneys' fees, costs, and disbursements as are deemed reasonable and proper by the appellate court(s).

16. Venue. This Agreement shall be deemed executed in the State of [your state] and shall be interpreted and construed in accordance with the laws of the State of [your state] relating to contracts made and performed therein. Venue shall be proper only in the County of [your county], State of [your state].

17. Merger. This Agreement constitutes the entire agreement between the parties and supersedes all prior agreements, understandings, and proposals (whether written or oral) in respect to the matters specified.

18. Modification. No alteration, modification, amendment, addition, deletion, or change to this Agreement shall be effective or binding unless and until such alterations, modifications, amendments, additions, deletions, or changes are properly executed in writing by both parties.

19. Headings. All headings used in this Agreement are for reference purposes only and are not intended or deemed to limit or affect, in any way, the meaning or interpretation of any of the terms and provisions of this Agreement.

20. Judicial Rule of Construction. It is expressly agreed by the parties hereto that the judicial rule of construction that a document should be more strictly construed against the draftsman thereof shall not apply to any provision.

21. Waiver. No waiver by either party of any breach or default hereunder shall be deemed a waiver of any repetition of such breach or default or in any way affect any of the other terms and conditions hereof.

22. Severability. If any provision of this Agreement is judicially declared to be invalid, unenforceable, or void by a court of competent jurisdiction, such decision shall not have the effect of invalidating or voiding the remainder of this Agreement, and the part or parts of this Agreement so held to be invalid, unenforceable, or void shall be deemed to have been deleted from this Agreement, and the remainder of this Agreement shall have the same force and effect as if such part or parts had never been included.

23. Counterparts. This Agreement may be executed in two (2) or more counterparts, each of which shall be deemed an original but all of which together shall constitute one and the same Agreement.

24. **Effective Date.** This Agreement is effective as of the date all parties hereto have executed this Agreement.

IN WITNESS WHEREOF, the parties hereto execute and date this Agreement.

Artist

_____ _____
Print Name: _____ Date
SSN: _____

Gallery
[name of gallery]
By: _____ _____
 Print Name: _____ Date
 Its: [Title]_____
TIN: _____

EXHIBIT A

ARTWORK AND PRICES

APPENDIX B:
STATE MULTIPLES LAWS

California: Cal. Civ. Code §§ 1740–45

Georgia: Ga. Code Ann. §§ 10-1-431–433

Hawaii: Haw. Rev. Stat. § 481F

Illinois: Ill. Ann. Stat. ch. 121½ ¶¶ 361 *et seq.*

Maryland: Md. Com. Law Code §§ 14-501–505

Michigan: Mich. Comp. Laws Ann. §§ 442.351–.367

Minnesota: Minn. Stat. §§ 324.08–.10

New York: N.Y. Arts & Cult. Aff. Law §§ 15.01–.19

North Carolina: N.C. Gen. Stat. §§ 25C-10–25C-16

Oregon: Or. Rev. Stat. §§ 359.300–.315

South Carolina: S.C. Code Ann. §§ 39-16-10–39-16-50

INDEX

Books from Allworth Press

Received
DEC 3 2008
Mission College Library

The Law (in Plain English)® for Crafts, Fifth Edition by Leonard DuBoff (softcover, 6 × 9, 224 pages, $18.95)

Corporate Art Consulting by Susan Abbott (softcover, 11 × 8½, 256 pages, $34.95)

Licensing Art and Design, Revised Edition by Caryn R. Leland (softcover, 6 × 9, 128 pages, $16.95)

Legal Guide for the Visual Artist, Fourth Edition by Tad Crawford (softcover, 8½ × 11, 272 pages, $19.95)

Fine Art Publicity: The Complete Guide for Galleries and Artists by Susan Abbott and Barbara Webb (softcover, 8½ × 11, 190 pages, $22.95)

The Artist-Gallery Partnership: A Practical Guide to Consigning Art, Revised Edition by Tad Crawford and Susan Mellon (softcover, 6 × 9, 216 pages, $16.95)

Caring For Your Art: A Guide for Artists, Collectors, Galleries, and Art Institutions, Revised Edition by Jill Snyder (softcover, 6 × 9, 192 pages, $16.95)

Lectures on Art by John Ruskin, Introduction by Bill Beckley (softcover, 6 × 9, 264 pages, $18.95)

Beauty and the Contemporary Sublime by Jeremy Gilbert-Rolfe (paper with flaps, 6 × 9, 208 pages, $18.95)

Sculpture in the Age of Doubt by Thomas McEvilley (paper with flaps, 6 × 9, 448 pages, $24.95)

Uncontrollable Beauty: Towards a New Aesthetics edited by Bill Beckley with David Shapiro (hardcover, 6 × 9, 448 pages, $24.95)

The End of the Art World by Robert C. Morgan (paper with flaps, 6 × 9, 256 pages, $18.95)

Please write to request our free catalog. To order by credit card, call 1-800-491-2808 or send a check or money order to Allworth Press, 10 East 23rd Street, Suite 210, New York, NY 10010. Include $5 for shipping and handling for the first book ordered and $1 for each additional book. Ten dollars plus $1 for each additional book if ordering from Canada. New York State residents must add sales tax.

To see our complete catalog on the World Wide Web, or to order online, you can find us at *www.allworth.com*.